KT-873-053

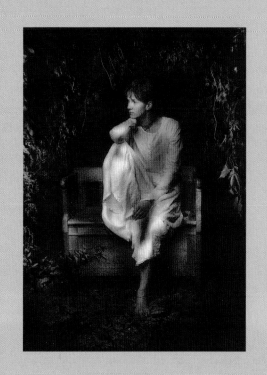

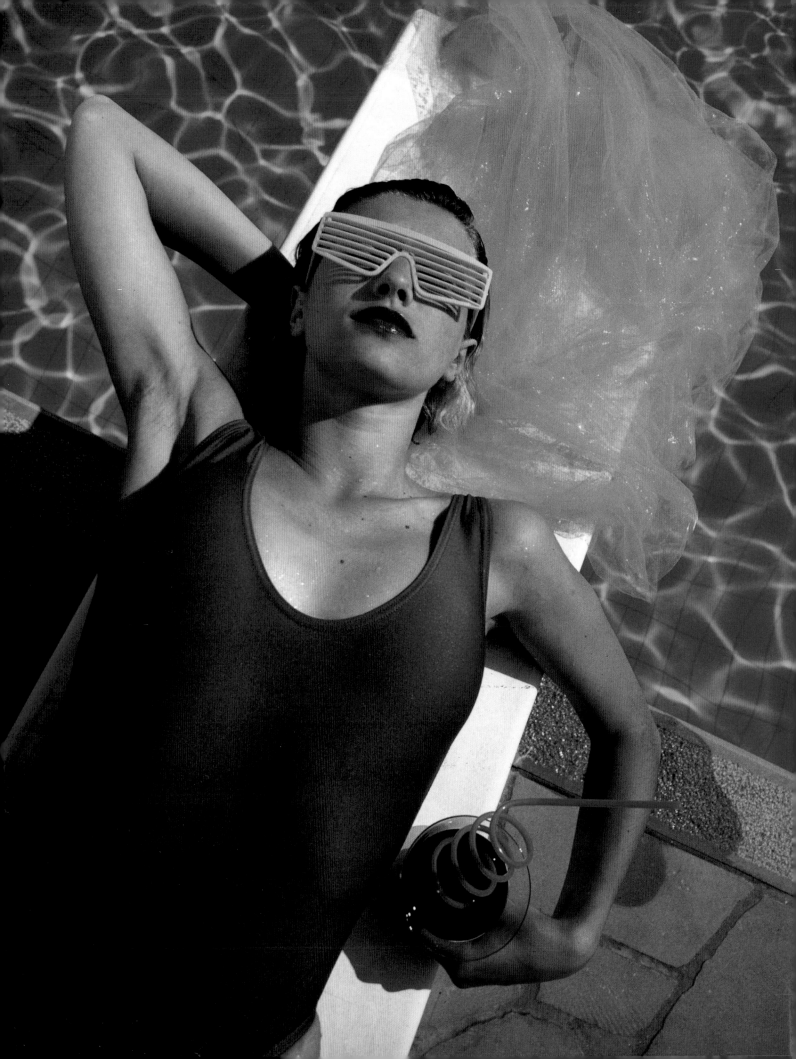

The AAPPL Yearbook of

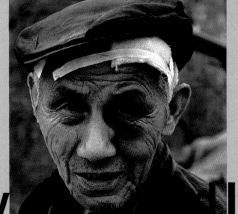

Photography and Imaging Vol.68

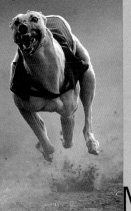

Masterpieces from around the World

LEARNING CENTRE

CLASS NO: 779 HIN

ACC NO: 052971

Harrow College
Harrow Weald Campus, Learning Centre
Brookshill, Harrow Weald, Middx.
HA3 6RR
0208 909 6248

The AAPPL Yearbook of
Photography and Imaging Vol. 68

Published by
AAPPL Artists'and Photographers' Press Ltd London

info@aappl.com
http://www.aappl.com

Distributed in USA and Canada by
Sterling Publishing Co., Inc.
387 Park Avenue South
New York, NY 10016
custservice@sterlingpub.com

Picture Editor
Chris Hinterobermaier
fotoforum@netway.at

Text Editors
Sarah Hoggett
Stefan Nekuda

Design: Carroll Associates London
carrollassoc@ndirect.co.uk

Reproduced in Hong Kong and
Printed in Singapore by Imago Publishing

info@imago.co.uk

All rights reserved.
No part of this book may be
reproduced in any form or
by any means without the express
permission of AAPPL.

Jacket, endpapers, prelims and introduction photographs
are reproduced by kind permission of:
Igor Berezunoy
Guerrino Bertuzzi
Tan Cheng
Ditz
Jörg Gründler
Thomas Herbrich
Kien Long Khuu
Hannes Kutzler
Dr. Wolfgang Laimer
Mauro Paviotti
Egon Petrowitsch
Michel Poinsignon
Romualdas Pozerskis
Nico Smit
Florian Stöllinger
Manfred Zweimüller

Contents

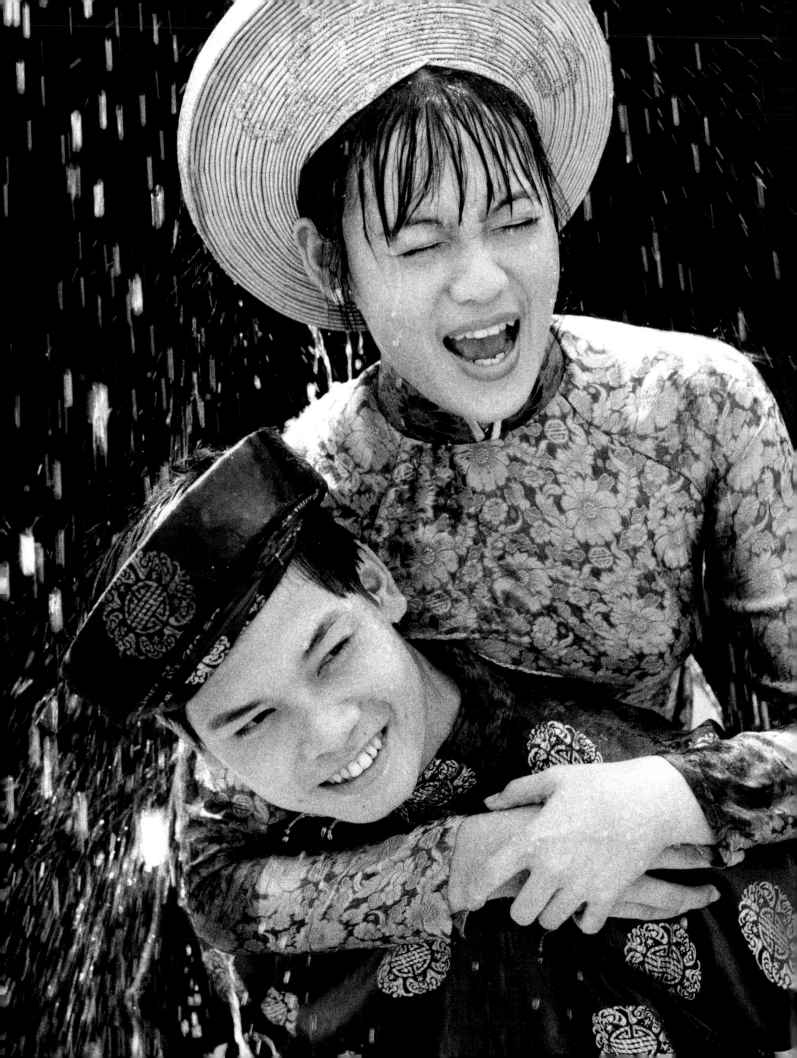

The AAPPL Yearbook of Photography and Imaging Vol.68
Introduction by the Publisher

The 68th Volume of the Yearbook is being brought to you for the first time by AAPPL: Artists' and Photographers' Press Ltd, itself a new venture, with this book its first publication. The Yearbook began its life in 1935 and has been published by Fountain Press since the 1970s. I have known Fountain's publisher, Harry Ricketts, for some years and, as he approached retirement, having sold Fountain Press, he suggested I might wish to take over publishing the Yearbook. I was delighted to do so and have received great support from Harry in getting this first AAPPL edition to press. I very much hope you will be pleased with the result.

Regular readers will see some changes. This year we have increased the focus on portfolios of work by particular photographers at the expense of large numbers of single pictures by individuals. Where we have featured such work it is now organized within coherent themed sections. This trend in the Yearbook has been well received over the past few years, the general view being that a portfolio of work can inevitably tell us much more about a photographer's art than any single shot. We do, nonetheless, carry the work of 75 photographers and digital-image makers from 26 countries in Volume 68.

We also recognize the fact that our readership comprises, in the main, professional or serious amateur photographers who are as interested in technical data as in aesthetic inspiration. To meet this interest we have ensured that technical information is presented with almost every image; each portfolio is also accompanied by a brief essay on the photographer and his or her techniques, sources of inspiration and *modus operandi*.

A more significant change is planned for next year, which will recognize the increasing popularity and artistic importance of digital work. From 2003 we will publish two Yearbooks, starting with Volume 69 of The Yearbook of Photography and Volume 1 of The Yearbook of Digital Imaging. It is, of course, impossible nowadays to make a clear distinction between the two forms. Much of the work that was once done in the darkroom is now carried out on the computer. The distinction we will make, perhaps arbitrarily, is to consider as 'photography' those images which start their existence as and remain predominantly derived from a single image captured by the camera of the photographer claiming authorship of the work. 'Imaging' will be everything else... composite pictures derived from multiple sources, pure digital "on-screen" creations, heavily manipulated images and so on. A shorter definition might be 'Artists behind a lense or artists before the screen' ... but however we define it, this will permit us to broaden the range of work we are able to publish and to satisfy the somewhat diverging tastes and interests within this art form.

This Volume 68 will be published in English and in German and we confidently expect to add further languages in the future. My ambition is to see the two Yearbooks recognized as the premier annual showcases of the best in world photography and imaging, and to achieve this we need to reach as wide an international readership as possible. Inevitably our selections will be subjective, but there will be input from a range of judges under the capable direction of Chris Hinterobermaier who, as many readers will know, is also responsible for the prestigious annual Hasselblad Austrian Super Circuit competition. I am deeply indebted to Chris, as well as to Harry Ricketts, for all their energy and skill in helping to bring this book to you.

Cameron Brown Publisher
AAPPL: Artists' and Photographers' Press Ltd. London

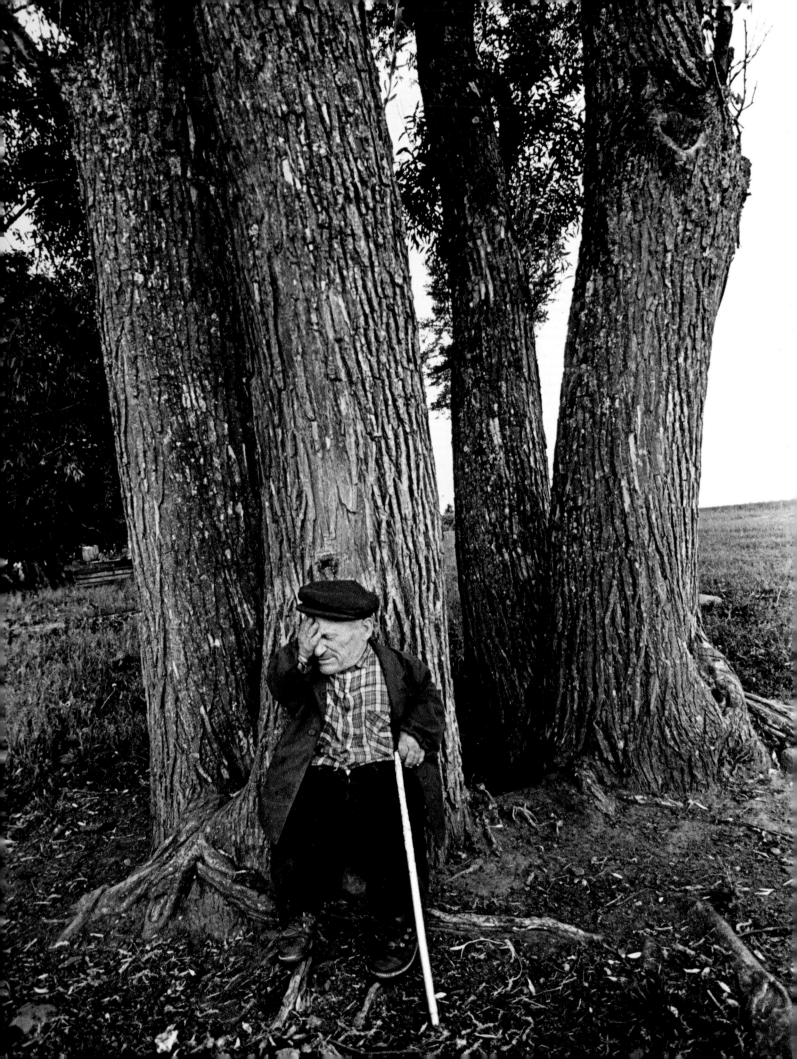

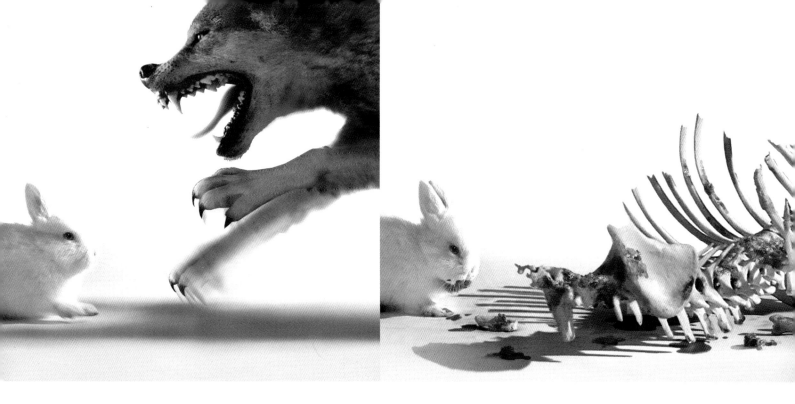

Digital Imaging
Everything under control

Computer and Art: seemingly a contradiction in terms. On the one hand cool, mathematical objectivity; on the other, subjective intuition and human creativity. Yet there are definite points of contact. Electronic art is now the fastest-growing segment of the US fine art market.

Programs first used in printing and advertising have now reached the point where they are standing the world of photography on its head. The presumption, valid until the 1980s, that photography's primary aim was to represent objective reality is, in this age of digital manipulation, no longer valid. Photos can now be altered wholesale at the whim of the computer-owner. The scope for manipulation of the image has now reached the point where the validity of a photograph as legal evidence is being challenged.

Like all revolutions, this one has its opponents as well as its supporters. There are still many photographers working happily in the classic analog world who absolutely reject the use of this 'artificial' technology, which so excites their colleagues.

The rapid spread of digitization through all aspects of our daily lives is, however, irreversible and is certainly supported by the photographic industry. For the forseeable future, we can expect to see the two branches of photography develop side by side – and to an increasing extent overlap.

The fundamental change brought about by the digital revolution is that the photographer today, with just the additional tool of a computer, can enjoy the same creative freedom as a painter with a blank canvas.

(Above) Hannes Kutzler/Austria
This picture was a commission and I was asked to create a sensation of surprise. The rabbit and the wolf were photographed in the studio and multiple images manipulated on the computer to obtain the best resulting shots. The skeleton was photographed whole and then broken up digitally.
Hasselblad 503 CW, Hasselblad 40mm,
Fujichrome RDPIII 120

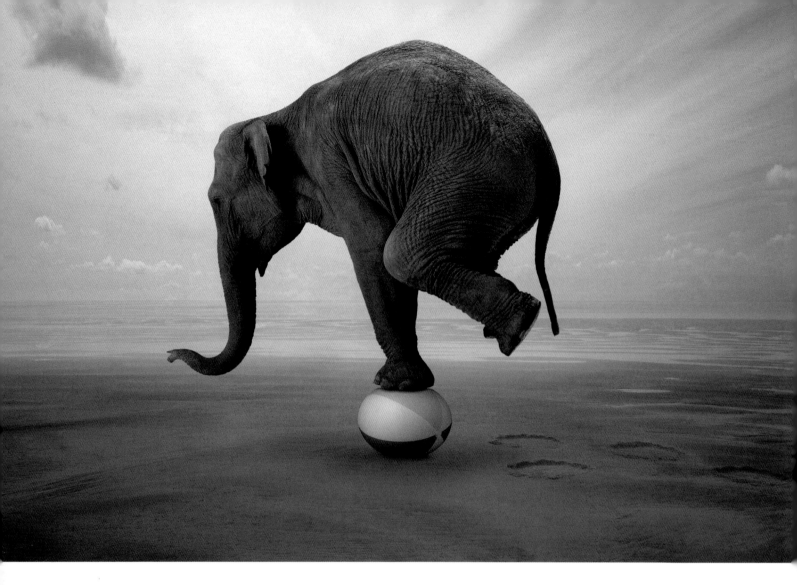

(Above) Bob Elsdale/England
We photographed the elephant in the large studio normally reserved for car ads. The background was a beach in Devon, UK. The ball, with its flattened top on which the elephant was to be placed, was also shot in the studio. Finally, I created the elephant's footsteps by hand in some sand in the studio, and then put the whole lot together.
Mamiya RB 6x7, Sekor 90mm, Fuji Provia 120

(Top right) Bob Elsdale/England
The glass was filled with red wine, diluted (otherwise it would have been too dark). The studio was in complete darkness and a 1/400 sec. flash was synchronized to the moment when the projectile hit the glass. We achieved this by fixing a sensor to the base of the glass which triggered the flash as soon as any movement was detected. The projectile was photographed separately and put into the final picture digitally.
Mamiya RB 6x7, Sekor 180mm, Fuji Provia 120

(Bottom right) Bob Elsdale/England
The same sheep was photographed three times in my studio, then put into this montage via Photoshop. The blue sky background was created on the computer.
Hasselblad 503 CW, Distagon 50mm, Fuji Provia 120

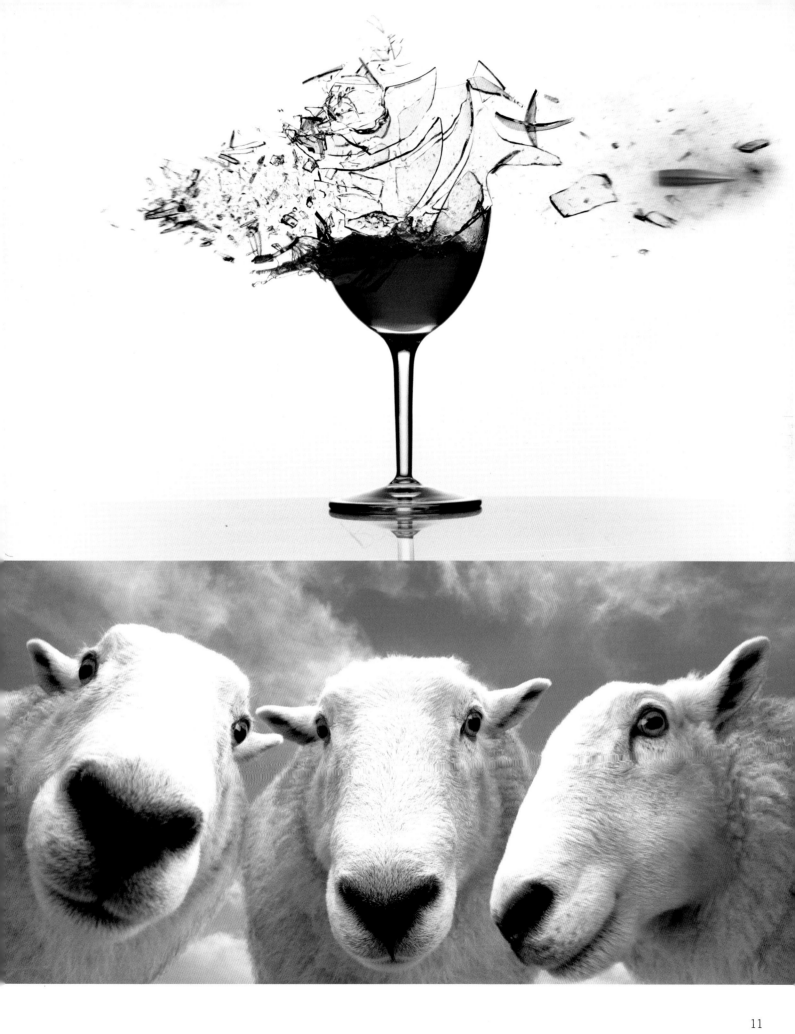

(Left) Pavle Jovanovic/former Yugoslavia
A remake of a classic. The basic shot came from parts of images that I'd created over 15 years earlier in the darkroom in black and white. I scanned the originals into my PC, put them together, and started work on coloring them. One thing I love about digital imaging is that, once the picture is stored in my PC, I can reproduce it perfectly as often as I like.
Canon F1, Canon lenses (24mm, 50mm, 135mm), Fujicolor 100

(Above) Pavle Jovanovic/formerYugoslavia
I love the work of the Belgian surrealist, René Magritte. His paintings are full of magic and mystery. I don't try to copy his pictures, but rather to develop his style in the medium of photography; Photoshop is astonishingly good for this kind of work. Again, I created this image from individual items in my archive.
Canon F1, Canon lenses (24mm, 50mm, 135mm), Fujicolor 100

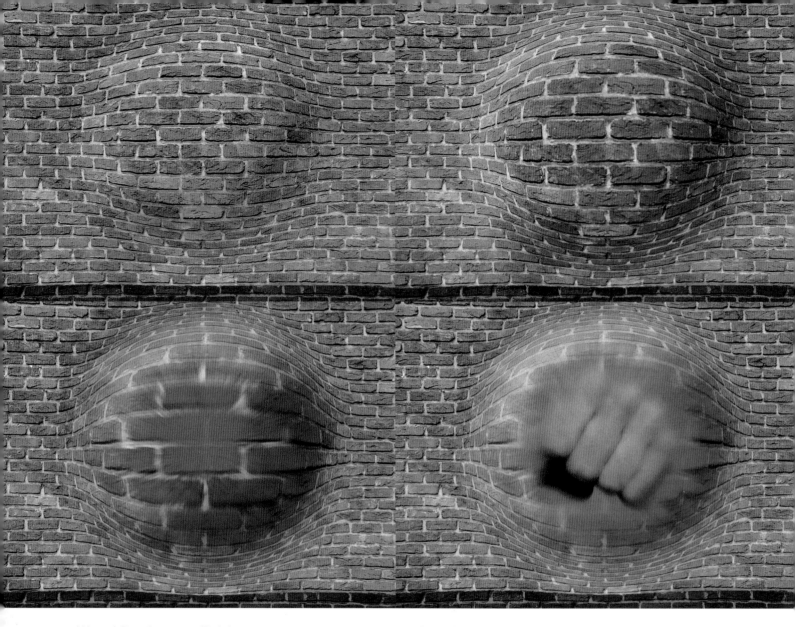

(Above) Ben Goossens/Belgium
Walls are secretive, hiding what's behind them. With
a little imagination I created this fist, punching its way
through the wall. I used to try this sort of work in the
darkroom, but only the advent of the digital workshop
has allowed me to realize my ambitions.
Nikon F80, Tamron 28–200mm Super II, Fuji Superia 200

(Right) Florian Stöllinger/Austria
This is a digital montage of shots taken in different
locations; the room is in a furniture store, the floor in a
private home, the people in a studio. To create the illusion
of levitation, it is critical that the perspective (camera
height and angles) is correct. I extended the floor and
ceiling artificially. The picture could not have succeeded
if the models had not been genuinely into yoga...
Rolleiflex 6008, 50mm, Fujichrome RDP 120

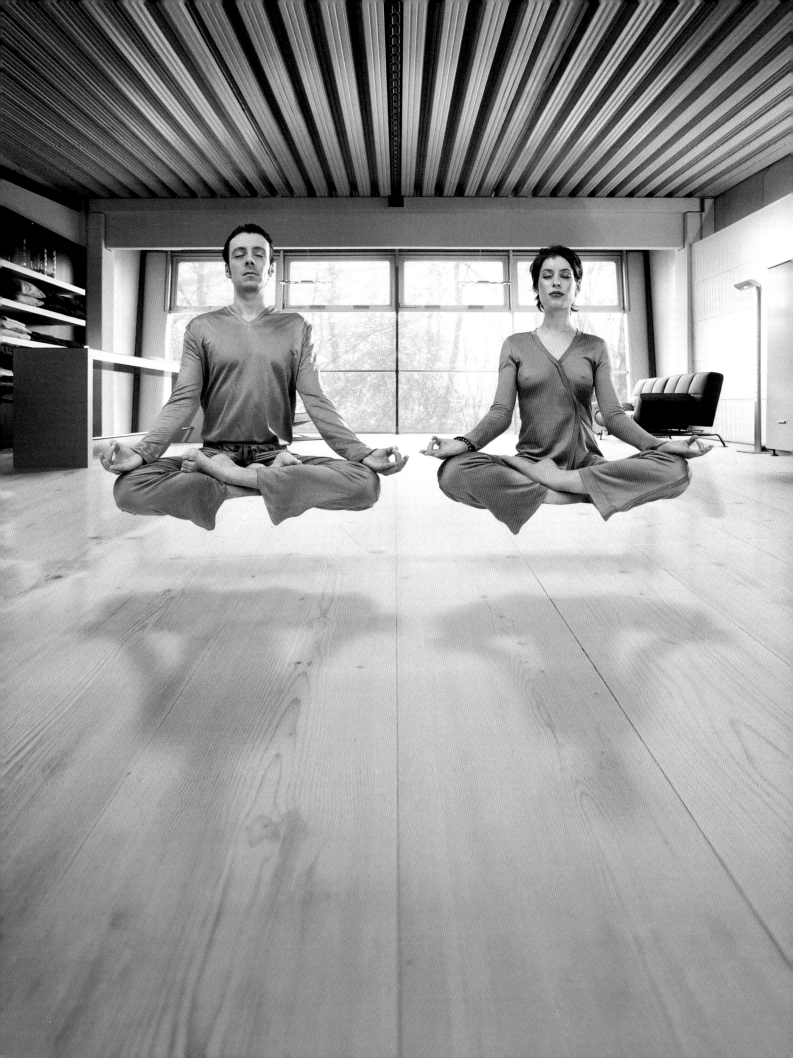

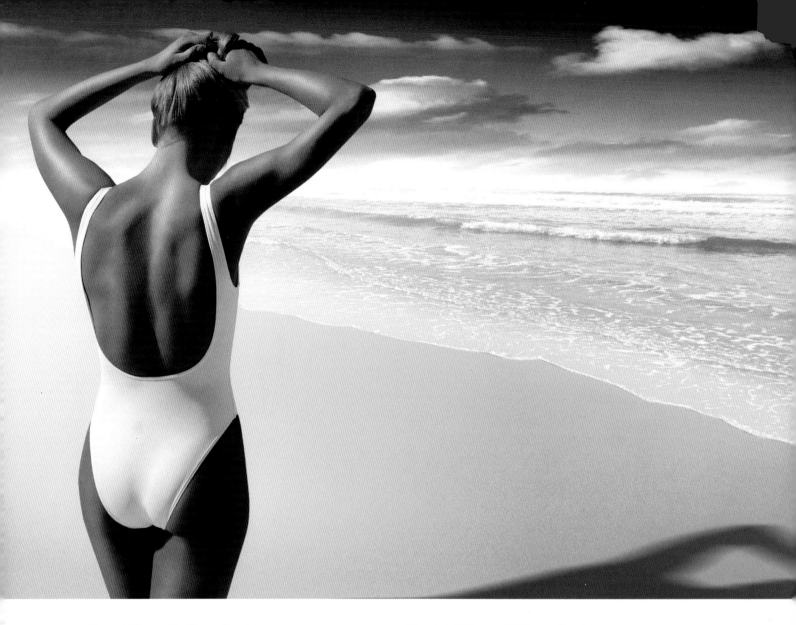

(Above) Florian Stöllinger/Austria
First the beach and clouds (shot on a beach in
Portugal) were brought together in the computer,
then the model was photographed in the studio in the
same sort of light as there had been on the beach.
I used Photoshop to exaggerate the contrast between
foreground and background.
Rolleiflex 6008; lenses: 40mm (landscape), 80mm
(model); Fujichrome RDP 120

(Top right) Florian Stöllinger/Austria
The background landscape shots were taken in New Zealand
and the rabbits and lettuce in my studio. We created a field in
the studio in which we planted 120 lettuces. Two stuffed rabbits
and one living one (on a leash to stop him running away) were
photographed in various positions and dropped into the field
using Photoshop. It took 10 days to do this picture.
Rolleiflex 6008; lenses: 80mm (landscape), 46mm (lettuce),
50mm (rabbits); Fujichrome RDP 120

(Bottom right) Florian Stöllinger/Austria
The model and computer screen were photographed in the
studio using a powerful wind machine. The tie was fixed in place
with a length of fishing line. The wind-blown hair is another shot.
After scanning, the screen was given its shine in Photoshop, the
background enlarged (made longer) and the picture assembled.
Rolleiflex 6008, 80mm. Fujichrome RDP 120

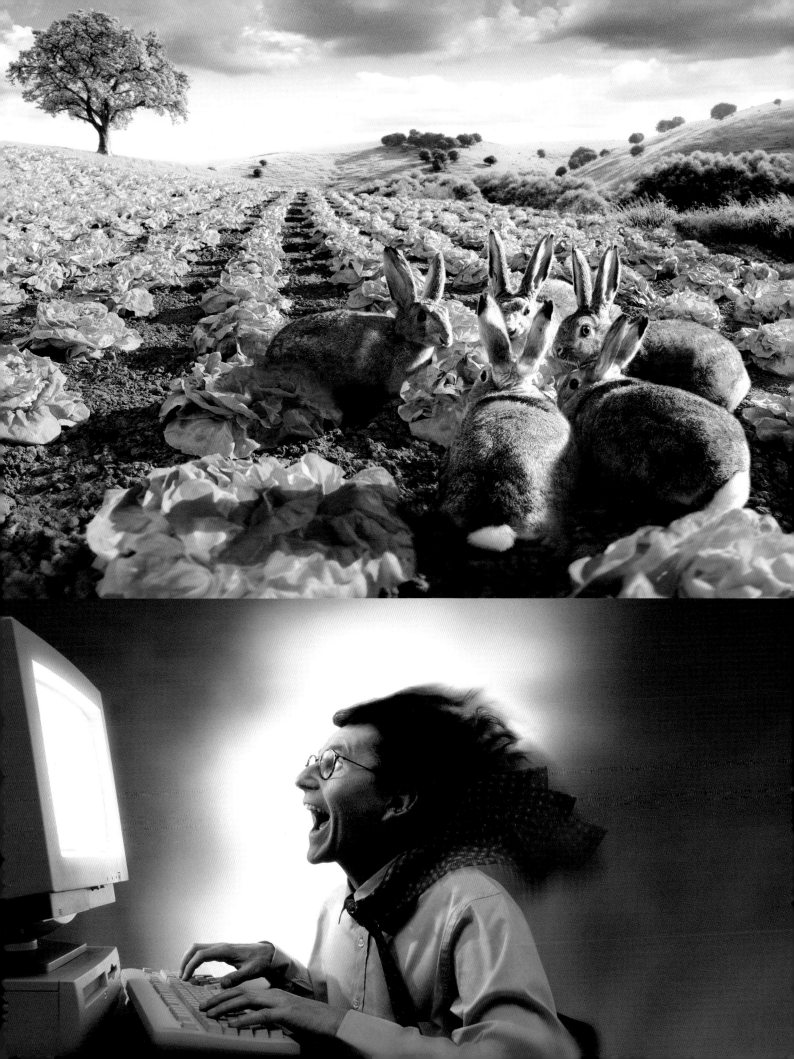

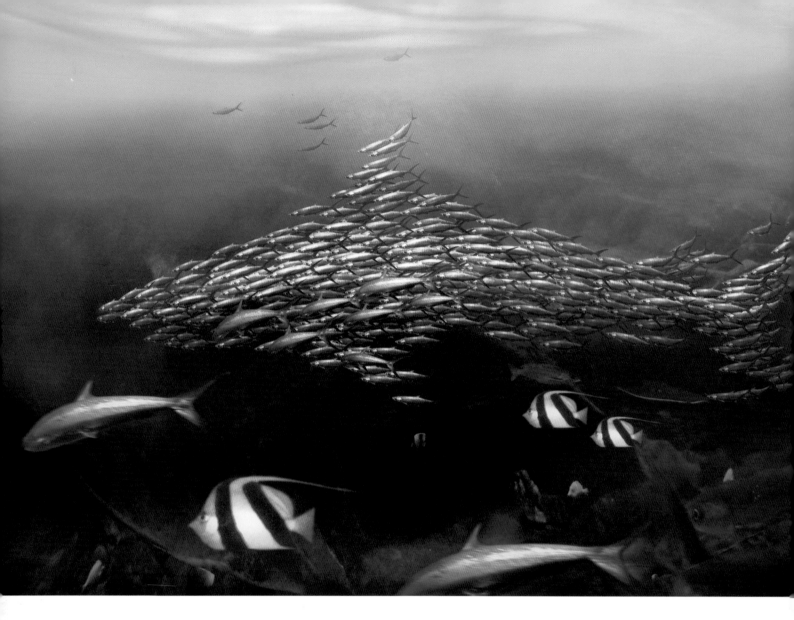

(Above) Hannes Kutzler/Austria
A shark made from a shoal of fish... I always take care with the color in my pictures; too much use of color distracts from the image itself.
Hasselblad 503 CW, Hasselblad 40mm, Fujichrome RDP 120

(Top right) Hannes Kutzler/Austria
For this picture I flew to Hawaii and photographed the dolphins in Oahu Sea-life Park's underwater area. Then I came home to my computer and set them free.
Hasselblad 503 CW, Hasselblad 40mm, Fujichrome RDP 120

(Bottom right) Hannes Kutzler/Austria
When a picture is made up of several images, it is essential that they are all properly integrated in terms of size, perspective and color values. The digital work on this image took 12 hours.
Hasselblad 503 CW, Hasselblad 40mm, Fujichrome RDP 120

(Overleaf) Hannes Kutzler/Austria
Computers make things possible which, a few years ago, were unimaginable.
Hasselblad 503 CW, Hasselblad 40mm, Fujichrome RDP 120

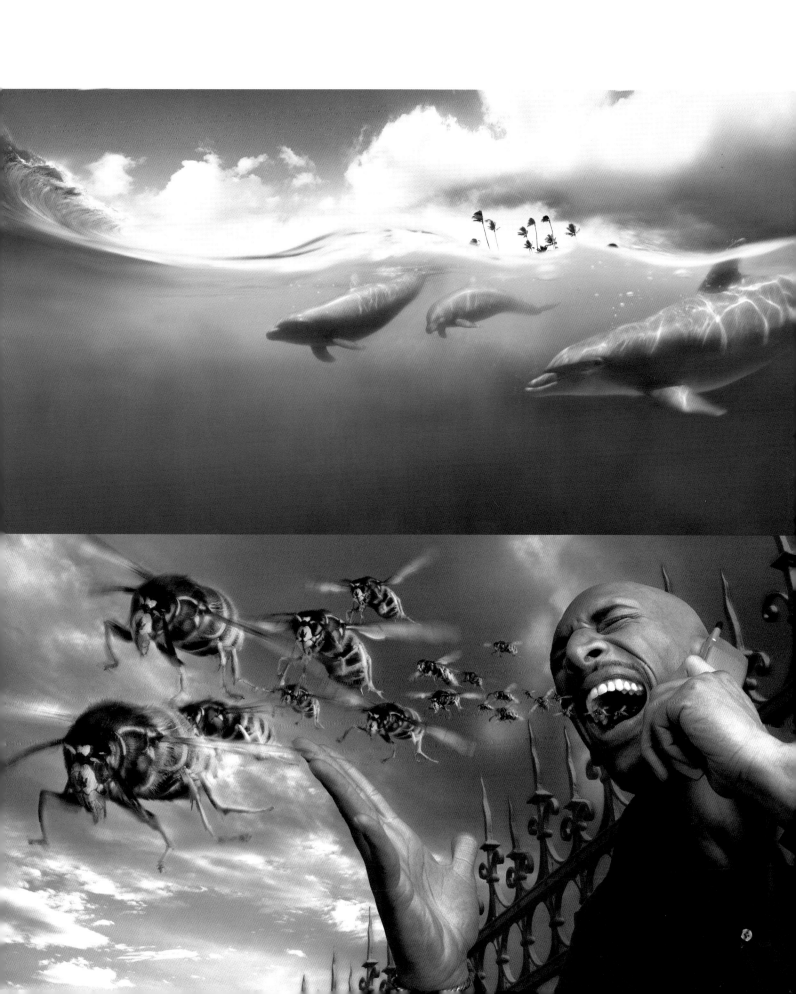

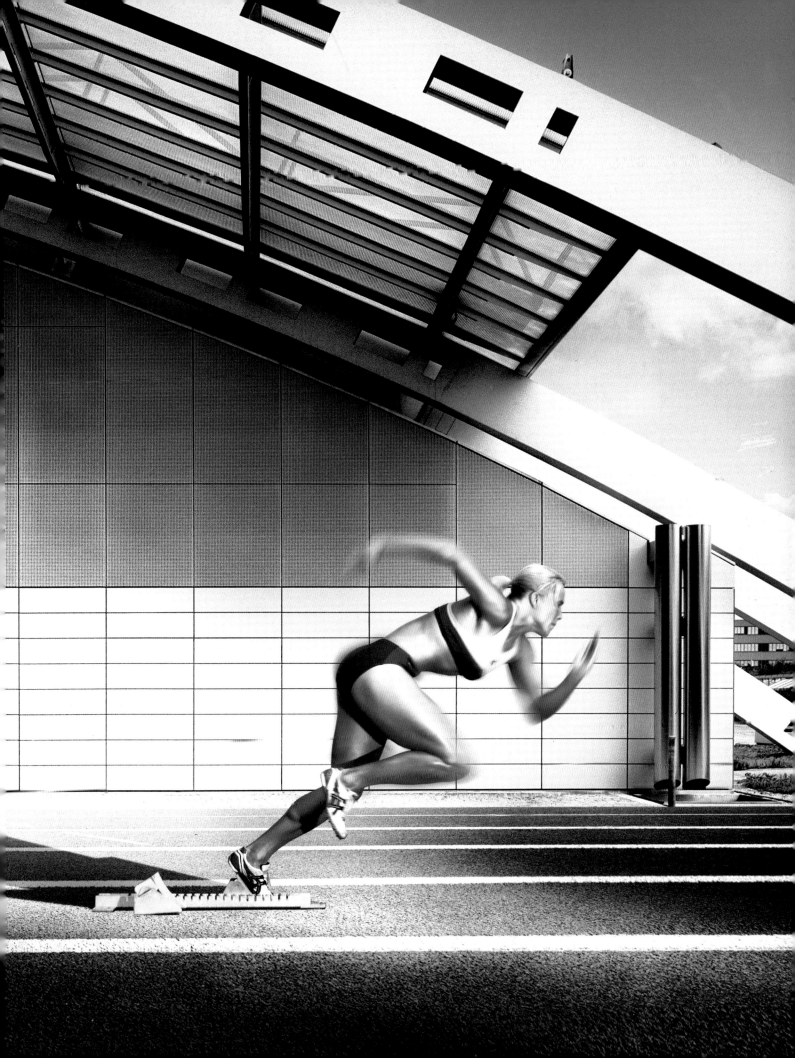

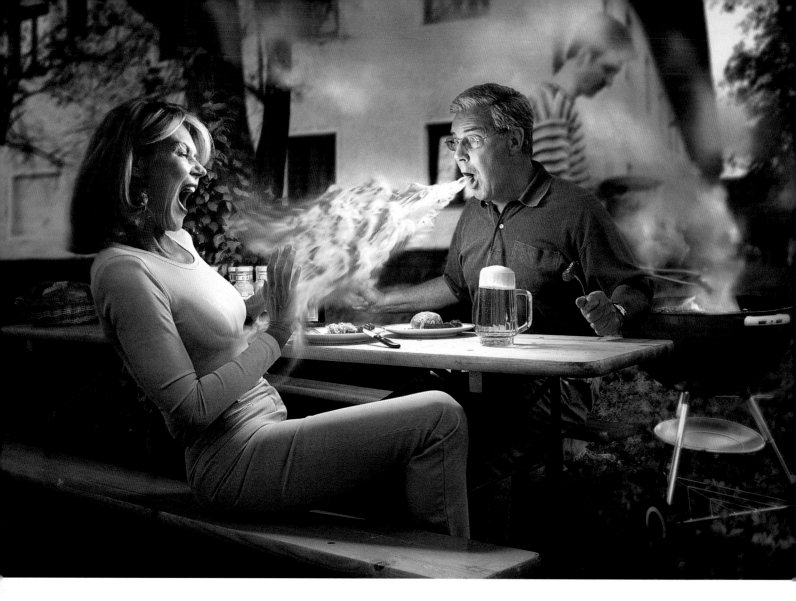

(Above) Hannes Kutzler/Austria
It goes without saying that this picture exaggerates somewhat. I made the flames by photographing a paint-stripping tool and spent six hours on the computer to get the picture looking realistic.
Hasselblad 503 CW, Hasselblad 40mm,
Fujichrome RDP 120

(Right) Hannes Kutzler/Austria
This image comes from a number of pictures taken whilst on a video shoot. As I had to remove images of stage sets, film crews, lamps and cameras, the whole thing took 20 hours on the computer.
Hasselblad 503 CW, Hasselblad 40mm,
Fujichrome RDP 120

(Overleaf) Hannes Kutzler/Austria
Just creating the tornado took 8 hours of work at the computer, but it enabled me to create a scene that would be impossible to capture in real life.
Hasselblad 503 CW, Hasselblad 40mm,
Fujichrome RDP 120

Harrow College
Harrow Weald Campus, Learning Centre
Brookshill, Harrow Weald, Middx.
HA3 6RR 0208 909 6248

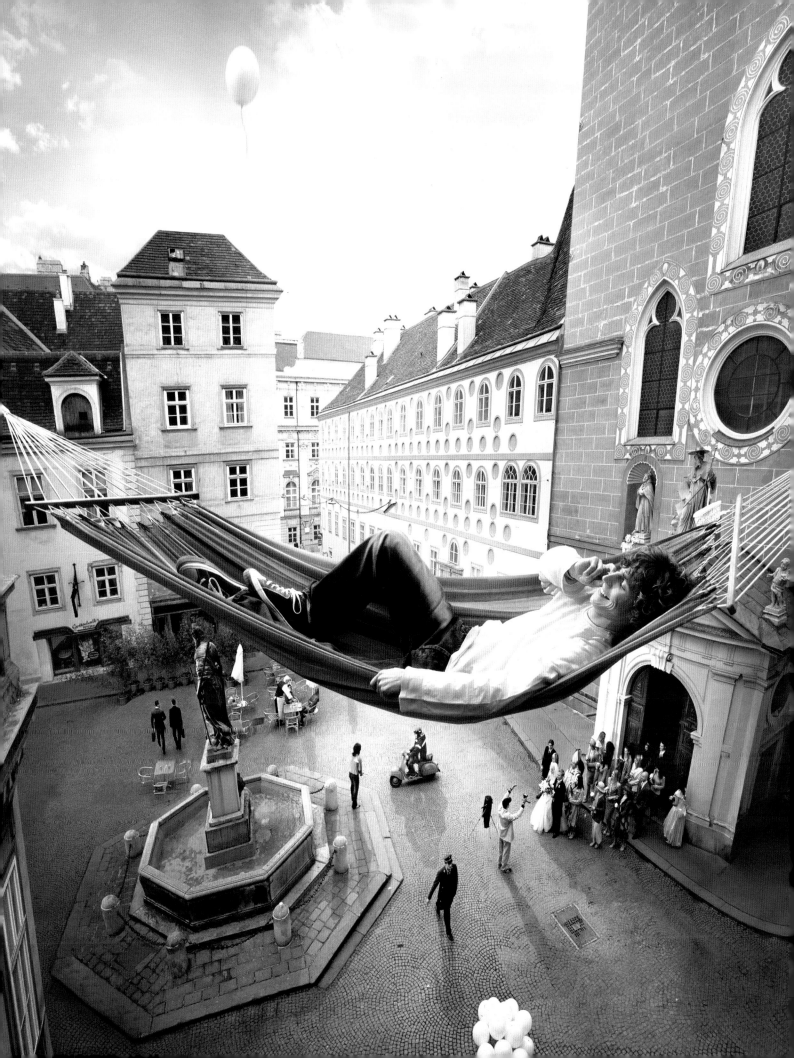

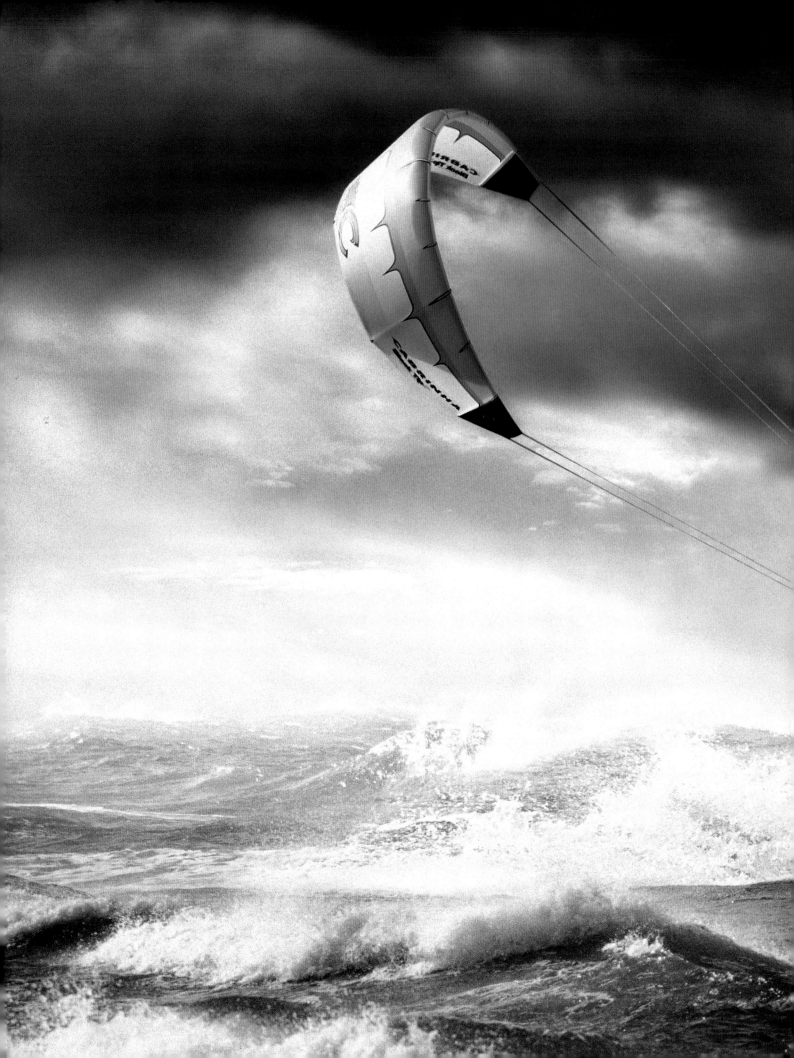

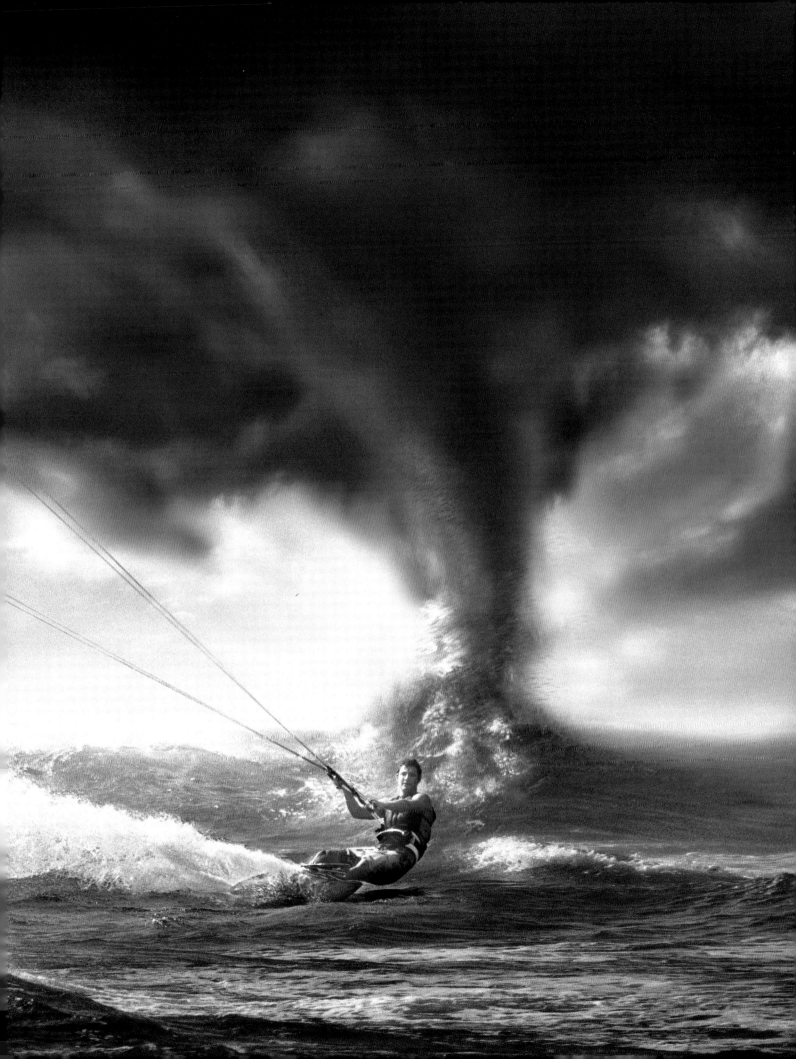

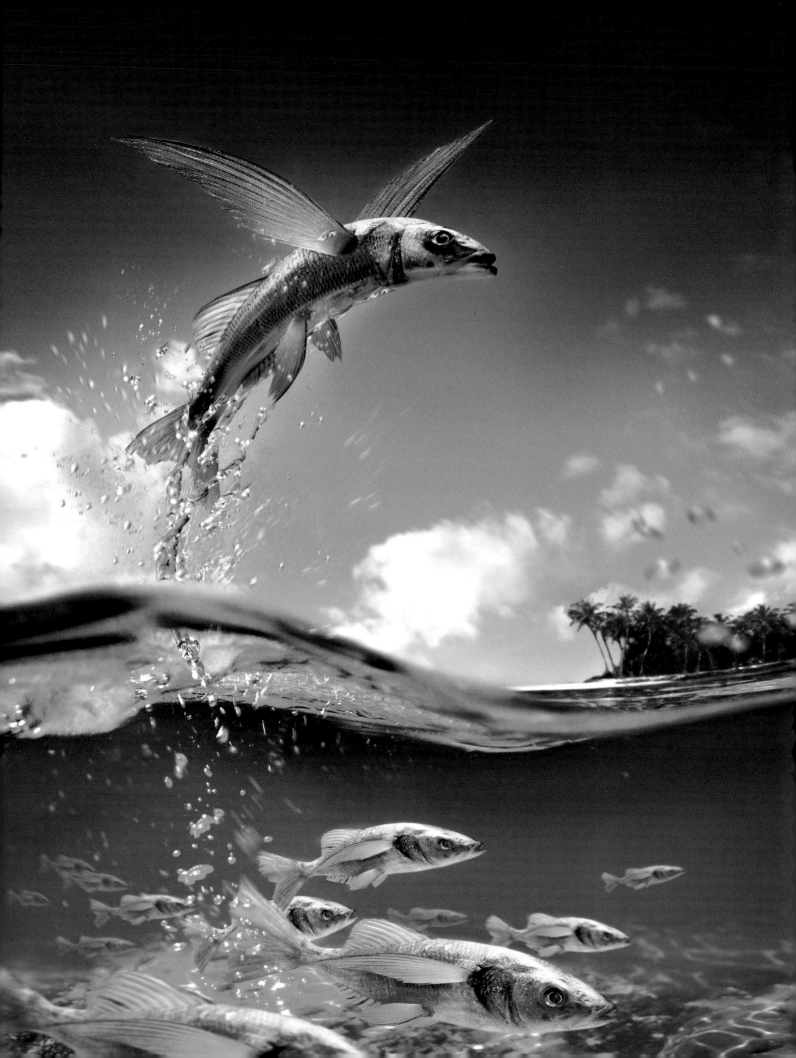

(Above) Hannes Kutzler/Austria
It is difficult to capture just the right moment for an action shot. In my view, digital manipulation is simply the best tool for turning good shots into excellent ones.
Hasselblad 503 CW, Hasselblad 40mm,
Fujichrome RDP 120

(Left) Hannes Kutzler/Austria
First I bought a herring in the market and photographed it in my studio. Using a picture of a flying fish as a reference, I then proceeded to metamorphose the herring and set it in the South Seas.
Hasselblad 503 CW, Hasselblad 40mm,
Fujichrome RDP 120

(Overleaf) Thomas Herbrich/Germany
The wolves were photographed with a Nikon 801 and 180mm lens and a Mamiya 4.5-6 cm camera with a 300mm lens. The landscape was also taken with the Mamiya, and the postman with a Fuji digital camera. I used Fuji Velvia for the non-digital shots. Then, of course, I had to put it all together digitally.

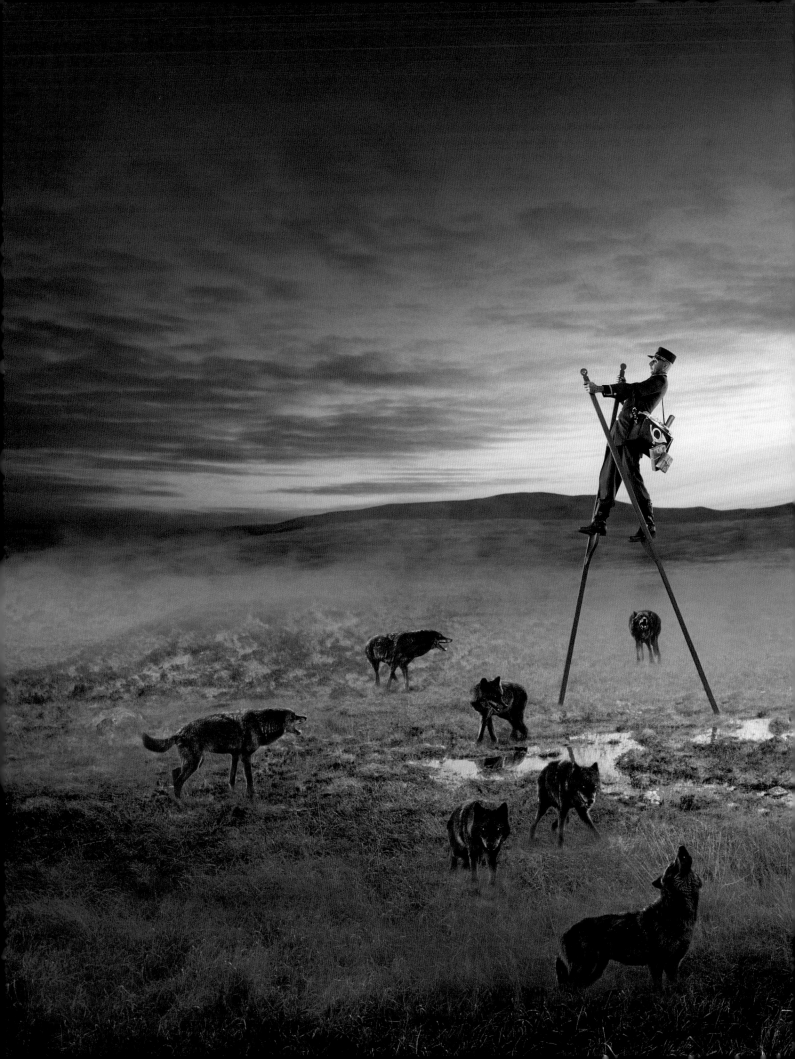

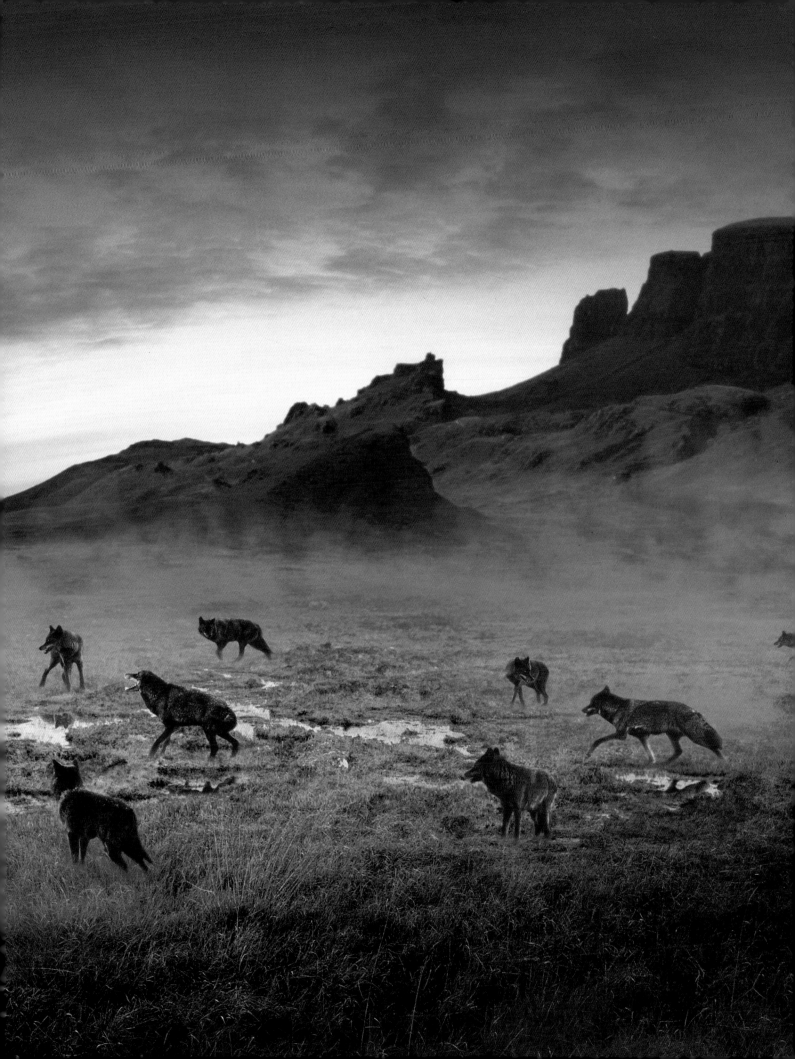

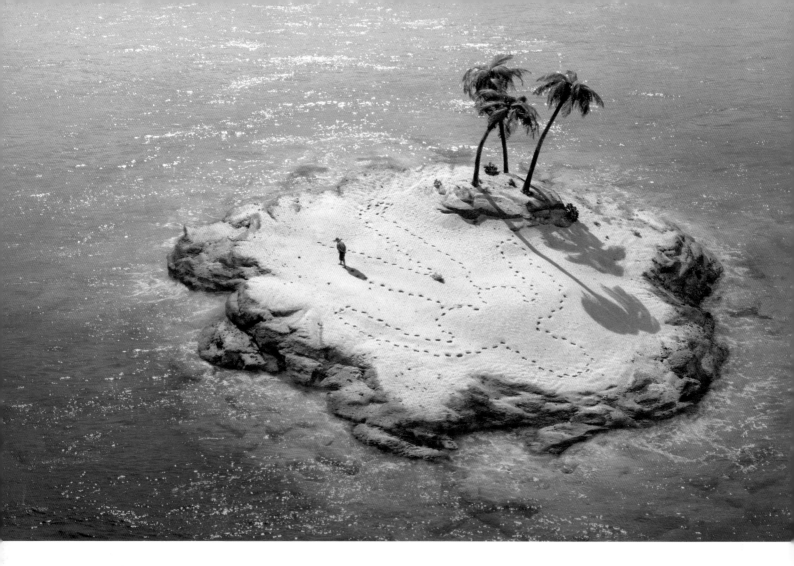

(Above) Thomas Herbrich/Germany
This island exists only in my Düsseldorf studio. My brother, a gifted model-maker, built it for me and I shot it on a Fuji GX 6/8 with an 80mm lens on Fuji Velvia. 'Robinson Crusoe' was photographed using a Fuji digital camera with a 180mm lens, and then he and the footprints were placed digitally on this island.

(Top right) Thomas Herbrich/Germany
The theme of this image was the daily 'flood' of information. The set was created in the studio, and individual images taken using a variety of cameras and lighting set-ups – Mamiya 4.5x6 cm with 80mm lens, Hasselblad 6 x 6 cm with 120mm lens, Fuji GX 6/8 with 80mm lens; all film was Fuji Velvia. The individual shots were then carefully manipulated into one image on screen.

(Bottom right) Thomas Herbrich/Germany
The water surface was a shot from my archive. The boat and fishermen were photographed in the studio, and I built the sharks' fins from wood and photographed them in various locations. The different elements were then combined in Photoshop.

(Overleaf) Thomas Herbrich/Germany
The car was photographed with a Fuji GX 6/8 and an 80mm lens using Fuji RTP tungsten-balanced film. The ski-hut is a model I built myself, and the snow is baking powder! The hut was shot in the studio using a Plaubel 4/5 inch camera with a 120mm lens on Fuji Velvia film. I then combined the two shots digitally.

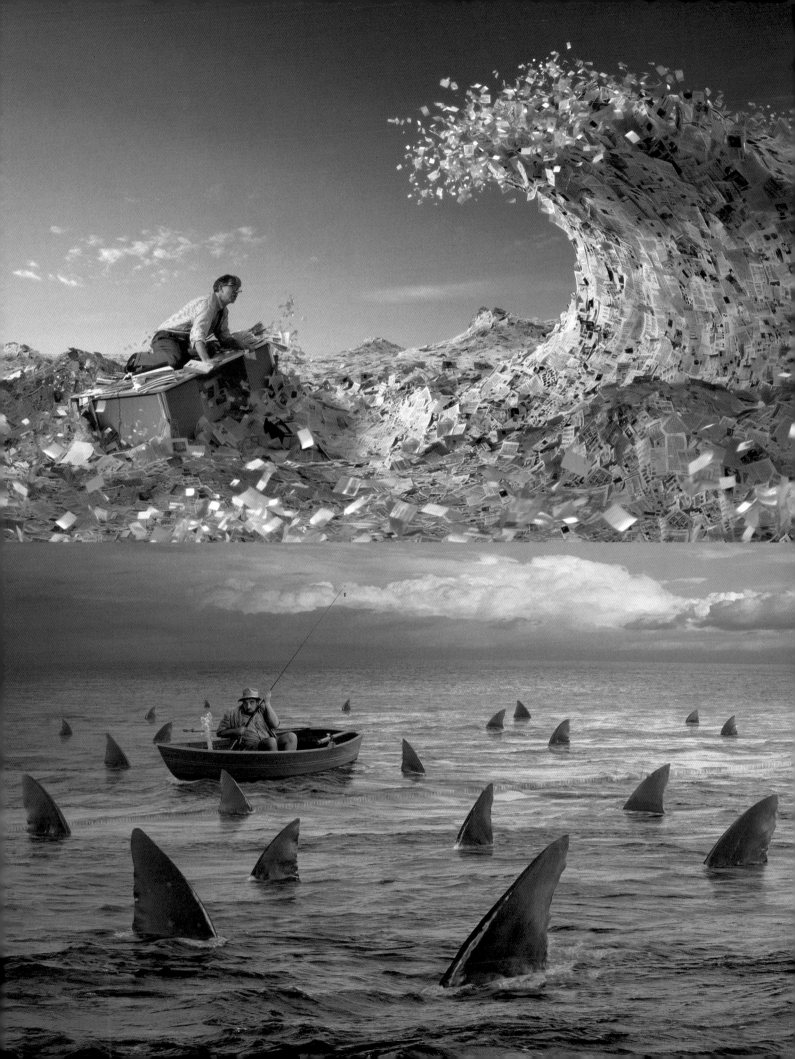

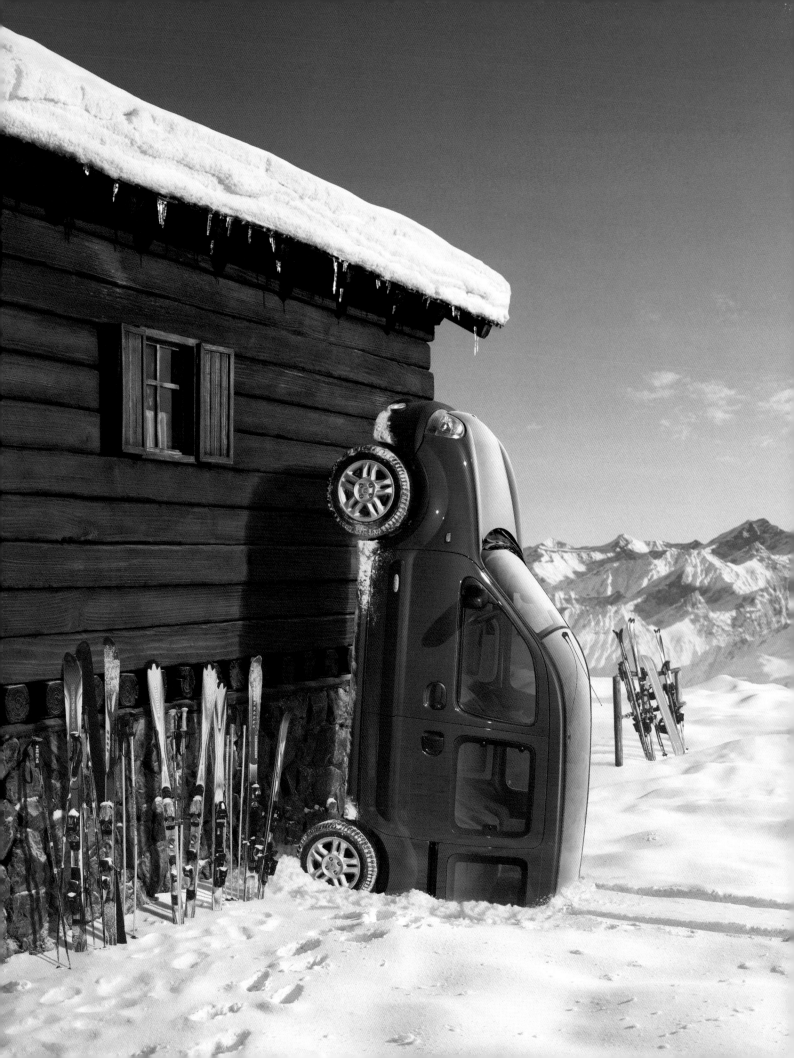

Edmund Whitaker
Aspects of Landscape

'Landscape photographs don't just happen. They are the result of stamina, patience and simply coming back to the same spot again and again. Good photography needs painstaking planning and preparation.'

Landscape has always been an important theme for the artists, whatever their chosen medium, and photography, by virtue of its ability to record the scene exactly as it appears, is perfectly suited to revealing landscape in all its guises. When a photographer rejects a purely realistic approach (and, indeed, the use of color), however, the results can take on an ethereal, almost surreal quality – as this portfolio of predominantly infrared images by English photographer, Edmund Whitaker, demonstrates.

Landscape images that stay in the memory seldom come from some sudden inspiration but require the photographer to be in tune with nature and its moods. 'The light, the weather and the time of day all play their part,' Whitaker says. 'I look for those mystical moments of peace and quiet, when time seems to stop'.

Infrared black-and-white film is Whitaker's preferred medium. He believes that its capacity to take us beyond the visible color spectrum allows us to capture what he terms 'the mysterious essence' of landscape.

When it comes to producing the finished print, Whitaker prefers the time-consuming, intensive approach of working in the darkroom to digital manipulation, which he considers 'superficial'. 'You need a lot of patience and experience to take a successful negative and turn it into a print showing the full tonal range and the contrasts available in your picture. I always need to make a lot of test strips before I start on the enlargement.'

The choice of printing paper is critical, too; for strong contrasts Whitaker uses grade 4 or 5.

As one might guess from the painterly nature of his work, Edmund Whitaker draws much of his inspiration from the great landscape artists of the 18th and 19th centuries, particularly Turner and Constable. With his mastery of black and white, and his seemingly innate ability to get to the heart of a scene, Edmund Whitaker is an example of the dedicated 'traditional' photographer, determined to push the craft of analog photography to the limits in order to create landscape images of a truly artistic quality.

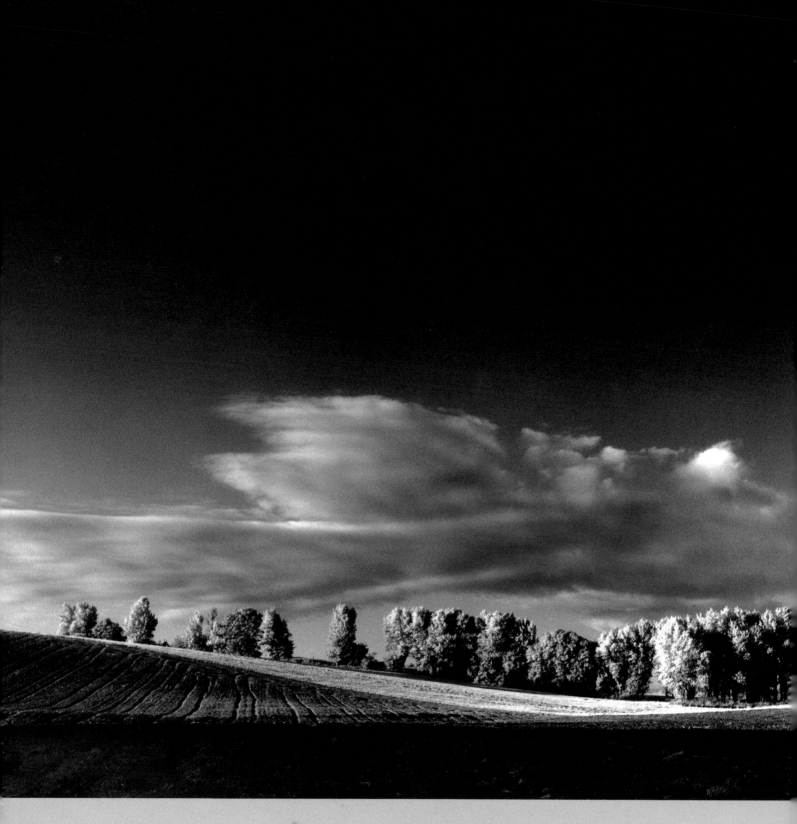

(Above) This picture, taken in Farnham, England,
where I was an art student, was one of the first landscape
shots I ever took.
Hasselblad 500 CM, Hasselblad 80mm lens,
Konica 750 infrared film

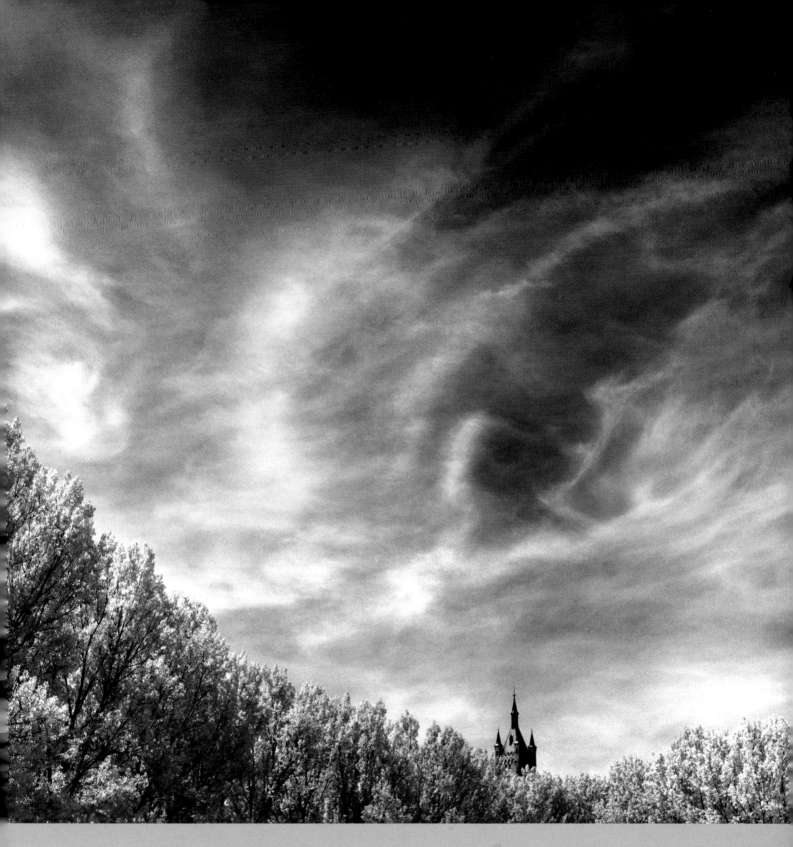

(Above) This often-photographed water tower
is in the spa town of Bad Wimpfen, Germany. I wanted
to integrate the tower into the landscape.
Hasselblad 500 CM, Hasselblad 80mm lens,
Konica 750 infrared film

(Overleaf) Lough Carib is the largest lake in
the Connemara region of Ireland, an area whose harsh
beauty and constant shifts of light never fail to make
an impression on me.
Canon AE1, Canon 24mm lens, Kodak HIE infrared film

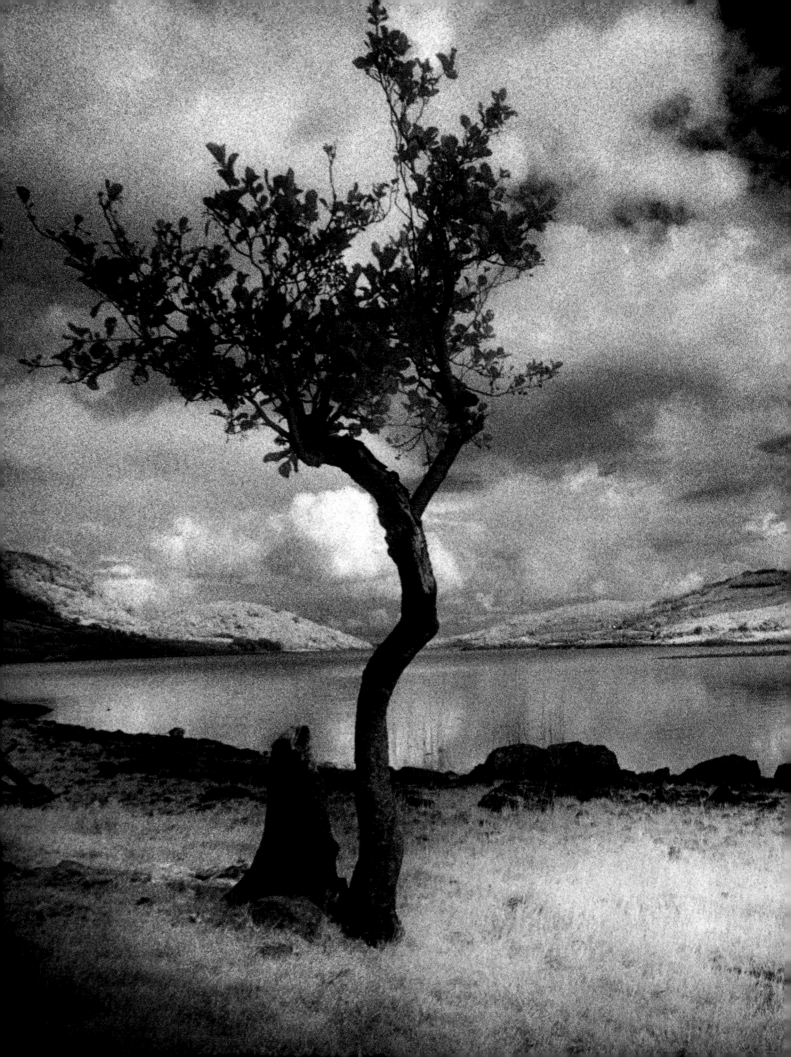

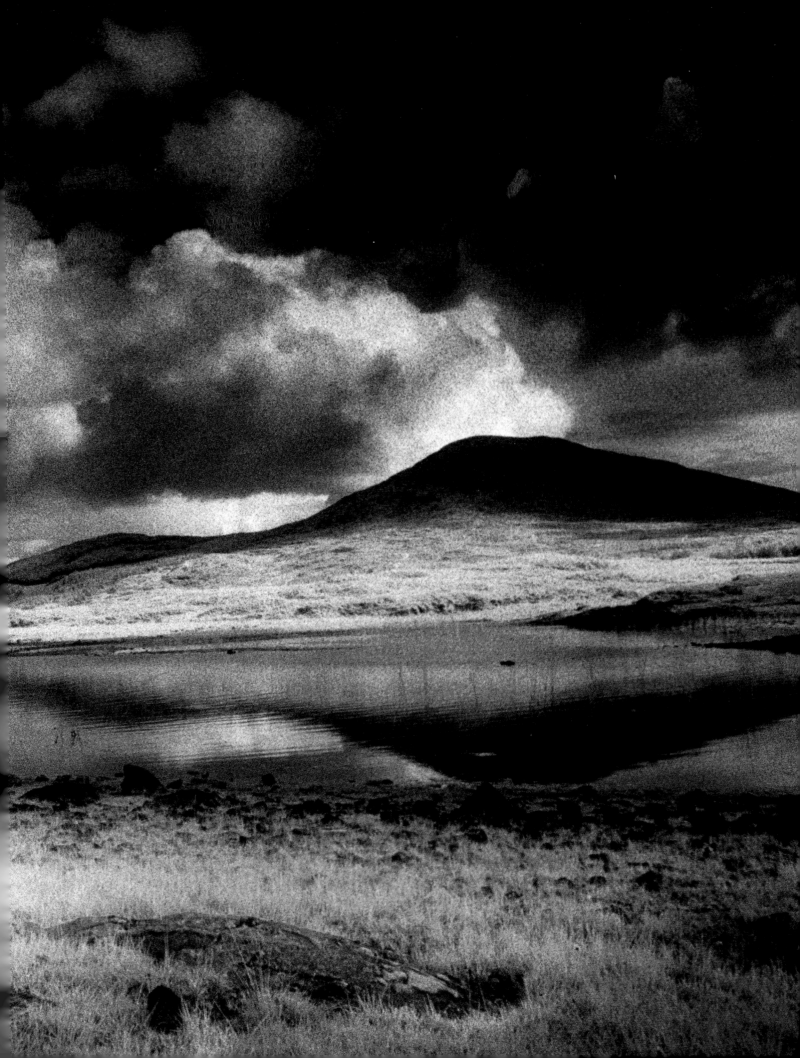

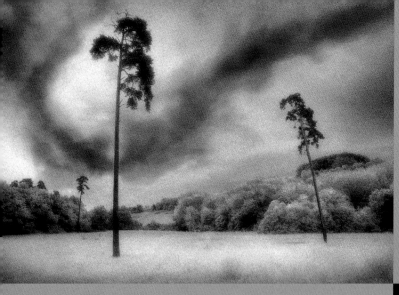

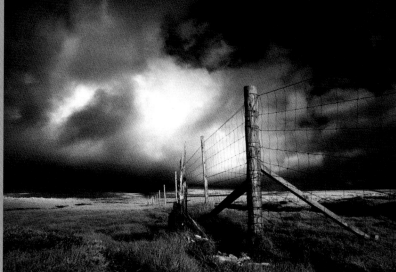

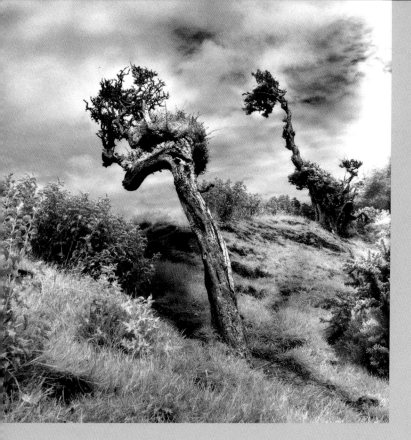

(Top left) Kestrels love to nest in these tall trees near Beilstein, Germany.
Canon AE 1, Canon 24mm lens, Kodak HIE infrared film

(Above) The small island of Jura, off the coast of Scotland, is home to some 5000 red deer who are prevented from grazing on farmland by these fences.
Canon AE 1, Canon 24mm lens, Kodak HIE infrared film

(Left) This shot of hawthorns was taken in the coastal region of Pembrokeshire, Wales.
Hasselblad 500 CM, Hasselblad 80mm lens, Konica 750 infrared film

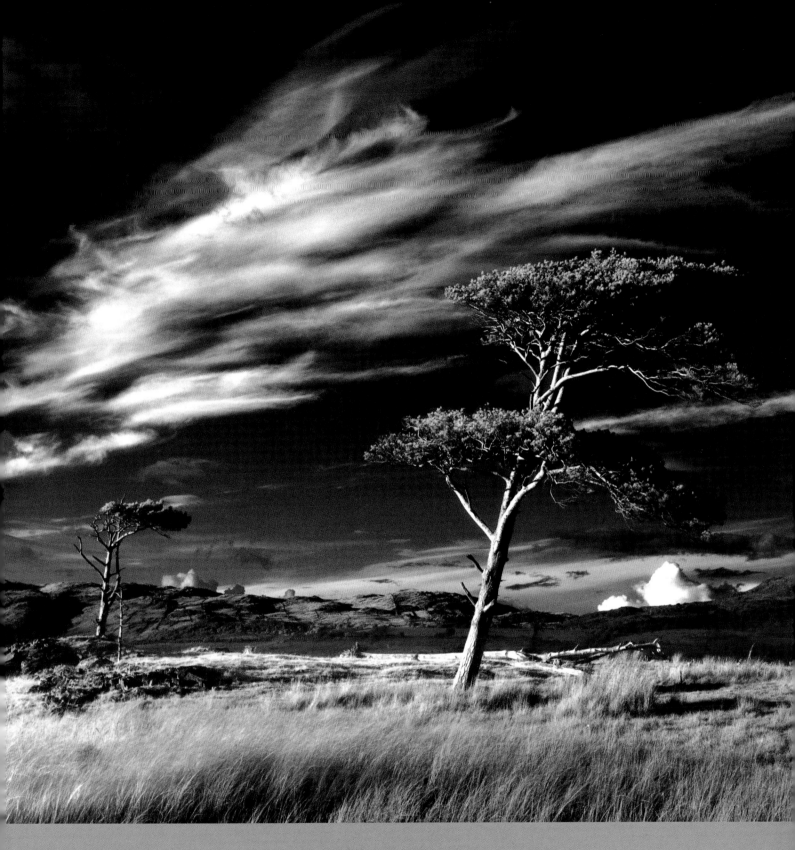

(Above) This picture really shows the wind-scoured, desolate Connemara region in exactly the way I experienced it. I could never have captured this mood as well in color as I did in black and white.
Hasselblad 500 CM, Hasselblad 80mm lens, Kodak HIE infrared film

(Overleaf) This picture was a challenge to my darkroom skills, as it was taken in the unforgiving midday light and contained a wide range of tones, from pure white to completely black.
Canon AE 1, Canon 24mm lens, Kodak HIE infrared film

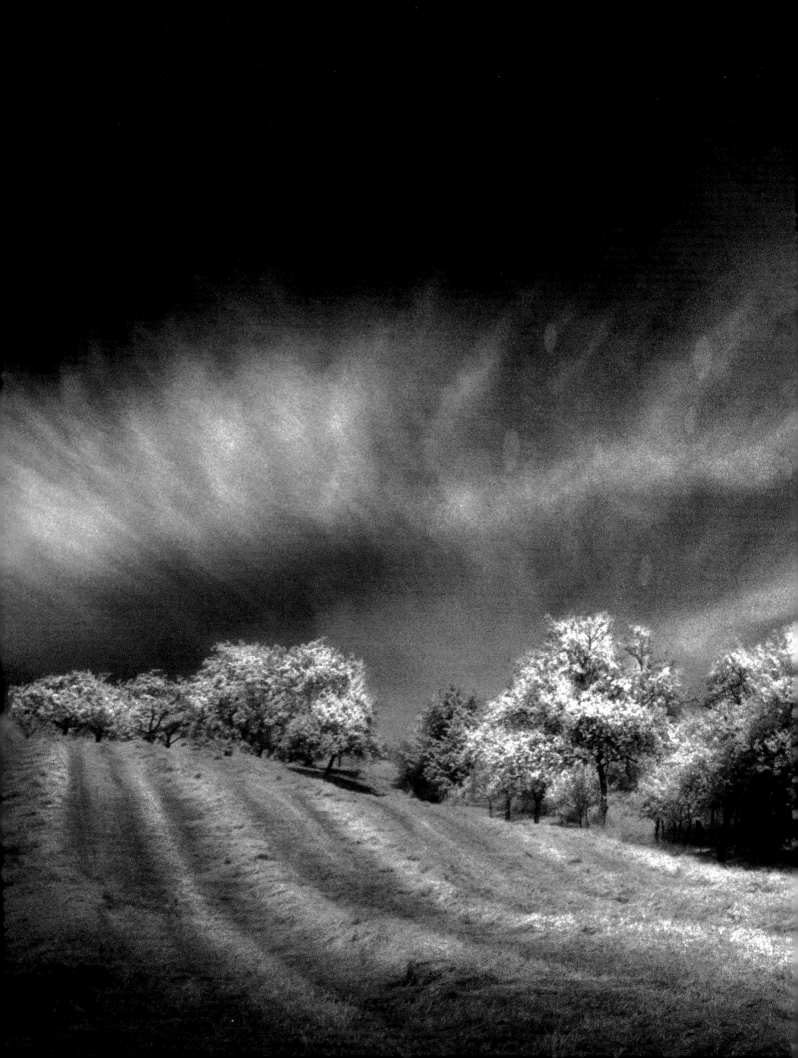

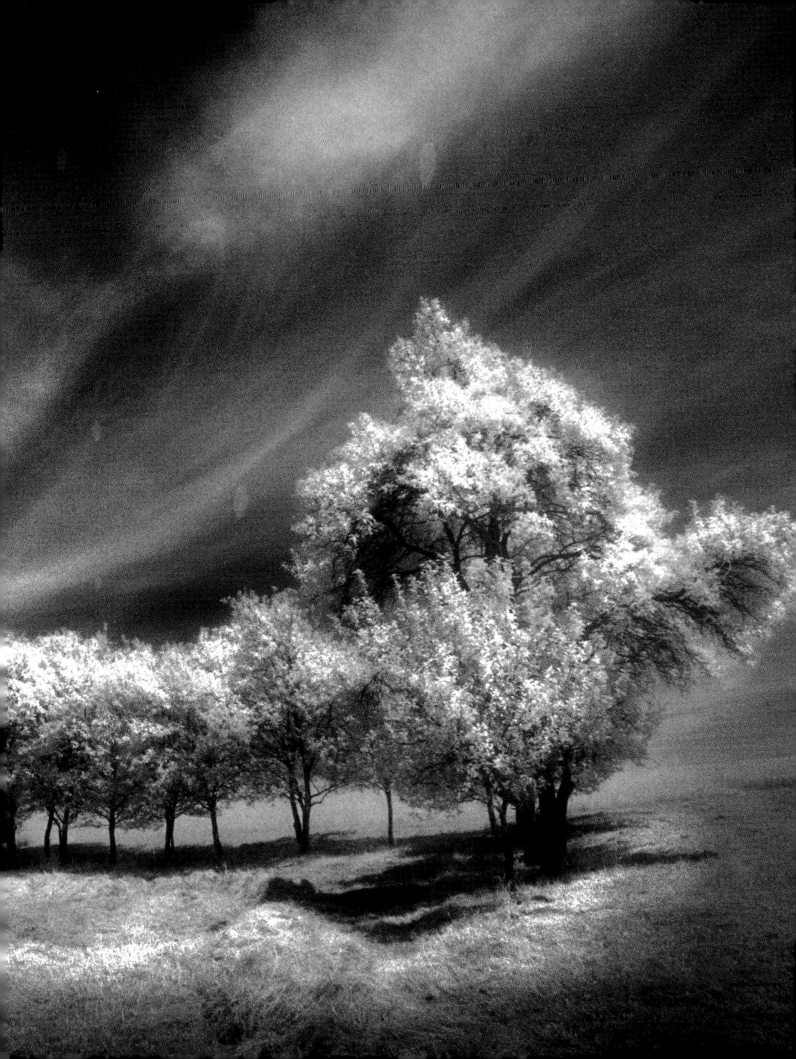

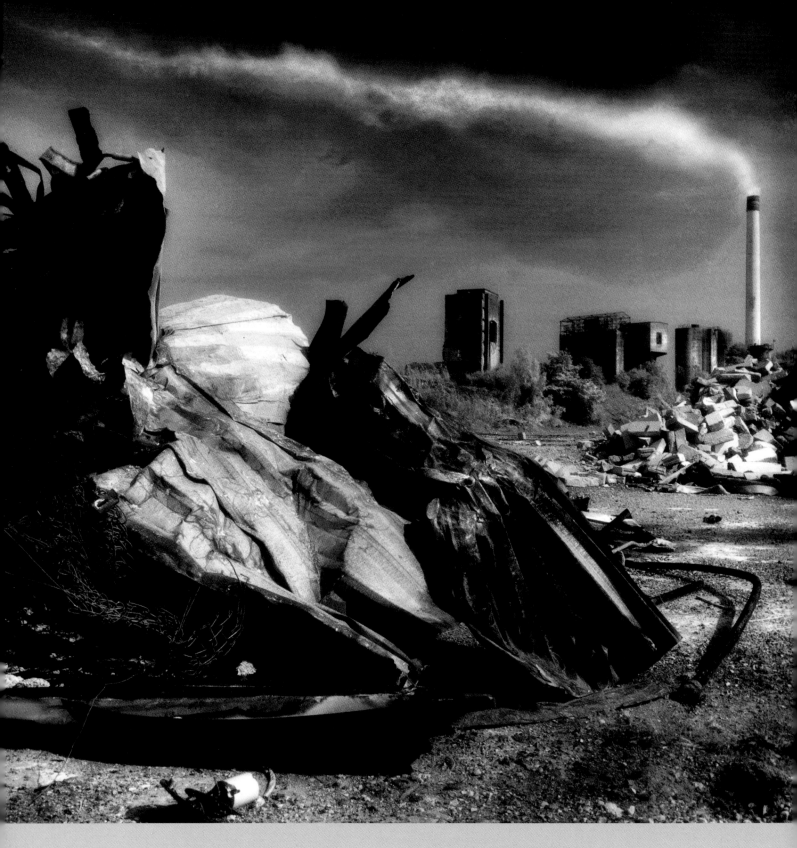

(Above) An abandoned cement works in Cherwell, Oxfordshire, England. I painted the smoke from the chimney onto the negative.
Hasselblad 500 CM, Hasselblad 80mm lens,
Konica 750 infrared film

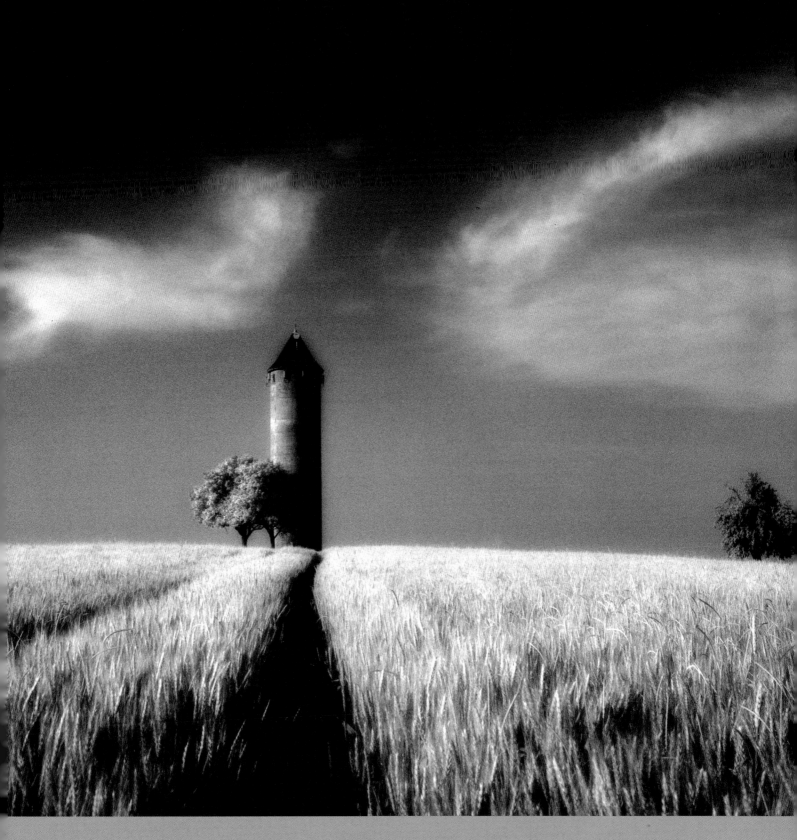

(Above) This water tower is in Hohenlohe in Baden Württemberg, Germany.
Hasselblad 500 CM, Hasselblad 80mm lens, Konica 750 infrared film

(Overleaf) I got this shot of washing on the line in Inverary, Scotland, when a chance ray of sunlight broke through the clouds.
Canon AE 1, Canon 24mm lens, Kodak HIE infrared film

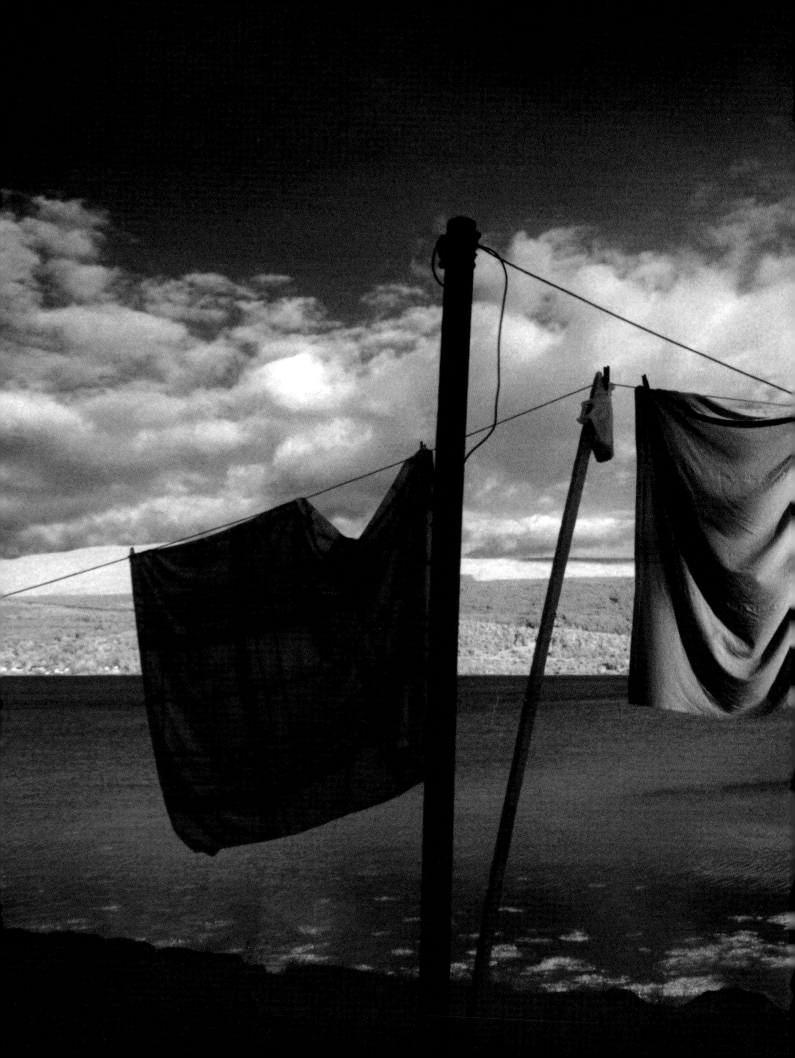

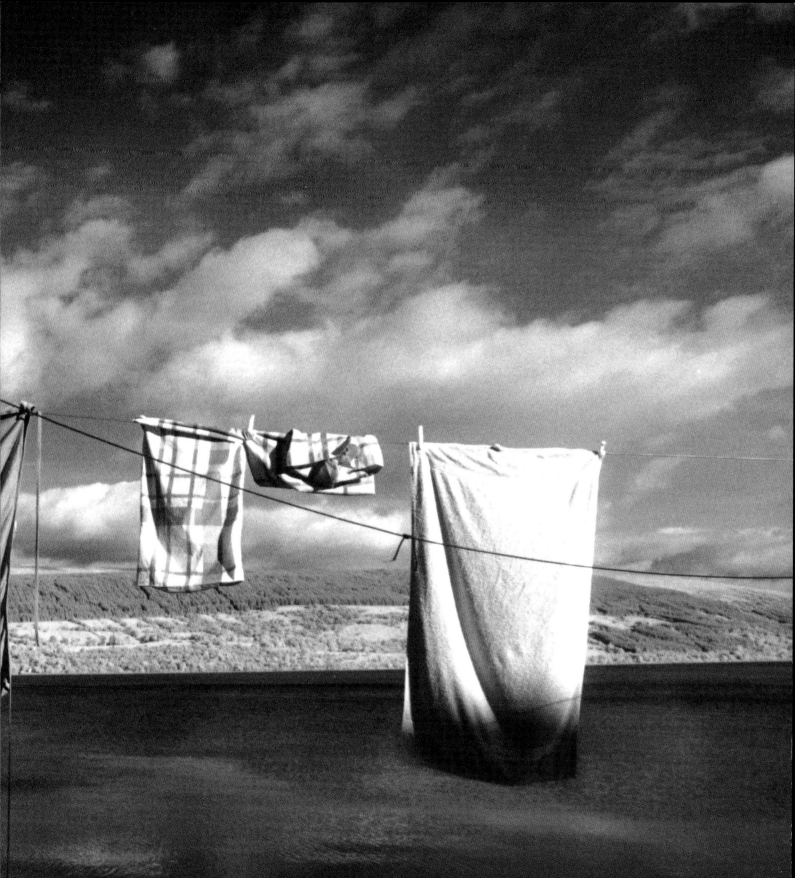

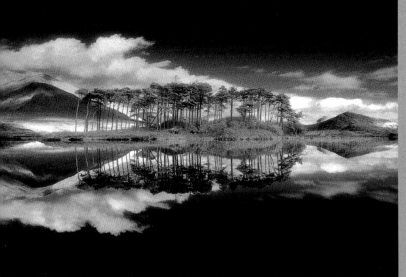

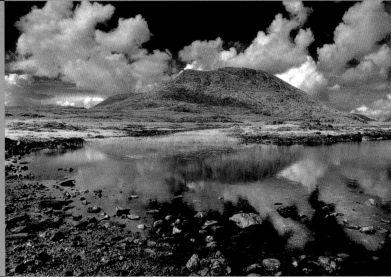

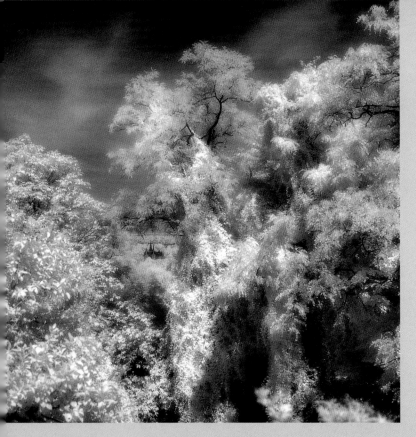

(Top left) In the early morning, the surface of Lough Derryclare in Connemara is as smooth as a mirror – perfect conditions for my picture.
Canon AE 1, Canon 24mm lens, Kodak HIE infrared film

(Above) With its hills and low mountains, Connemara attracts its share of tourists who appreciate the hard-edged charm of the area. As in most of my landscapes, I photographed Lackavrea with a wide-angle lens.
Canon AE 1, Canon 24mm lens, Kodak HIE infrared film

(Left) Everyone thinks this picture of Bad Wimpfen, Germany, is a montage – but it's completely natural. Unusually for me, I used a Kodak Wratten infrared filter which required an exposure of 3 seconds – no problem, as I always use a tripod.
Canon AE 1, Canon 24mm lens, Kodak HIE infrared film

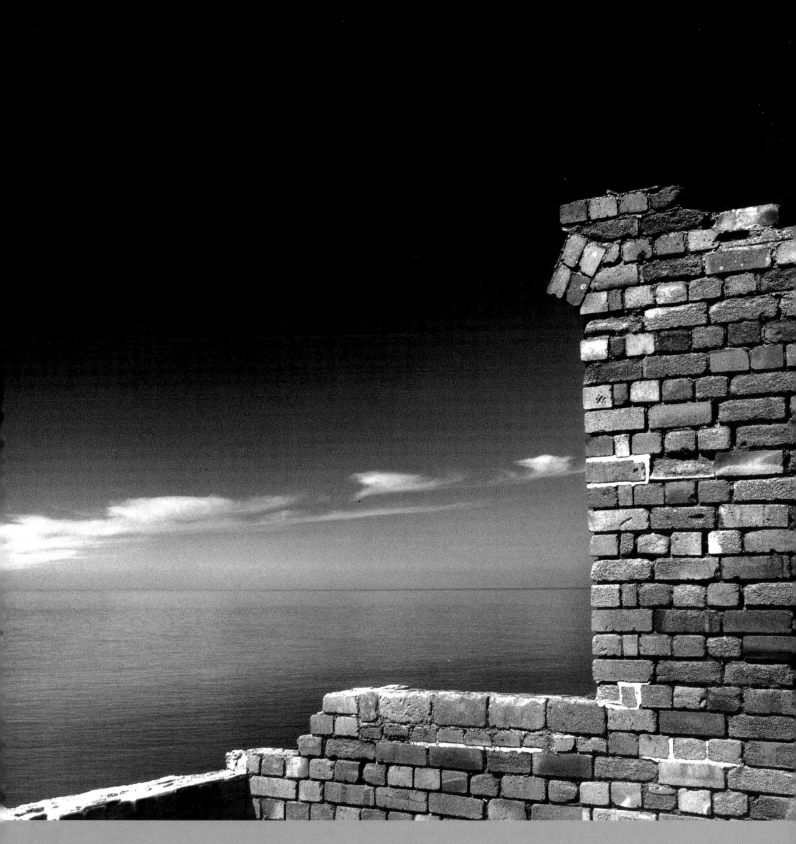

(Above) An old quarry in Pembroke, Wales, was the location of this ruin and it provided me with the opportunity for a picture of contrasts. I enjoy subject matter where time appears to be standing still.
Hasselblad 500 CM, Hasselblad 80mm lens,
Konica 750 infrared film

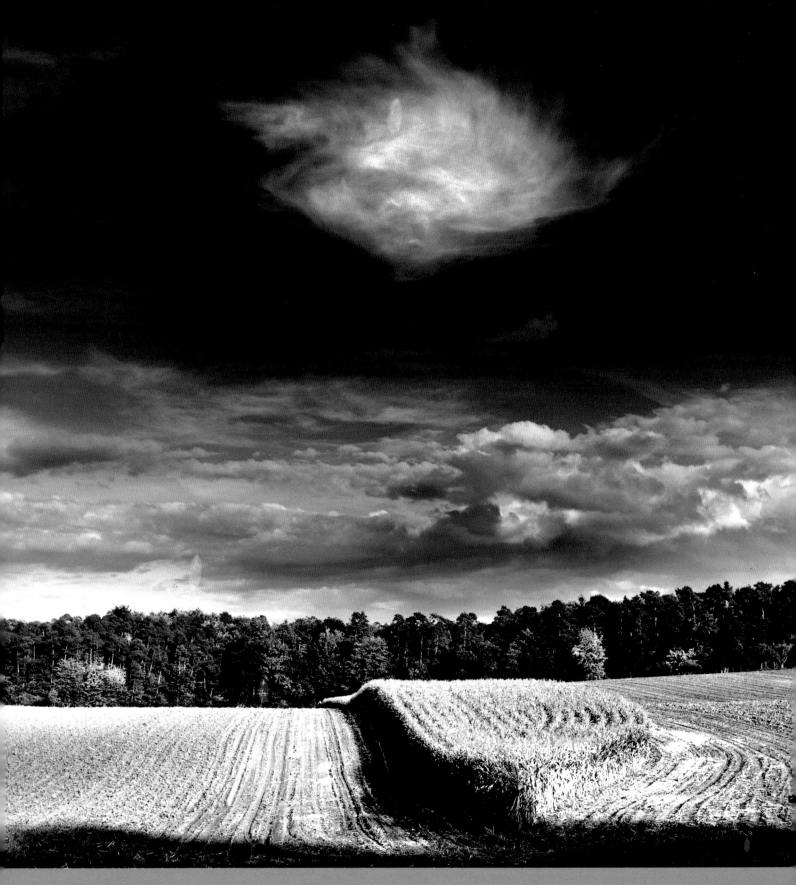

(Above) I used a red filter to enhance the contrast in the clouds in this picture, taken at Talheim, near Heilbronn, Germany. I kept the cornfield in focus by using an extremely slow film.

Hasselblad 500 CM, Hasselblad 80mm lens, Agfa 25

Nudes
Humanity revealed

Engagement with the naked human body, its shape, its eroticism, its humanity, has always been at the heart of human endeavour. Where would the history of art be without Botticelli's Venus? Imagine Rodin's The Thinker or Picasso's Les Demoiselles d'Avignon with clothes! And think how such great photographers as Helmut Newton, Richard Avedon and Robert Mapplethorpe have each, in their own way, contributed to the way we perceive and interpret the beauty of the human form.

Why, then, are we so fascinated by the naked human body? Obviously there is an underlying sexual aspect, however much we might deny it. But as nude photography specialist Miroslav Stibor said, 'The camera is not a threatening extension of the photographer's body, it's the transformer of eroticism into art. Even though it represents the erotic, artistic nude photography need not of itself be erotic.'

Our dominant sense is probably that of sight, and so the pure pleasure of looking, of taking in information through the eyes, is surely part of the explanation. The nude study also removes any preconceptions about a person that their choice of clothing might confer and allows us to see the real person without any disguise. It is perhaps this that gives it its special fascination.

The artist, whether painter, sculptor or photographer, can approach the representation of the nude in numerous different ways: with classical decency or aggressive modern directness, the body coyly reserved or shamelessly displayed, posed in a studio or at one with nature, using techniques either conventional or avant-garde. The images shown in the next 15 pages represent the whole gamut of contemporary nude photography – from erotic and sensual to images that challenge the accepted view of female beauty.

(Right) Manfred Kriegelstein/Germany
A ruined house in Lanzarote provided the background for this shot and I tried to complement the soft, faded colors in the model's accessories.
Leica R4, 28mm, Kodachrome 64

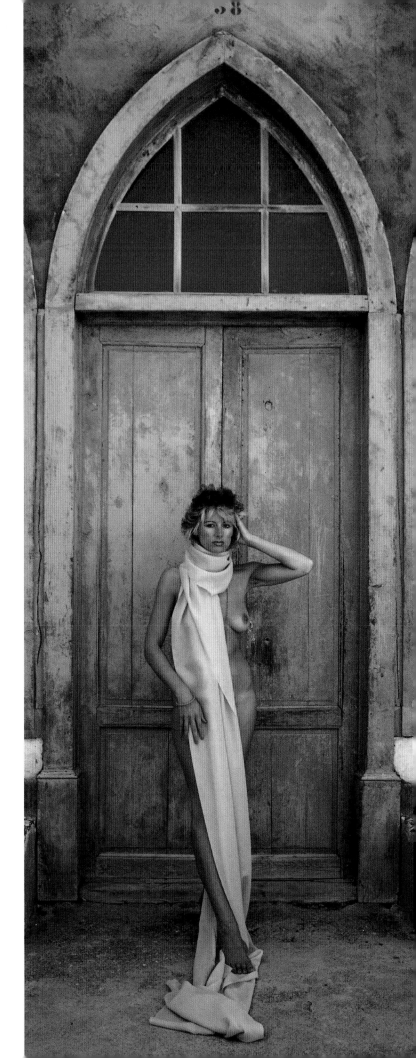

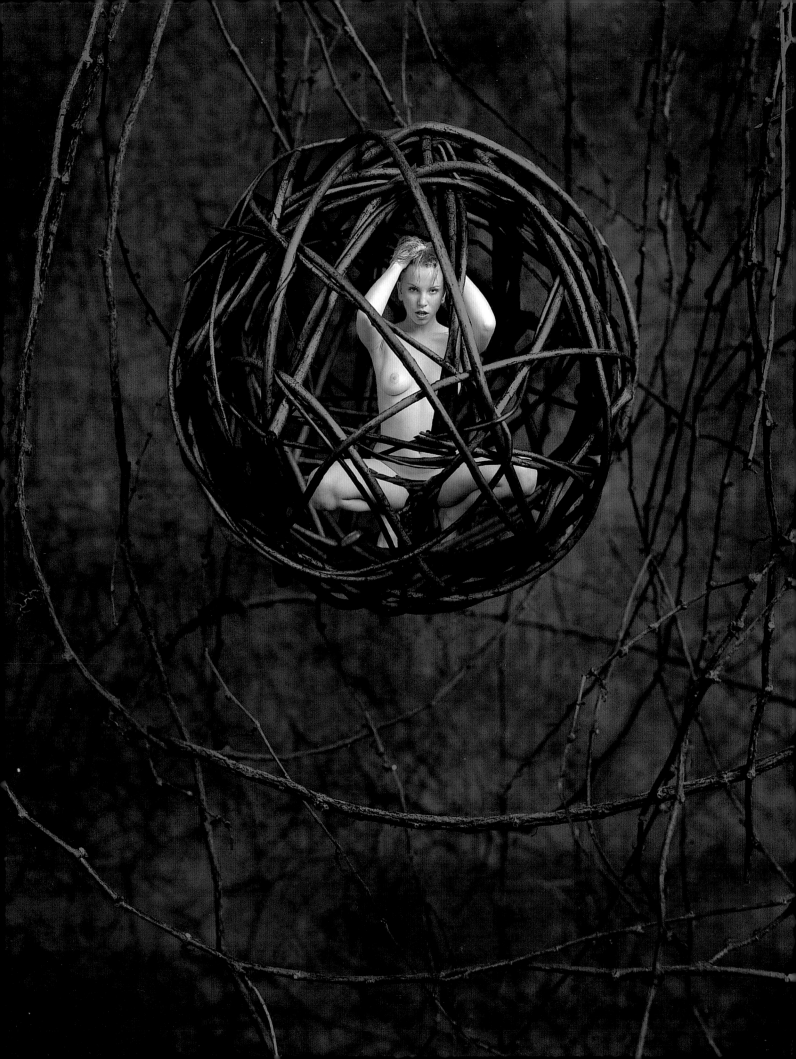

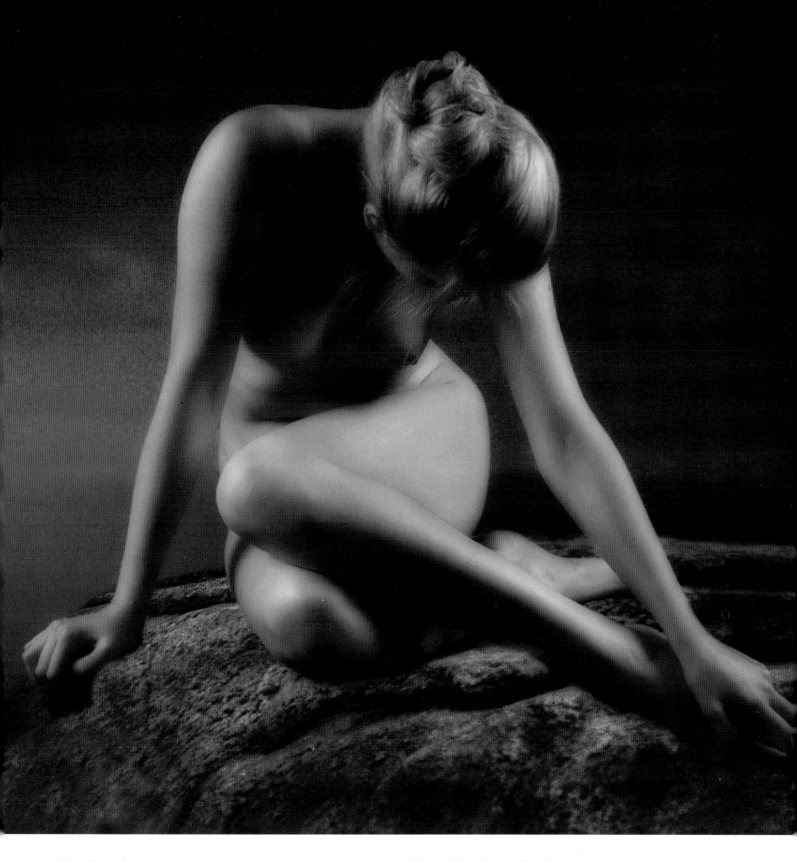

(Left) Francisco Pace/Argentina
This picture is made up in two sections, the cage of twigs and the model, both shot in the studio at the Buenos Aires Photo Club. I achieved the result I wanted, including the reduction of the natural color intensity, in Photoshop.
Nikon F2, Nikkor 55mm, Agfa 160

(Above) Gerald Appel/USA
The nude was shot in the studio, but the cliffs were taken on location. The two pictures were combined digitally.
Hasselblad, Hasselblad 100mm, Fuji Astia

(Overleaf) Alfred Pall/Austria
My photography is influenced by Helmut Newton. I used the harsh midday sun to help emphasize the contrasts.
Nikon F4, Nikkor 20mm, Ilford Pan F 50

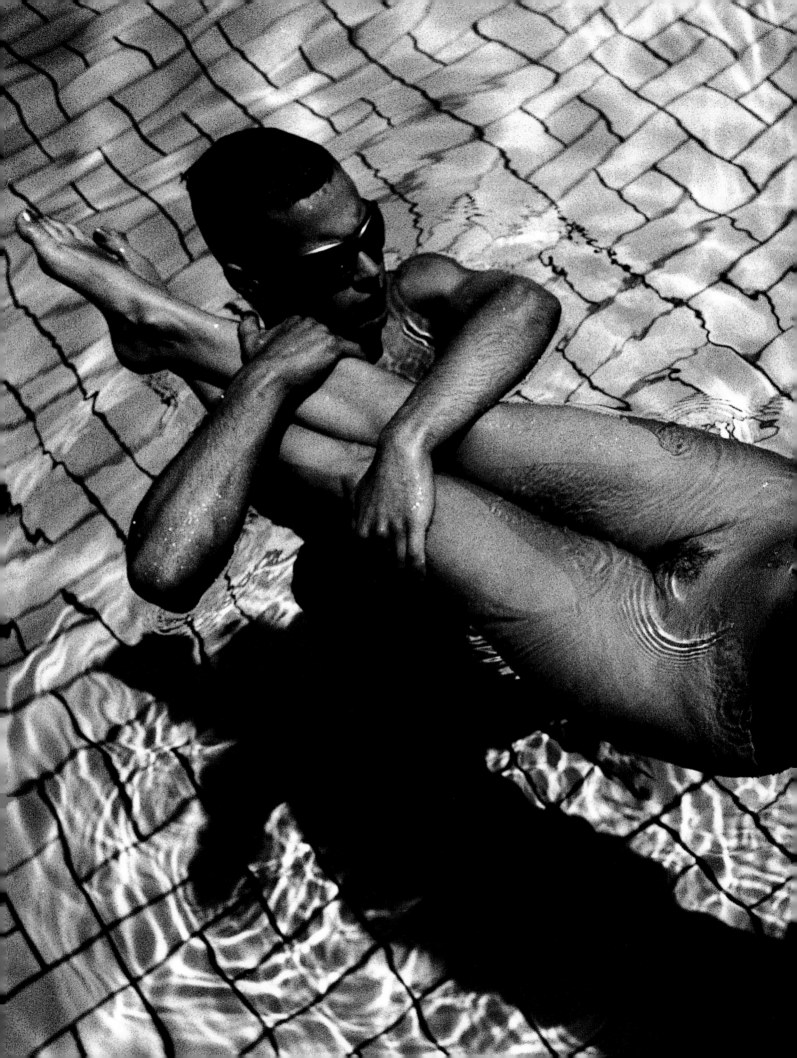

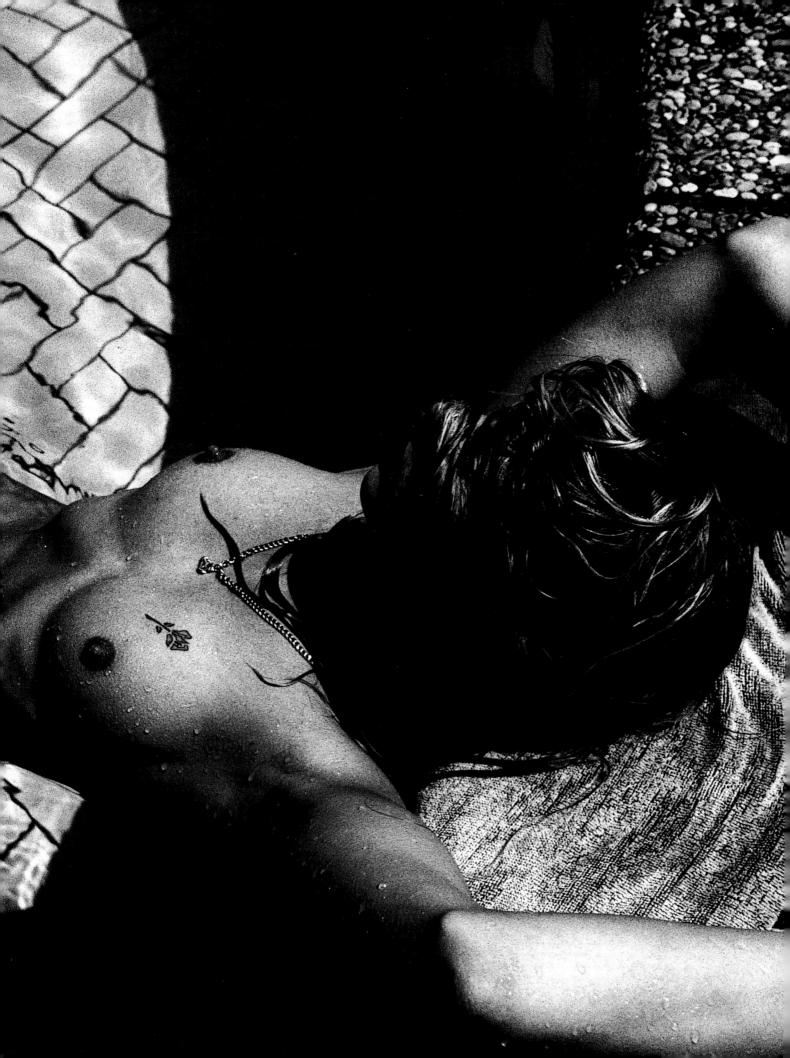

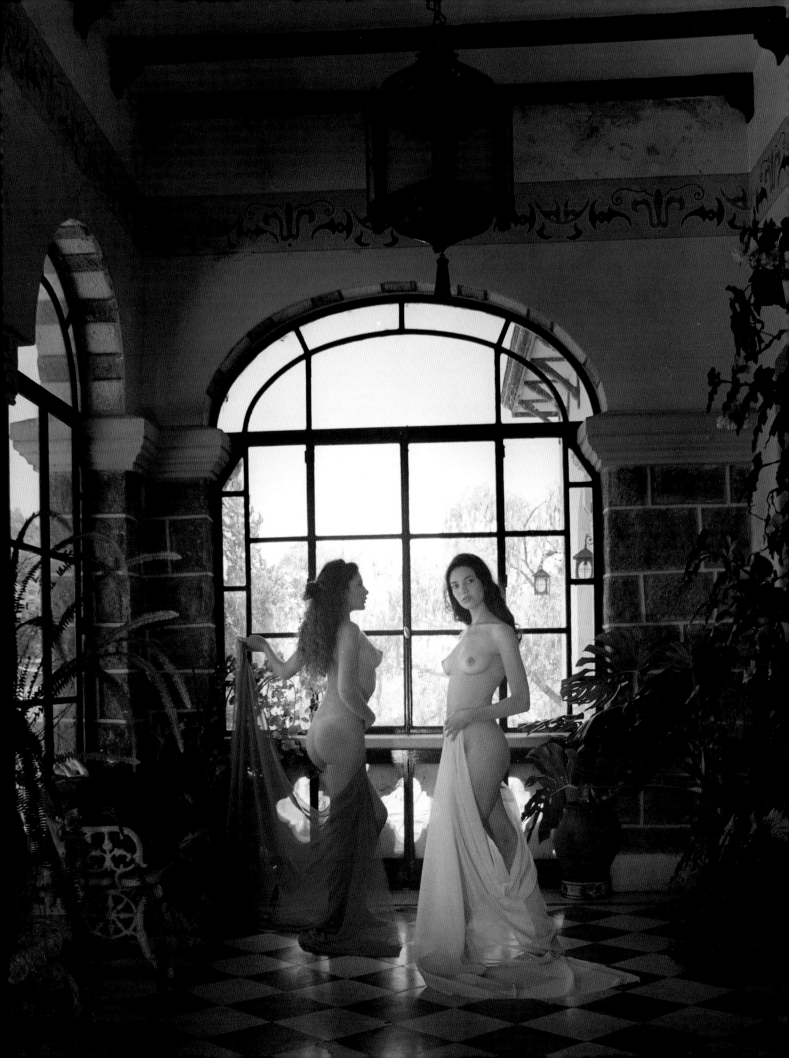

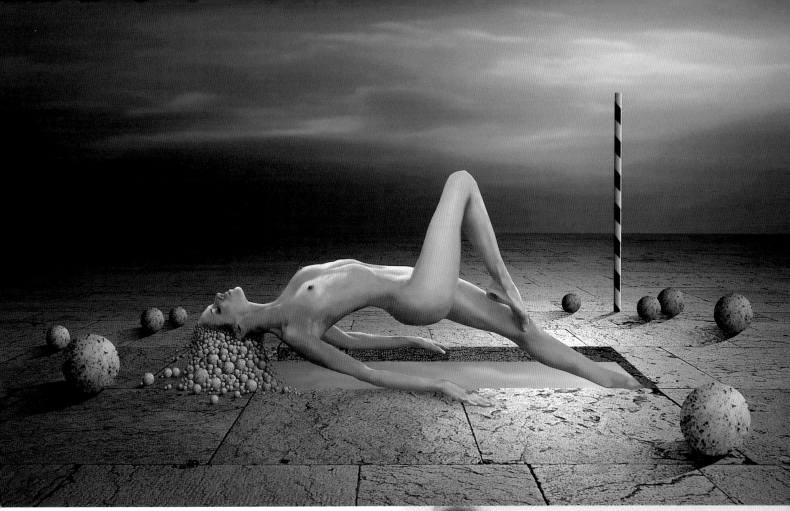

(Above) Pavle Jovanovic/former Yugoslavia
Even before digital manipulation, I was experimenting
with surrealism. Now it is so much easier: I use the new
techniques to give free rein to my imagination and reveal
things that 'unadorned' nudity cannot show.
Canon F1, Canon 24mm, Fujicolor 100

(Left) Feliciano Jeanmart/Argentina
A very soft, gentle picture in which the colors of the
models' scarves catch the eye.
Mamiya Pro 4.5 x 6cm, 80mm, Agfa Optima 2000

(Right) Chris Hinterobermaier/Austria
For this shot, a flexible mirror was manipulated by an
assistant while the models watched the resulting distortion.
Minolta XE5, Minolta 20mm, Kodak Ektachrome 100

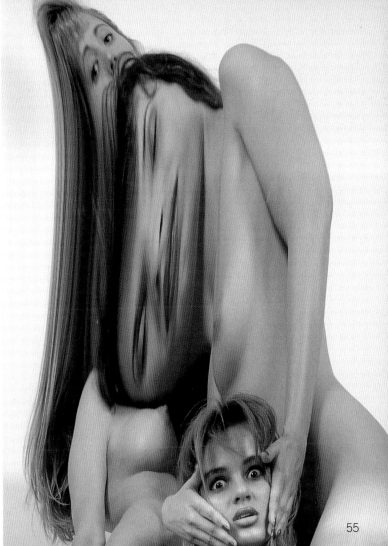

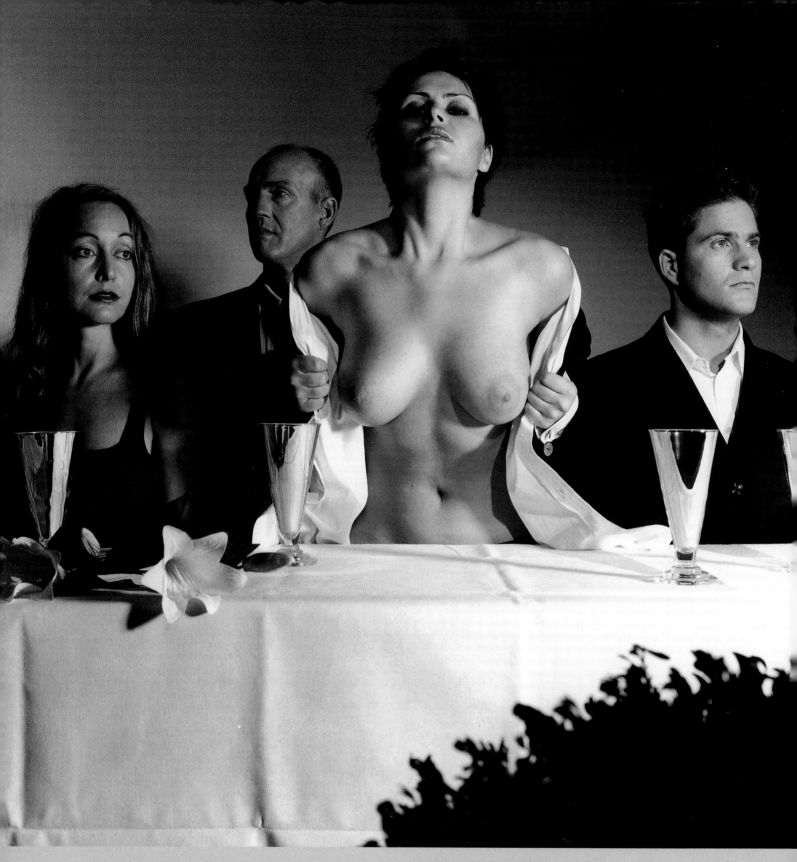

(Above) Saschawolf/Germany
For us, nude photography means a certain amount of socio-political engagement. We like to be provocative, but in this instance, the model undressing in polite society seems to provoke nothing more than indifference...
Hasselblad 500CM, 80mm Synchro Compur, Ilford Delta 100

(Right) Rudolf B. Pekar/Austria
The composition was perfect in its color and symmetry. I couldn't resist the series of triangles.
Nikon FM2, Nikon 85mm, Kodachrome 64

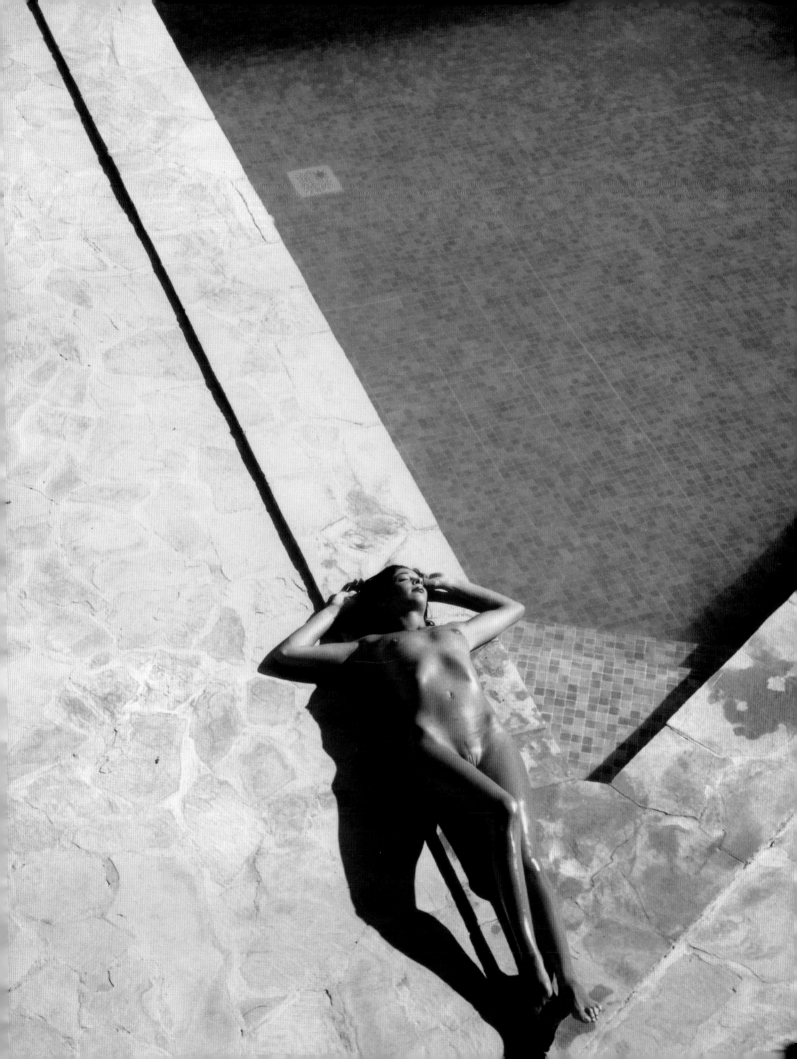

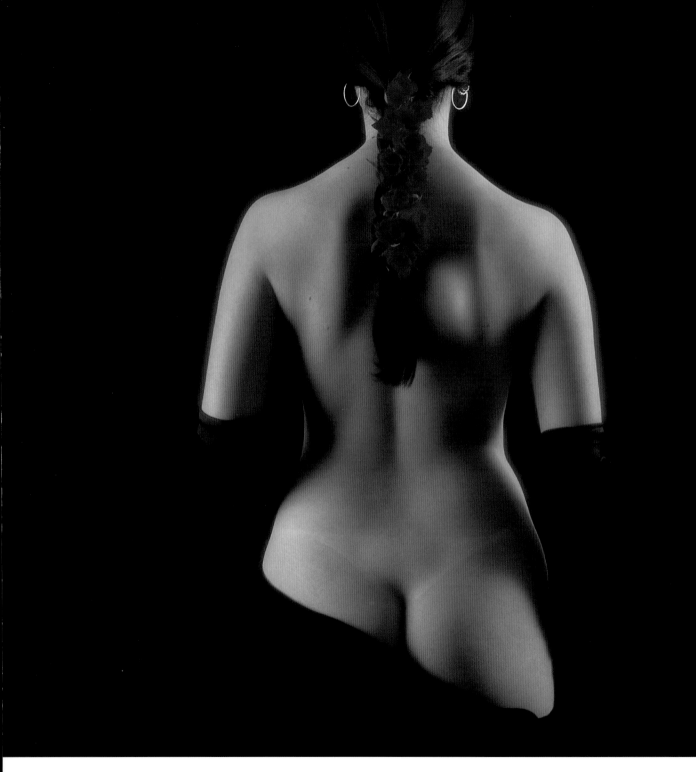

(Above) Jan Thomas Stake/Sweden
The curves of this classic back view were lit with soft
light from a diffuser and only at the last minute did I decide
to add the roses. The red of the flowers goes beautifully
with the rich auburn of the model's hair.
Hasselblad 500 ELX, Hasselblad 150mm, Fuji Reala 100

(Right) Piotr Lyczkowski/Poland
I always sketch my ideas before I photograph them, so this
time I decided to combine the two! The story of Pygmalion and
a cartoon in which a boy had a magic pencil that brought to
life anything that he drew provided the inspiration.
Nikon F100, Nikkor 85mm, Fujichrome Provia F

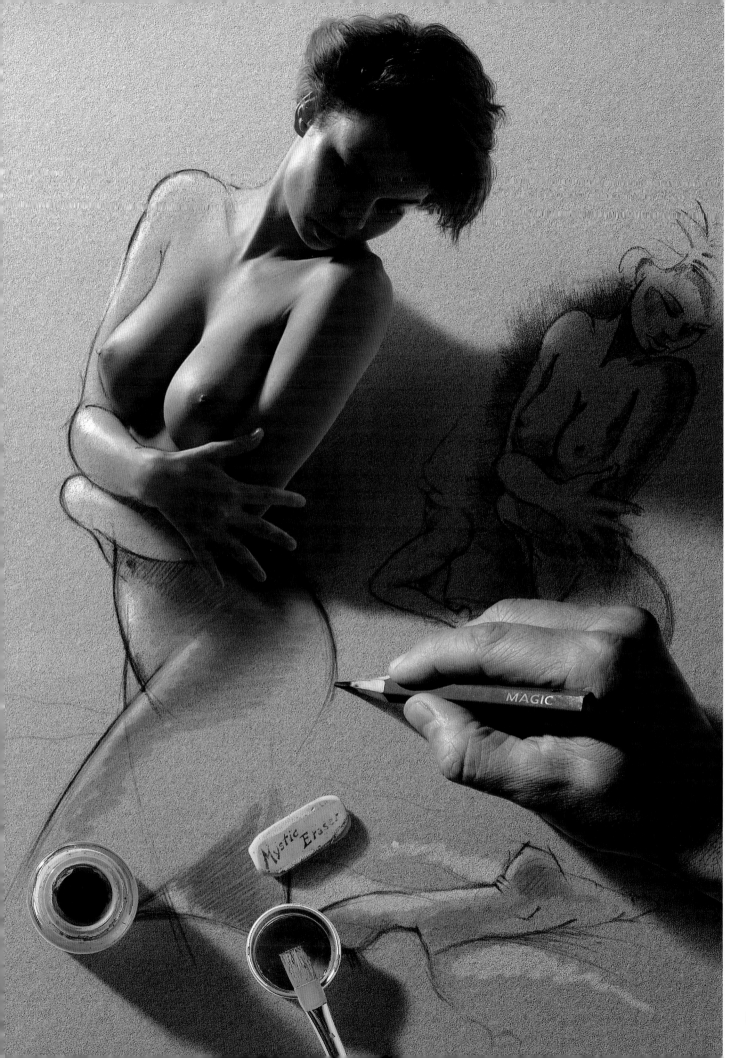

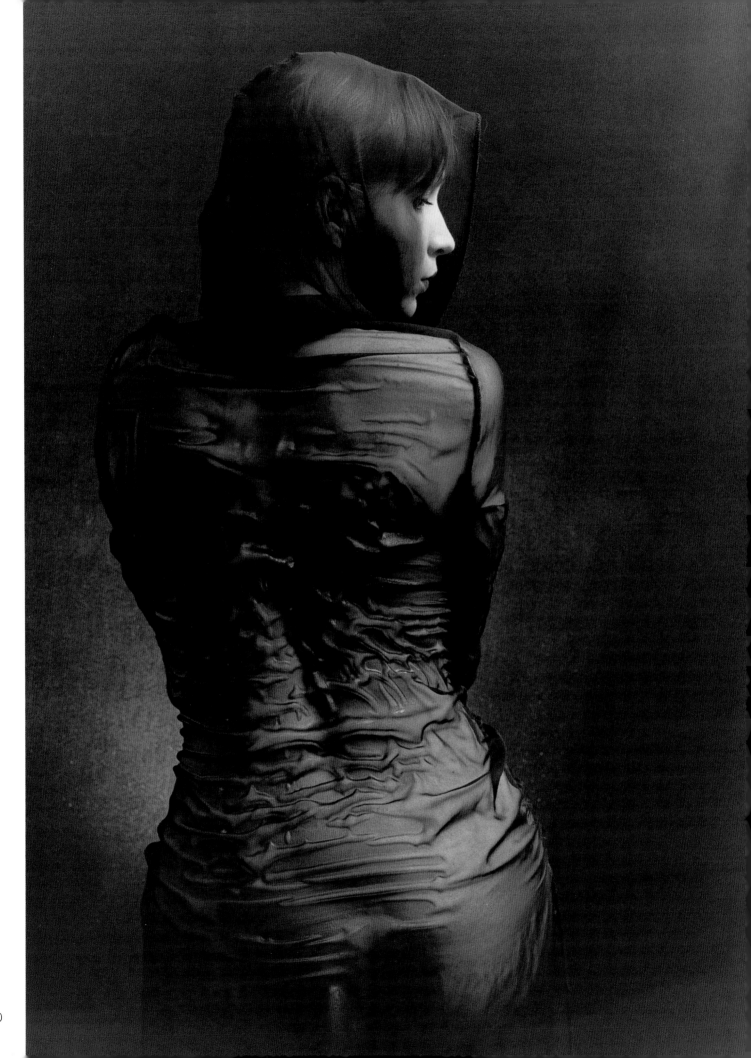

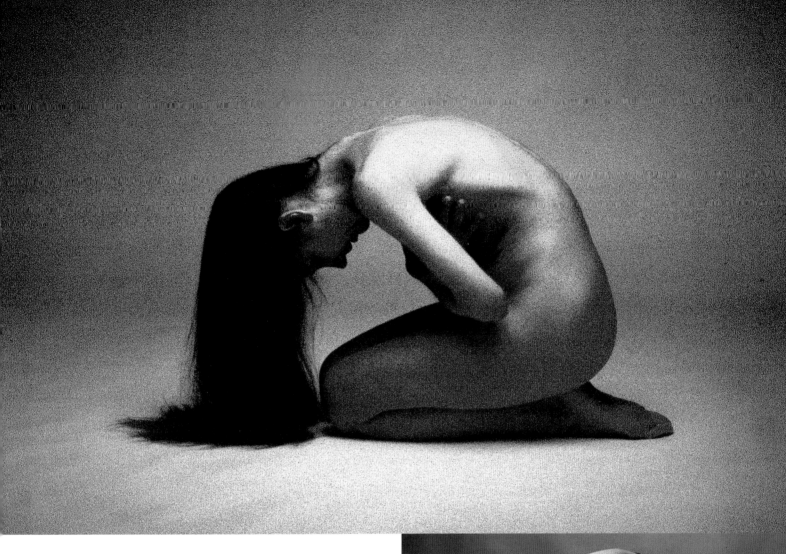

(Above) Gerald Appel/USA
Instead of flash, I used a spotlight to allow me a longer exposure of 1/15 sec. This resulted in a slight blurring of the model, giving a sense of movement. I adjusted the colors a little on my computer.
Hasselblad, Hasselblad 100mm, Fuji Astia

(Left) Igor Berenuzoy/Ukraine
My wife as a model, a wet cloth, and an improvised studio in the garden of our dacha were all I needed for this shot.
Minolta 5000i, Minolta 70–210mm, Kodak Pro Photo 100

(Right) Ricardo Alonso/Argentina
The subject of this picture is a dance teacher in a tango school in Buenos Aires. The study is one of a series of women over the age of 40. I have specialized in documenting the beauty of the mature woman.
Nikon N90, Sigma 70–210mm, Agfa Vista 400

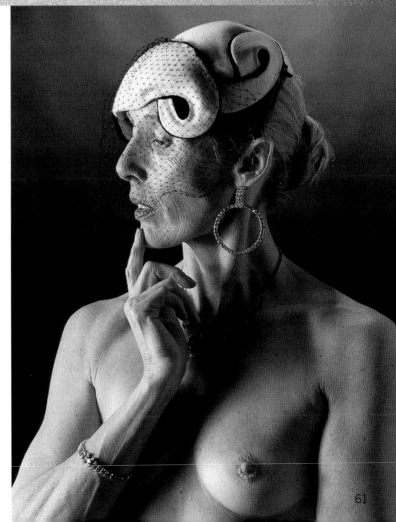

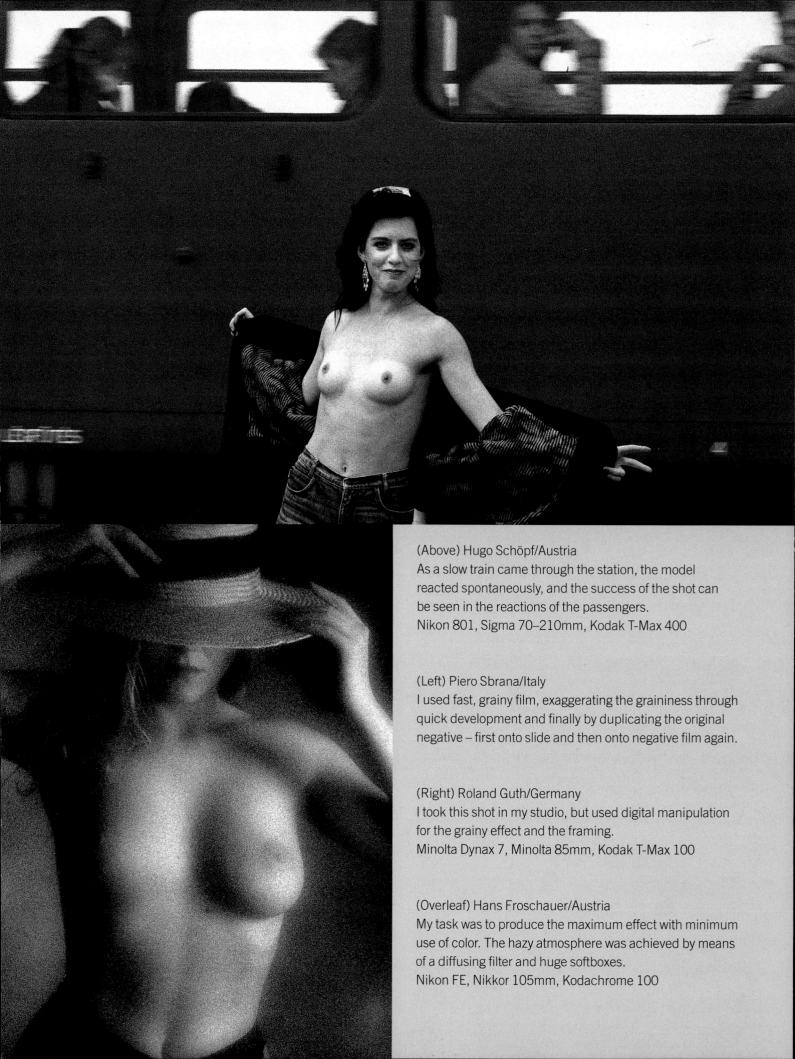

(Above) Hugo Schöpf/Austria
As a slow train came through the station, the model reacted spontaneously, and the success of the shot can be seen in the reactions of the passengers.
Nikon 801, Sigma 70–210mm, Kodak T-Max 400

(Left) Piero Sbrana/Italy
I used fast, grainy film, exaggerating the graininess through quick development and finally by duplicating the original negative – first onto slide and then onto negative film again.

(Right) Roland Guth/Germany
I took this shot in my studio, but used digital manipulation for the grainy effect and the framing.
Minolta Dynax 7, Minolta 85mm, Kodak T-Max 100

(Overleaf) Hans Froschauer/Austria
My task was to produce the maximum effect with minimum use of color. The hazy atmosphere was achieved by means of a diffusing filter and huge softboxes.
Nikon FE, Nikkor 105mm, Kodachrome 100

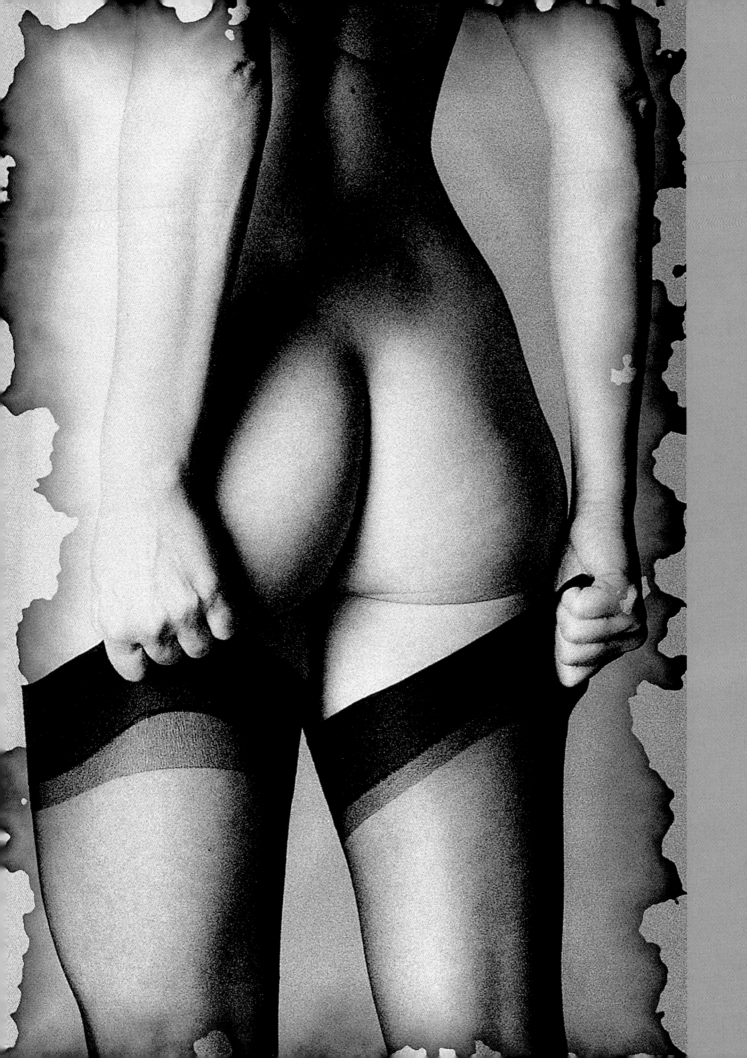

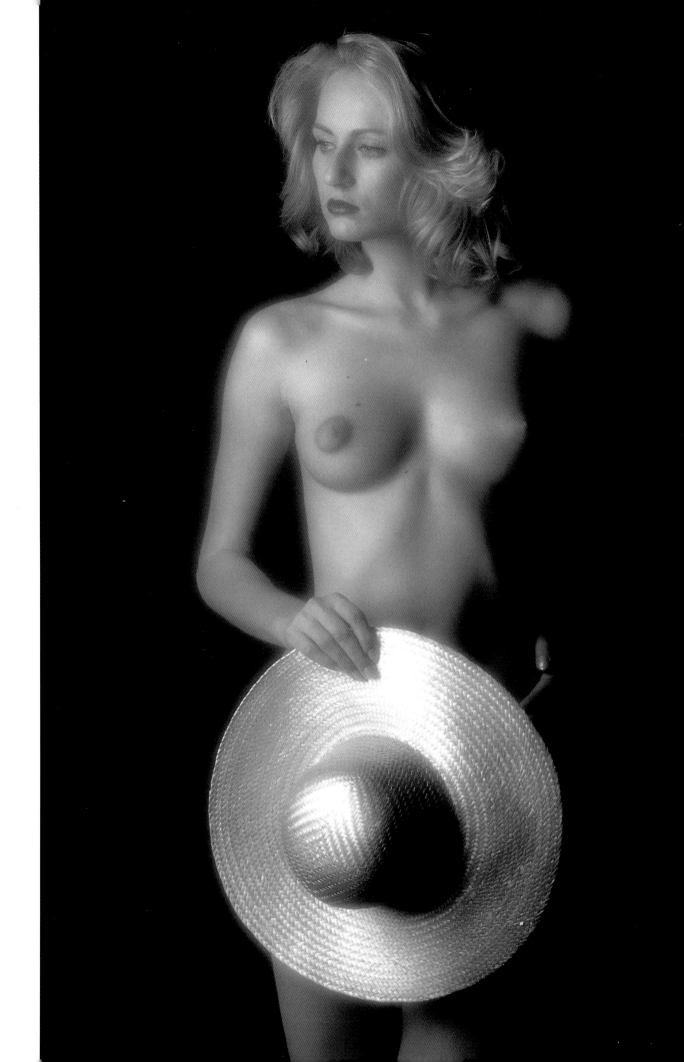

Jörg Gründler
Painting With Light

'I've always been fascinated by the Old Masters, with their mastery of light – and particularly by Rembrandt. For many years I've searched for a photographic techniqe that would allow me to emulate this kind of painting.'

Jörg Gründler, from Pretzsch in the former East Germany, discovered his very personal technique quite by chance. Photographing on a beach at night, he accidentally illuminated some rocks with his flashlight when the shutter was open and the result encouraged him to experiment further.

Gründler works in total darkness and illuminates individual parts of the scene in turn with hand-held lights. This involves him moving around the studio while the shutter is open – no easy task. As he himself says, '... it can require acrobatics and contortions and I always have to take care not to get in front of the open shutter and into the photograph.' To enable him to find the right position in the dark, he marks key spots on the floor with luminous paint.

'My studio has been specially adapted; the walls, floors and ceiling are all black and there are no windows. I never use standard flash equipment; it's too harsh and does not allow me sufficient control. Even reduced-intensity background lighting would detract from the final light-painting effect.'

Gründler's photographs are planned with great precision, sometimes over as much as two weeks. He works out exactly where he wants the light to fall and what exposure he needs for each part of the shot, and uses polaroids to check he has got the lighting levels right. 'It's a very slow creative process,' he says. 'I use my light gun like a paintbrush… The fascination and uniqueness of these pictures is that the light does not fall from outside onto the set in the normal way, but seems to have an invisible source within the picture itself.'

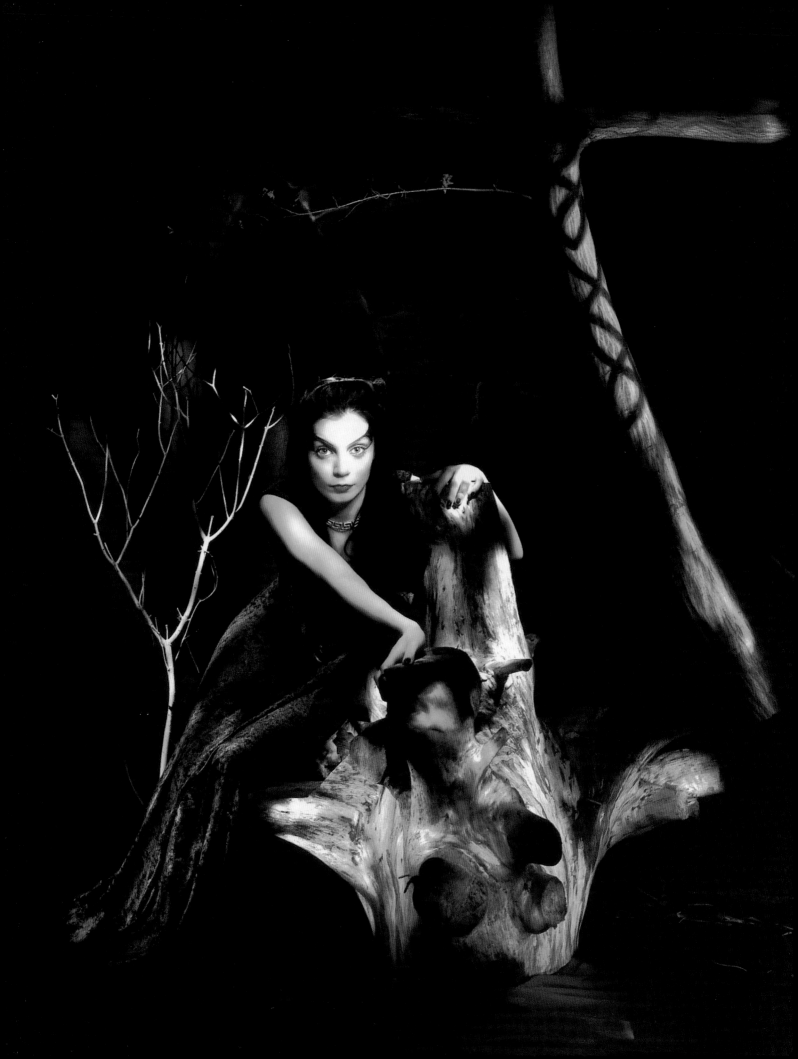

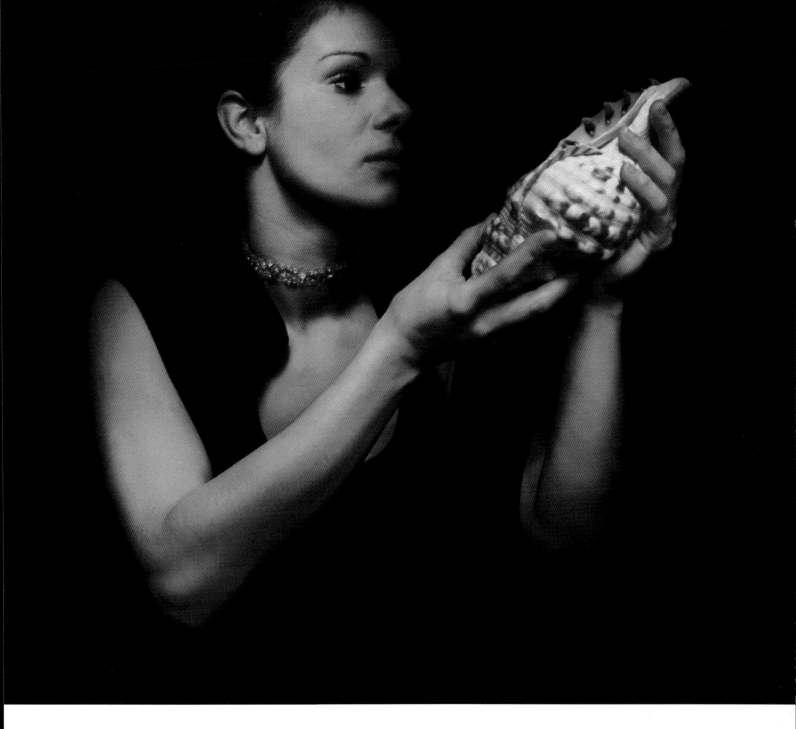

(Left) The idea for this composition came to me when I first saw the cross-shaped piece of beech hedge. The model's make-up was achieved with an airbrush. Studio shot. Modified Kiev 88, 80mm lens, 4 mins at f/6.7, Fuji Provia 100F 120

(Above) I like to have the model hold an object that has some personal or emotional significance. They tell me the story and – consciously or unconsciously – it influences the picture's mood. Studio shot. Modified Kiev 88, 80mm lens, approx. 40 secs at f/6.7, Fuji Provia 100F 120

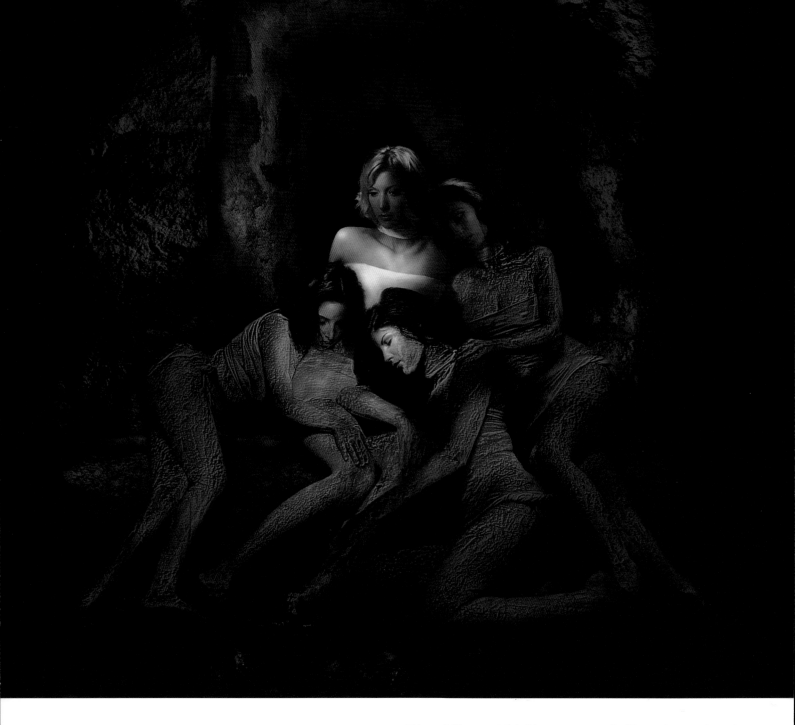

(Above) The models' skin was covered with a mixture of mud and colored chalk which, when dry, gave a stone effect. The final picture was made with six different colored gels. Location shot. Modified Kiev 88, 80mm lens, approx. 3 mins at f/6.7/9.5, Fuji Provia 100F 120

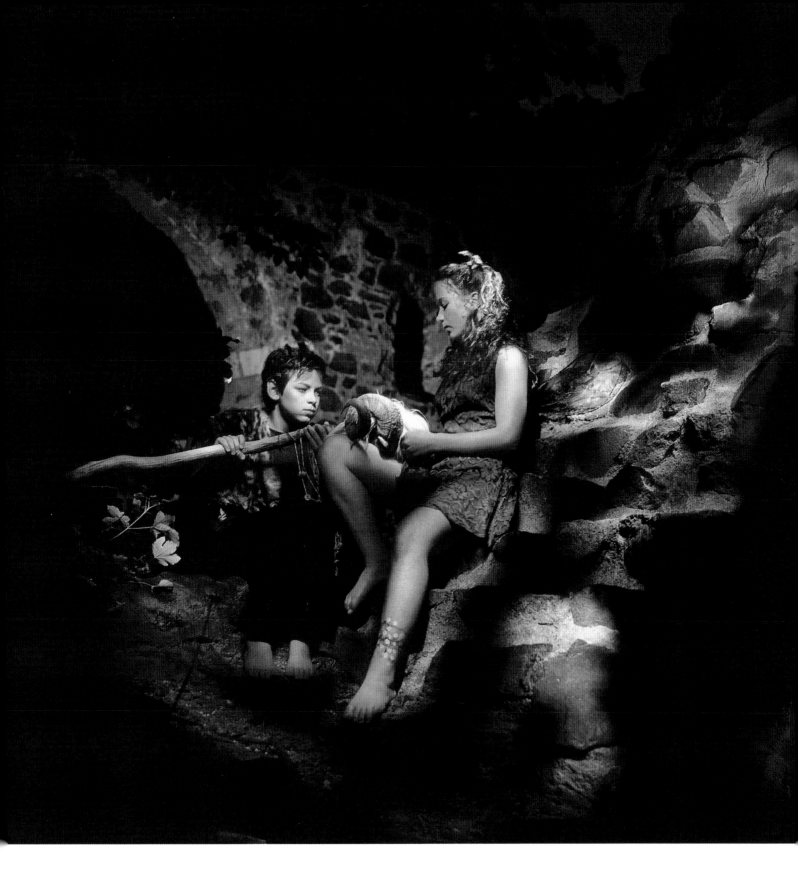

(Above) These cloister ruins at night were the ideal
place for elves and goblins. I wanted to show the everyday
life of these creatures.
Location shot. Modified Kiev 88, 80mm lens, approx. 5 mins
at f/6.7/9.5, Fuji Provia 100F 120

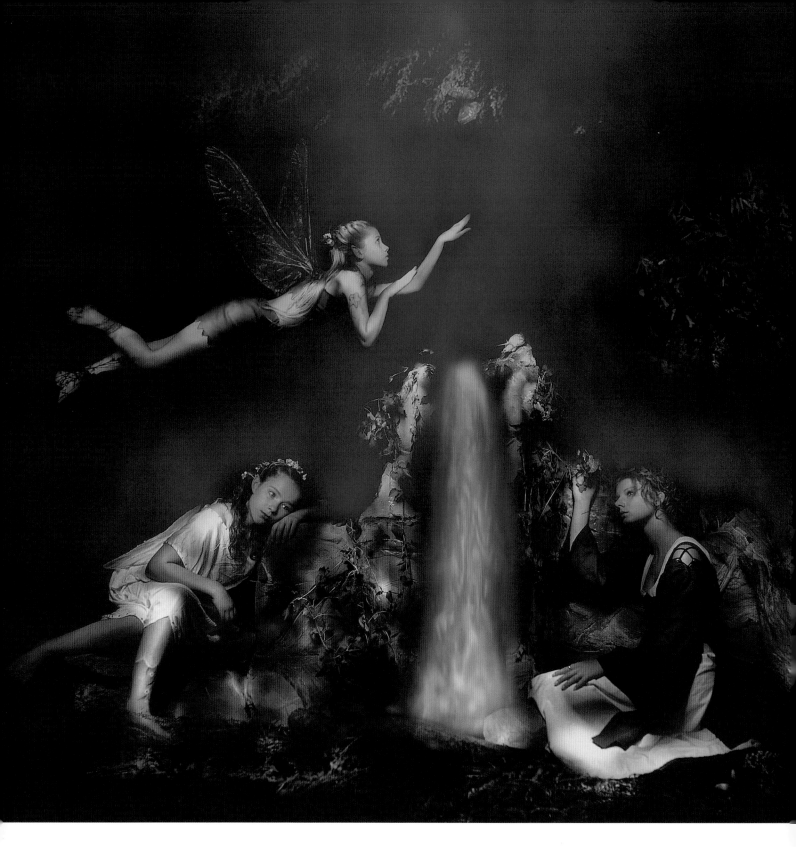

(Above) The inspiration for this series was a holiday
in Ireland, since when I can't get enough of elves, fairies
and goblins. We used dry ice to create the fog.
Studio shot. Modified Kiev 88, 80mm lens, approx. 7 mins
at f/8/3.5/5.6, Fuji Provia 100F 120

(Right) The inspiration for this picture was a
Van Morrison song ('Forgotten flower'). The props were
suspended from the ceiling; we had to keep spraying the
leaves to stop them drying out.
Studio shot. Modified Kiev 88, 80mm lens, approx. 5 mins
at f/6.7, Fuji Provia 100F 120

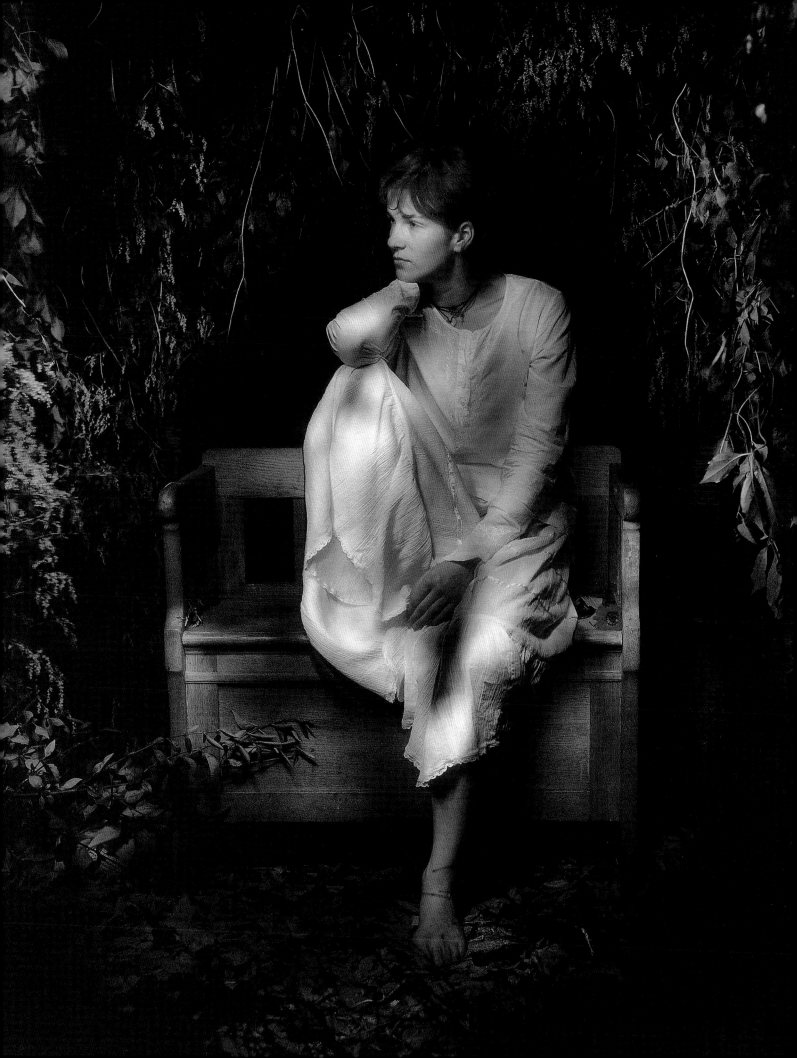

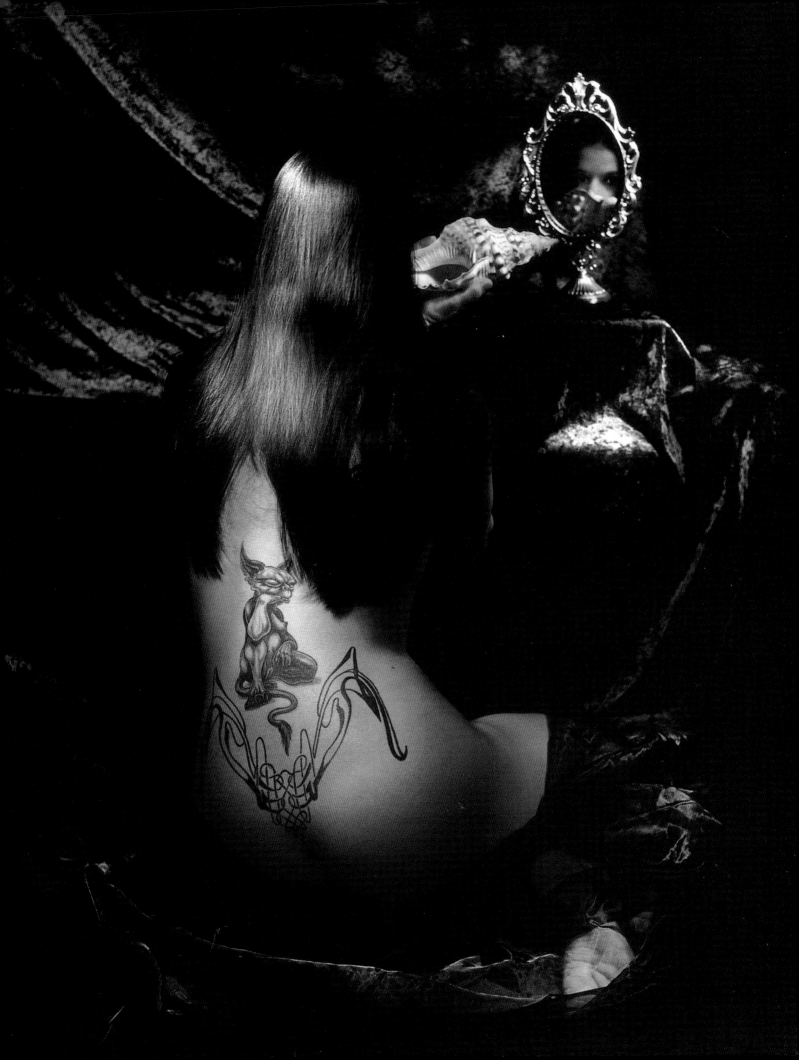

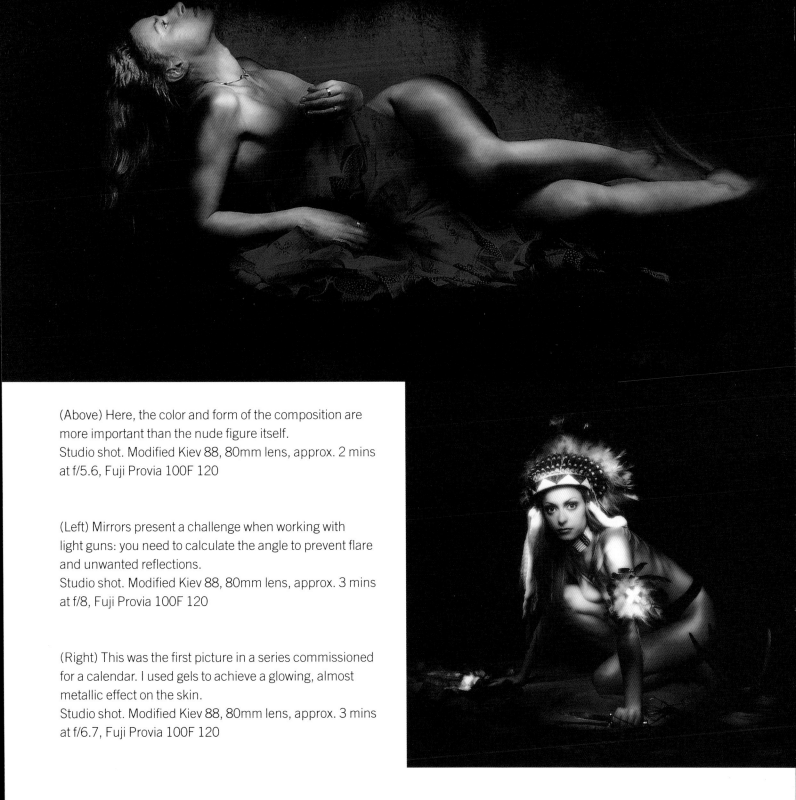

(Above) Here, the color and form of the composition are more important than the nude figure itself.
Studio shot. Modified Kiev 88, 80mm lens, approx. 2 mins at f/5.6, Fuji Provia 100F 120

(Left) Mirrors present a challenge when working with light guns: you need to calculate the angle to prevent flare and unwanted reflections.
Studio shot. Modified Kiev 88, 80mm lens, approx. 3 mins at f/8, Fuji Provia 100F 120

(Right) This was the first picture in a series commissioned for a calendar. I used gels to achieve a glowing, almost metallic effect on the skin.
Studio shot. Modified Kiev 88, 80mm lens, approx. 3 mins at f/6.7, Fuji Provia 100F 120

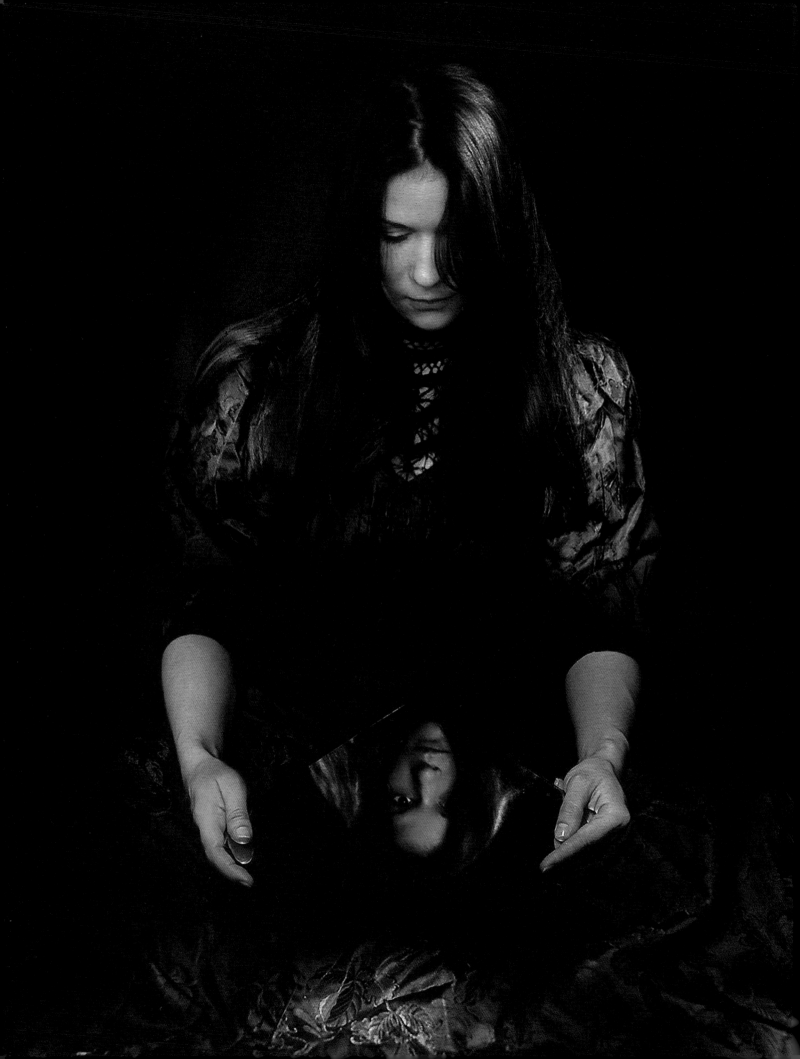

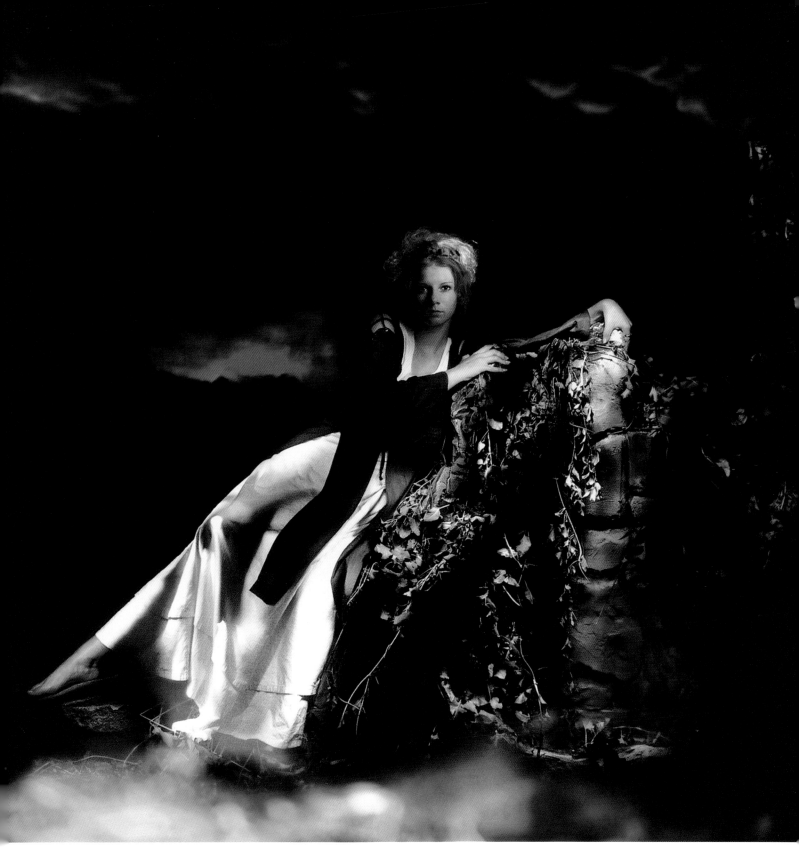

(Left) I deliberately broke the mirror to experiment with the direction of the model's glance; I feel her luminous eyes should have come through more intensely.
Studio shot. Modified Kiev 88, 80mm lens, approx. 3 mins at f/6.7, Fuji Provia 100F 120

(Above) I wanted an SLR 'snapshot' of Carolin, but all the scenery had been set up for a square format. So, at 4 a.m., I unpacked my medium-format gear...
Studio shot. Modified Kiev 88, 80mm lens, approx. 5 mins at f/6.7/2.8, Fuji Provia 100F 120

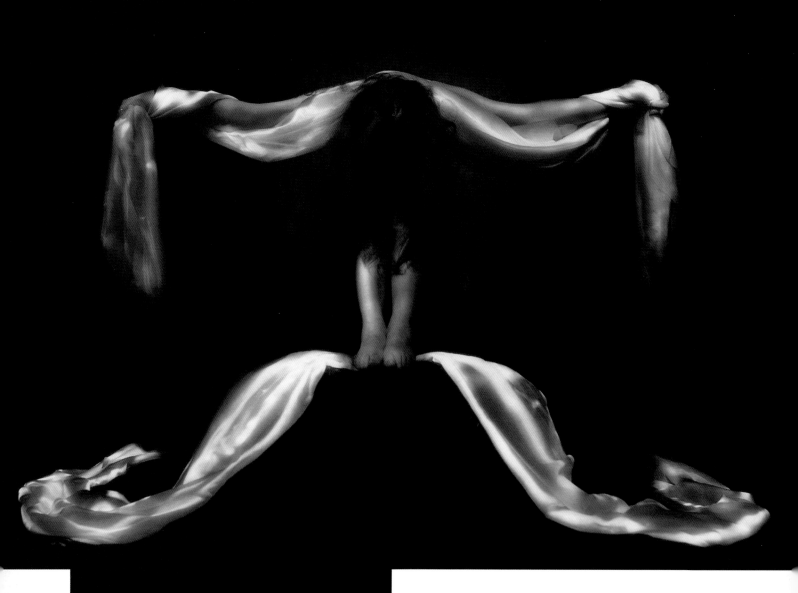

(Above) In darkness, people can be freed from their surroundings and made to float in air... I built a bench covered with black, non-reflecting cloth for the model to stand on and, to get the hands into precisely the position I wanted, I wrapped her wrists in black velvet and tied them to a fixture in the ceiling.
Studio shot. Modified Kiev 88, 80mm lens, approx. 3 mins at f/5.6, Fuji Provia 100F 120

(Left) I kept this dessicated flower in a box for two years before I got the idea for this picture. Some people have said they find it disturbing, even frightening, because it hints at growing old or at the passing of the years. If so, the picture has worked...
Studio shot. Modified Kiev 88, 80mm lens, approx. 30 secs at f/6.7, Fuji Provia 100 F 120

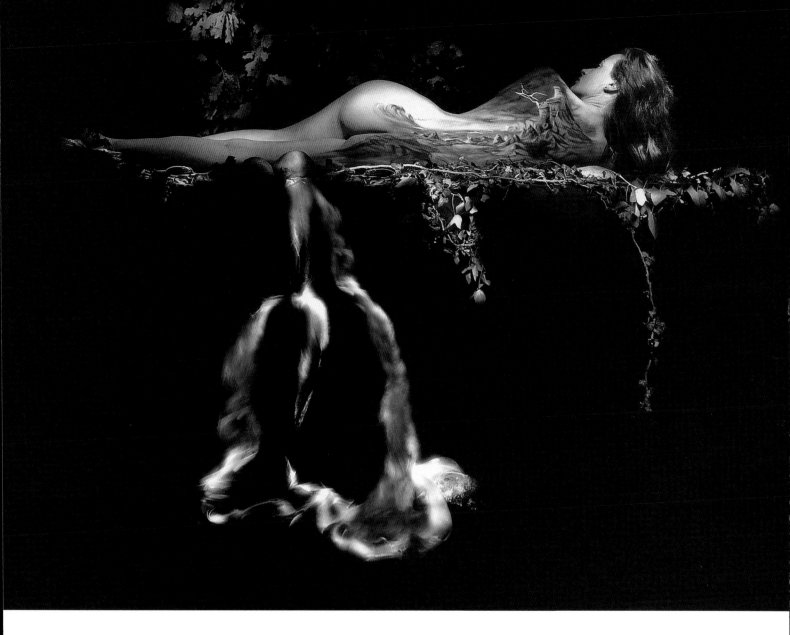

(Above) The idea here was to unify the 'landscape of the body' with the landscape on the backcloth. Airbrush artist Jörg Starke spent seven hours creating a painting to complement the shape of the body.
Studio shot. Modified Kiev 88, 80mm lens, approx. 4 mins at f/6.7/2.8, Fuji Provia 100F 120

(Above) The clothing and jewellery used in this shot is based on original Native American designs.
Studio shot. Modified Kiev 88, 80mm lens, approx. 4 mins at f/6.7, Fuji Provia 100F 120

(Above) Katrin and Sven own a ranch near where I live. To hold sky detail, I used a 6-minute exposure. I'd wanted to include their horses, but they wandered off before I could light them.
Location shot. Modified Kiev 88, 80mm lens, approx. 6 mins at f/8, Fuji Provia 100F 120

(Overleaf) I was working on a series of shots here when I spotted the model resting between poses. I took a reference polaroid and finished the picture an hour later, using just one colored light gun.
Location shot. Modified Kiev 88, 80mm lens, approx. 2 mins at f/6.7, Fuji Provia 100F 120

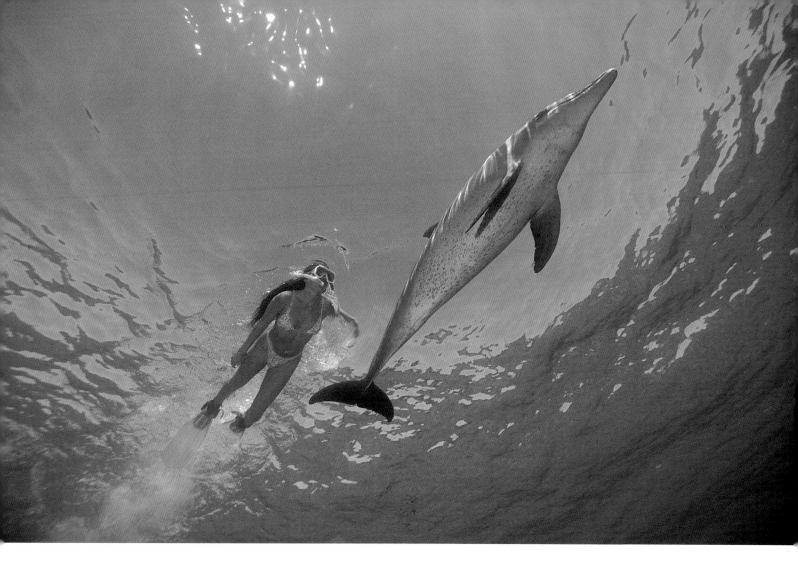

Water
An elemental subject

Water: one of the four elements that, according to ancient cosmology, constitute the universe. Its importance cannot be overstated – but why does it exert such a fascination for us?

From an artistic point of view, perhaps part of the answer lies in the fact that water offers us new ways of seeing the familiar: reflections and objects viewed under water appear distorted, as light hitting the water surface is refracted.

Its very intangibility, too, may be part of its appeal: impossible to pin down, it (quite literally) trickles through our grasp. Colorless, its appearance is governed by what's around it, be it the azure blue of a swimming pool or the murky gray and brown swirls of a stormy sea. Constantly changing, dancing as pin-pricks of light hit its surface, it is unpredictable and uncontrollable.

For the photographer, water presents an intriguing and endlessly renewable challenge. You cannot direct it to do what you want; instead, you must explore your own responses to it and seize the moment when all the different elements of the shot – composition, color, light and mood – come together.

This portfolio explores the myriad moods and appearances of water. It is a photographic subject that can never be fully exhausted and one whose appeal will never pall

(Above) Werner Thiele/Austria
This dolphin is 'wild', but has made his home for many years in a bay at Nuweiba in Egypt, near the home of a deaf-and-dumb bedouin whom he swam up to one day. He clearly trusts him, and this made it possible for me to get this shot in only 10 feet (just over 3 metres) of water.
Nikon F90, Nikon 16mm fisheye, Kodak VS 100

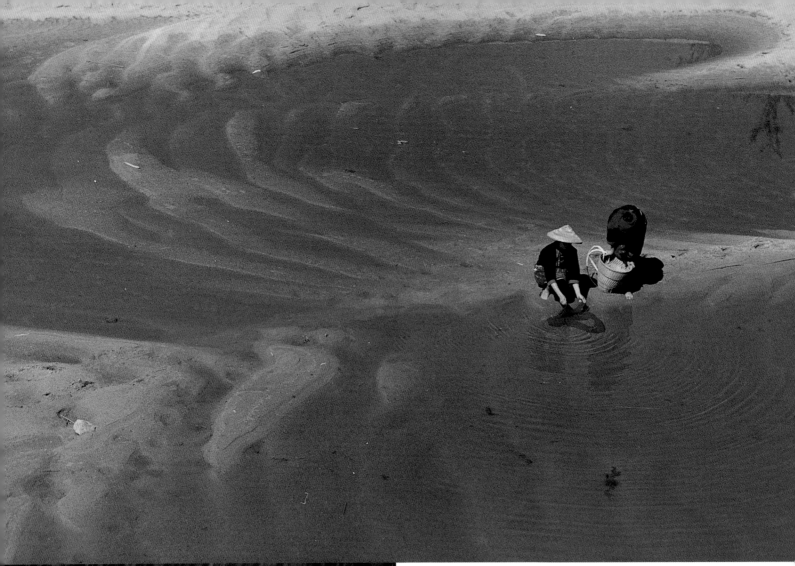

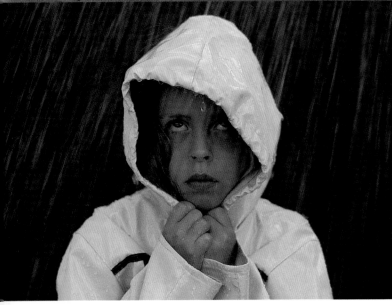

(Above) Ip Peng Kun/Hong Kong
For this shot in rural China, I climbed a hill to shoot
from an angle that would exclude the riverbank.
Canon EOS 1, Sigma 28–70mm, Fuji Velvia

(Top right) Norbert Baranski/Germany
I got this shot in the first light of dawn, as wisps of mist
still hung in the air around the tree's bare branches.
Canon EOS 3, Canon 17–35mm, Fujichrome 100

(Bottom right) Daniel Kyndt/Belgium
Wind-still conditions turned the surface of the river into a
natural mirror as this group of impala paused to drink.
Canon EOS 1N, Canon 300mm, Fuji Sensia 100

(Above) Egon Petrowitsch/Austria
My wife took her watering can up a ladder, out of the
picture, to create the rain in this shot.
Leica R7, Summicron 90mm, Kodachrome 64

(Overleaf) Franz Rettenegger/Austria
This bathing pool at Grainvik, Iceland, is part of a natural
thermal heating plant.
Leica R7, Leitz Angulon 21mm, Fujichrome 50

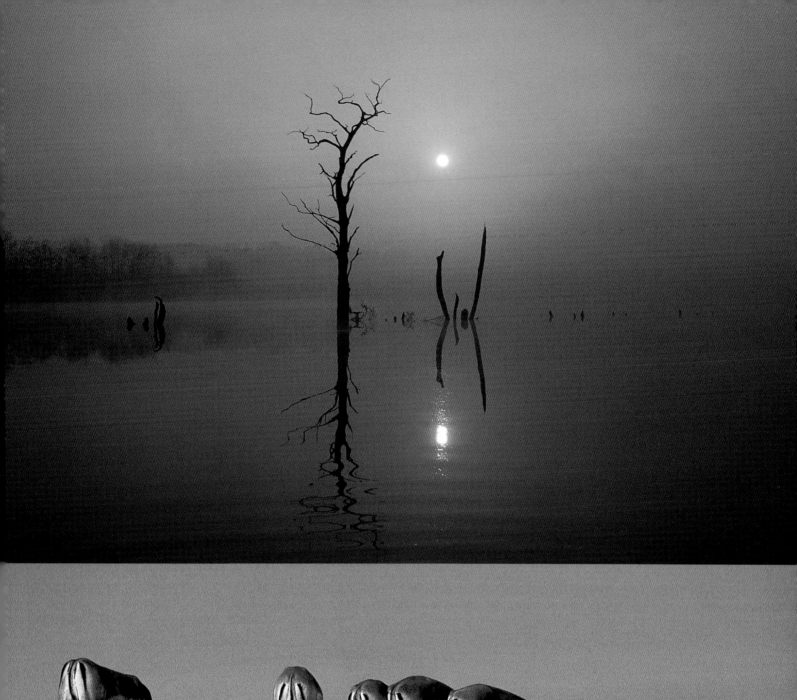
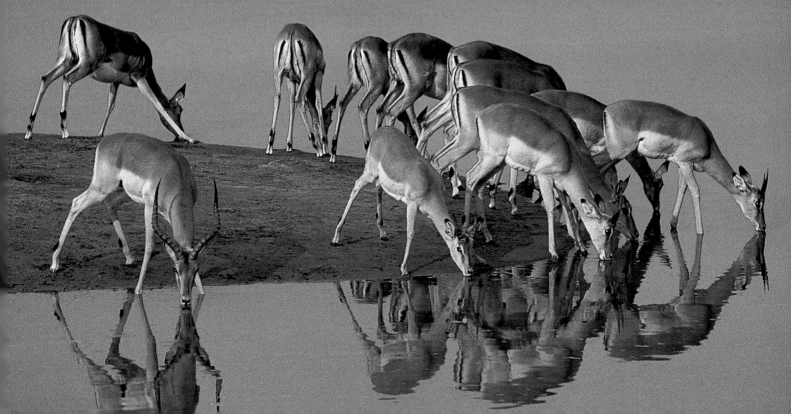

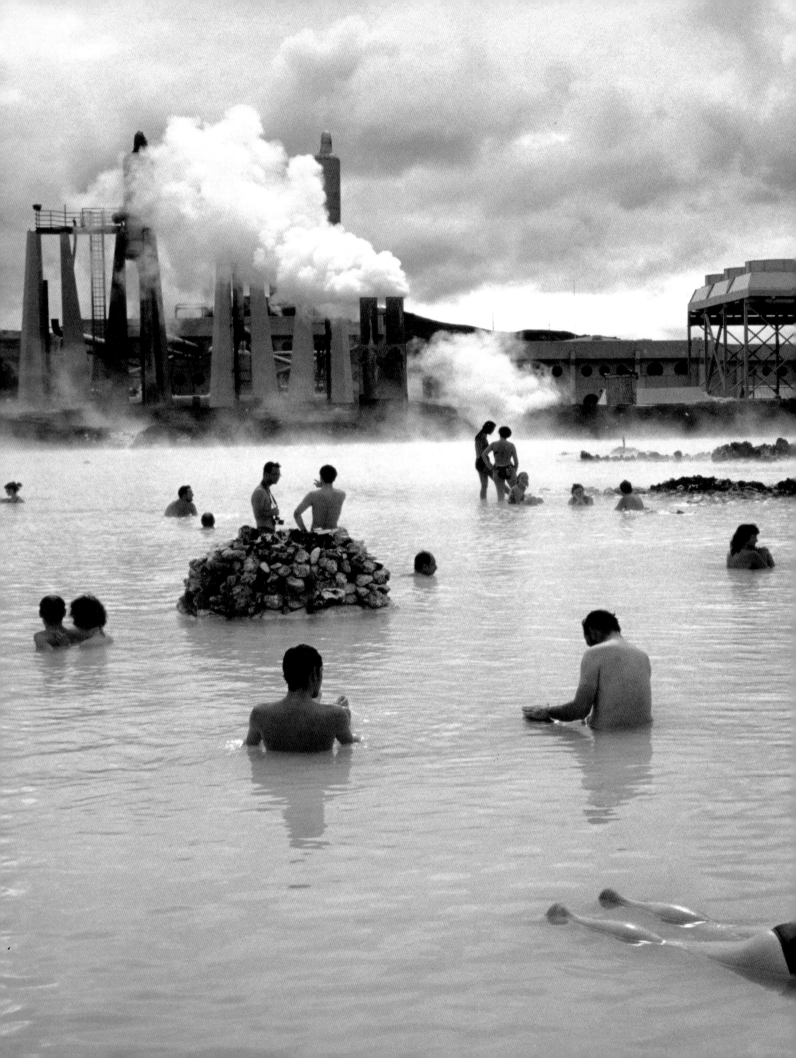

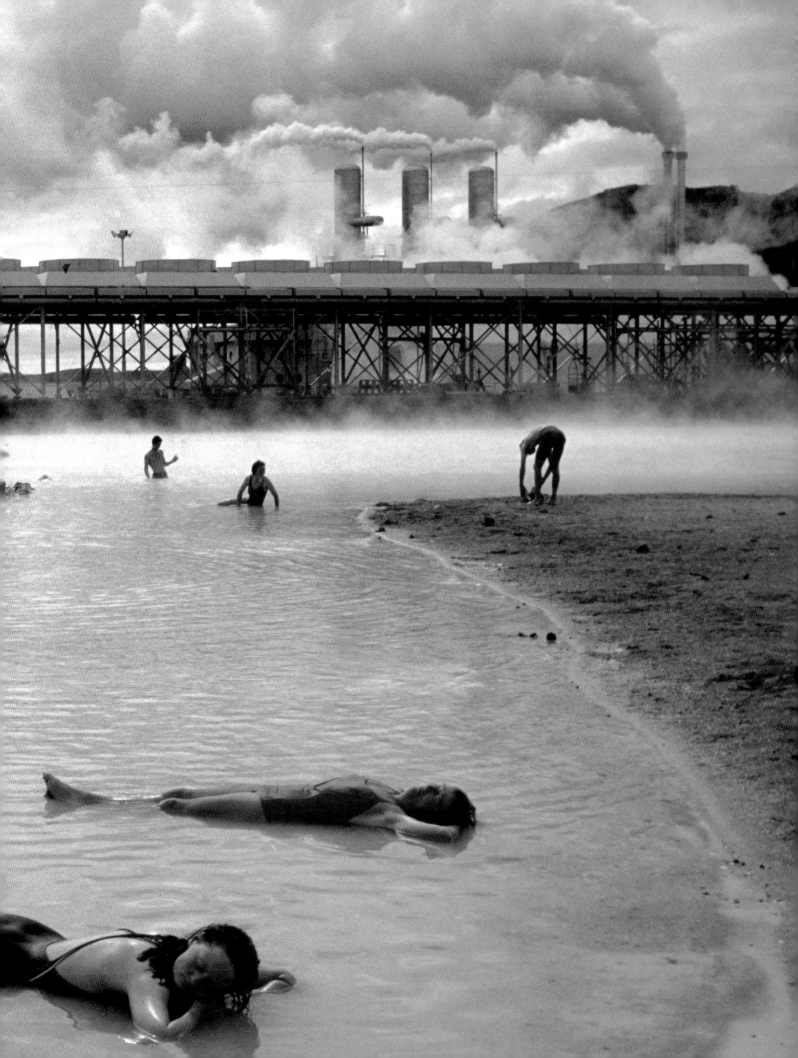

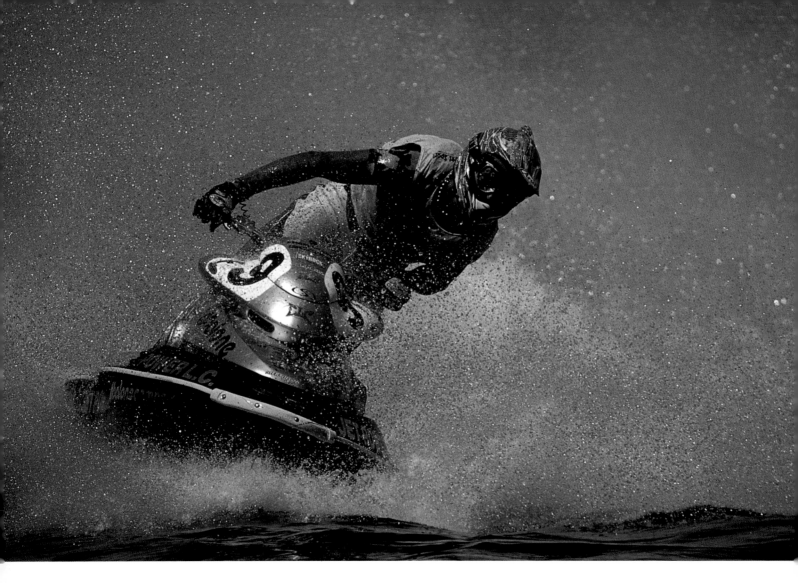

(Above) Michel Poinsignon/France
I got the best pictures at the corner-buoys on this jet-ski course, where the riders have to slow down and the machines throw up huge waves. The spray hides the intrusive background of advertisements and spectators.
Nikon F5, Nikkor 600mm, Fuji Velvia

(Right) Kam Po Paul/Canada
To capture the atmosphere of total peace and unbroken calm in this shot, it was critical that the boats did not overlap each other. The relative positions of the components are as important to the picture's success as the monochrome effect of the reflection in the water.

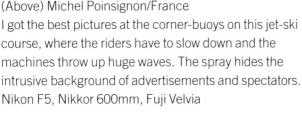

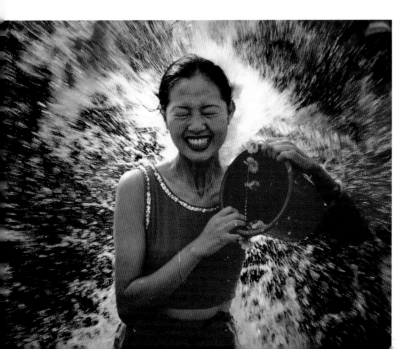

(Left) Norman Lau/Hong Kong
The Water Festival takes place every May in Canton, China. Amongst other things, buckets full of ice-cold water are thrown over everyone.
Miranda T11, Soligor 300mm, Kodak Gold 100

(Overleaf) Un Yun-Pui/Hong Kong
I particularly like the light conditions when sun starts to burn off early-morning mist. I had been waiting to photograph this river crossing in Nepal in just such conditions. The farmer's cart came along at just the right moment: a few minutes later, the mist had gone.
Hasselblad 503 CW, Hasselblad 80mm, Fuji film

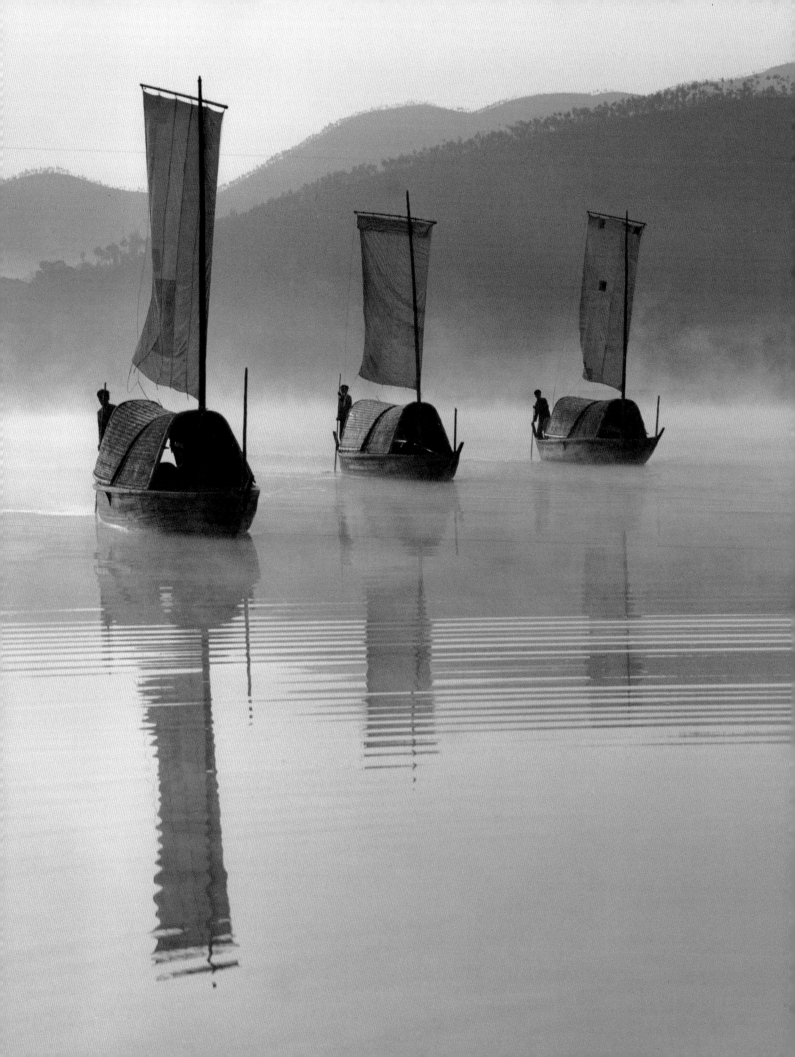

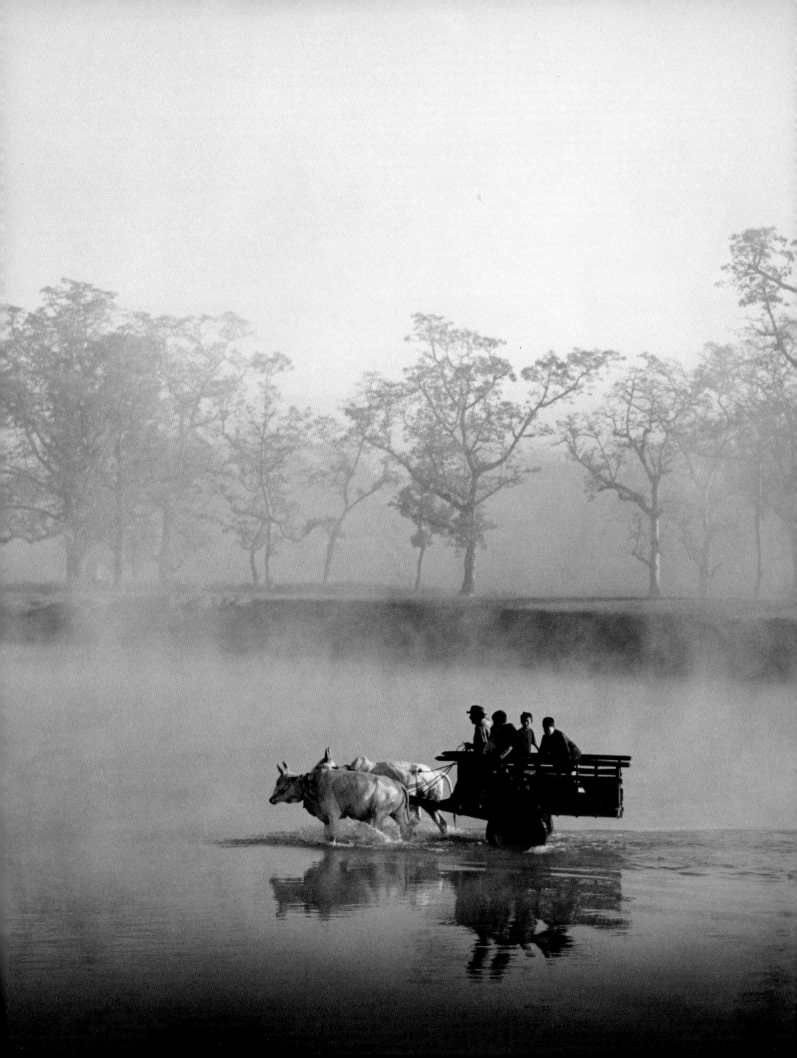

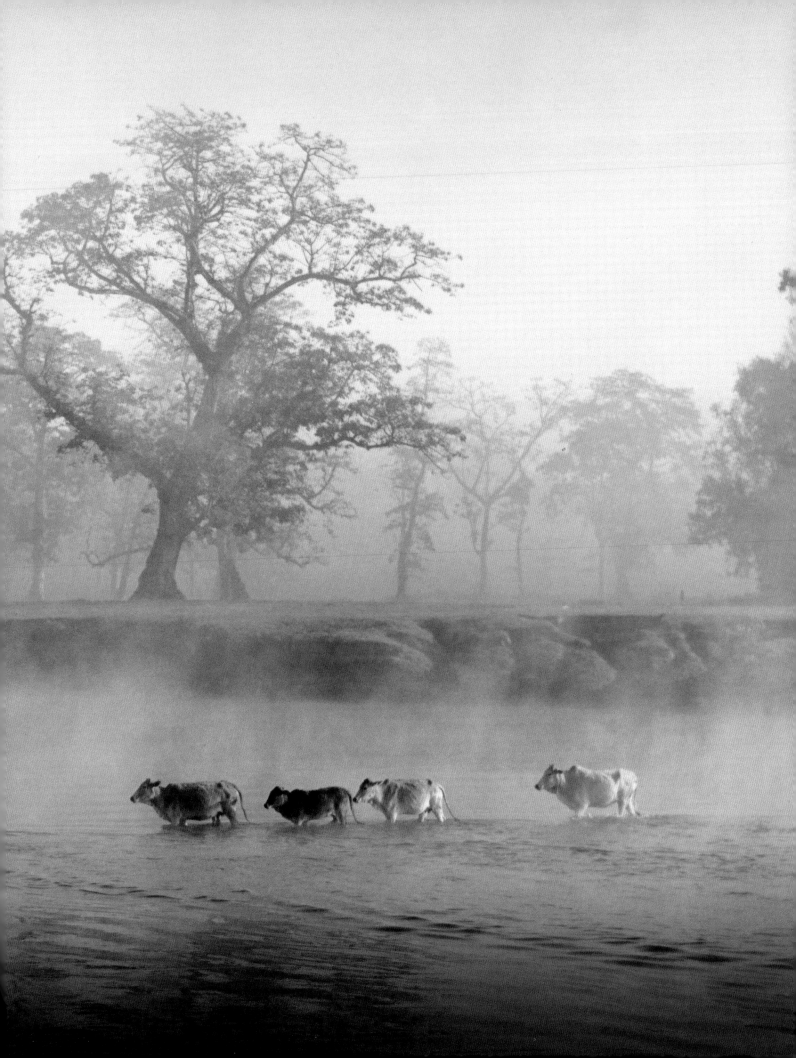

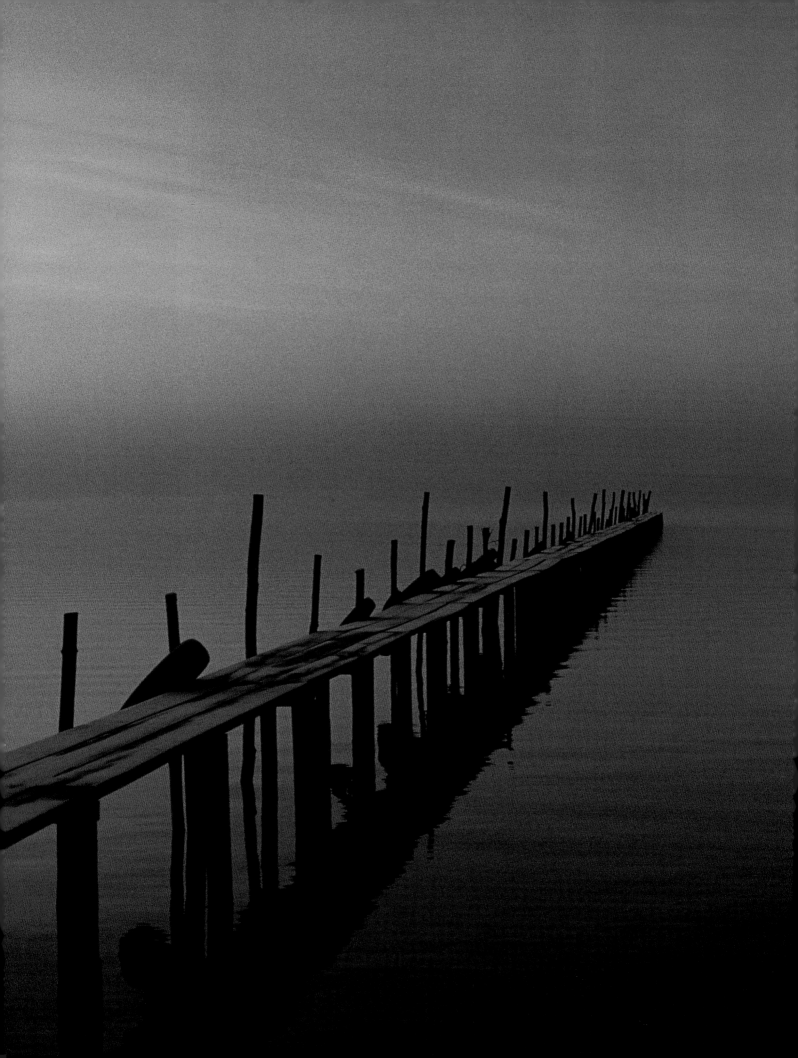

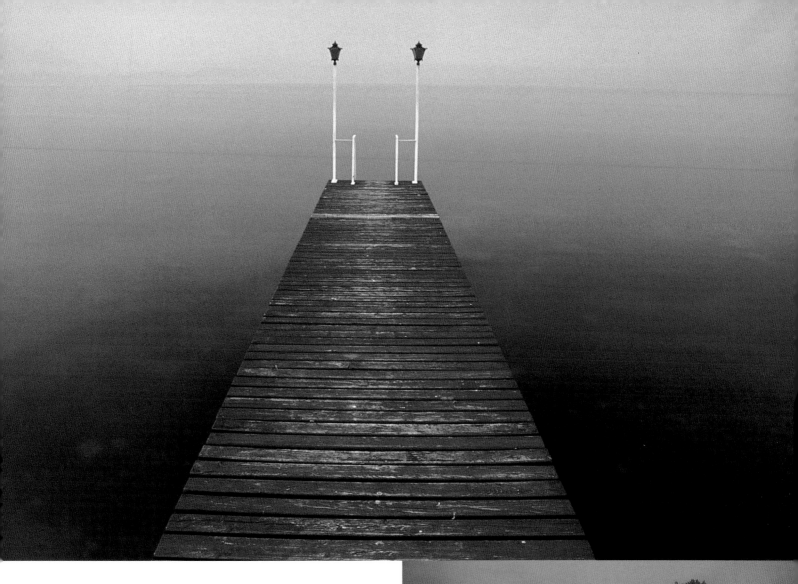

(Above) Norbert Gehrmann/Germany
At 6.30 a.m., the lights on this jetty at Lake Garda
were still lit. To get perfect symmetry I placed a grid
behind the viewfinder.
Nikon 801S, Nikkor 35–70mm, Fuji Sensia

(Left) Jean Jacques Milan/France
A frosty morning on Lake Cazaux near Bordeaux, France.
The wooden deck was covered in ice and there was a
fabulous red sunrise – perfect for photography.
Minolta X 500, Minolta 35–70mm, Kodak Ektachrome 100

(Right) Lasse Johansson/Sweden
This island is in the middle of a marshland area in Sweden.
To get the full effect of the magical atmosphere, with early-
morning mist in the shot, I had to get up before dawn –
but it was worth it.
Canon EOS 5, Canon 28–105mm, Fuji Velvia

(Overleaf) Tan Swee Heng/Singapore

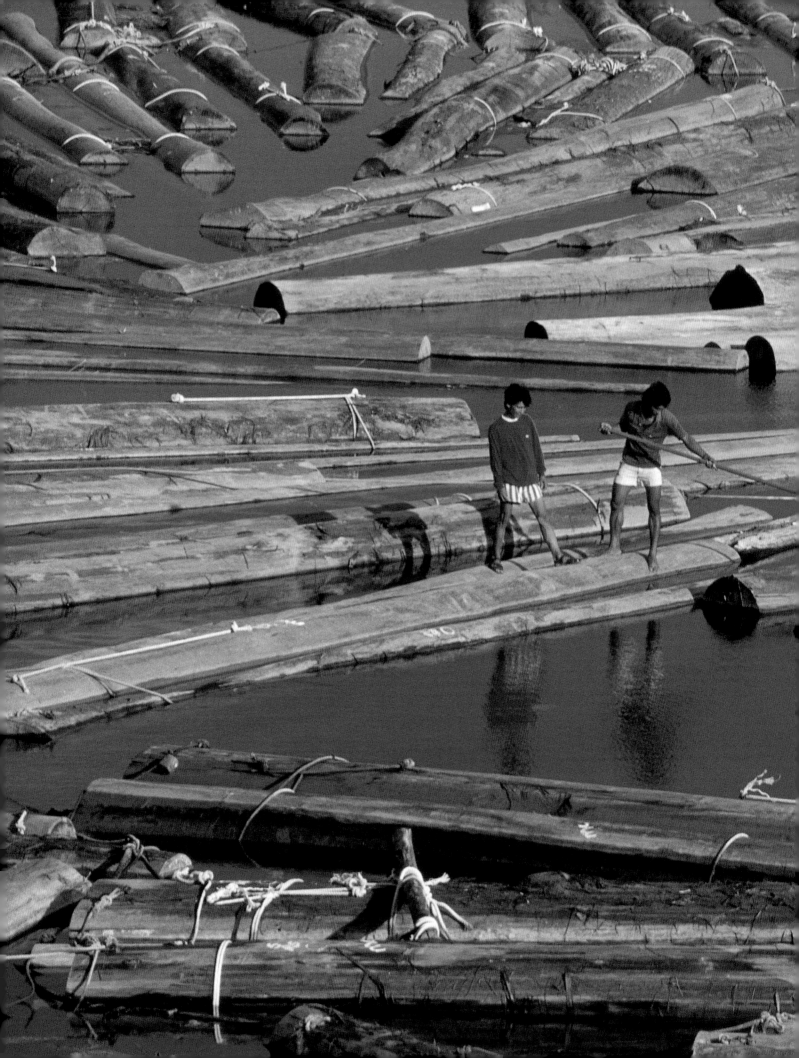

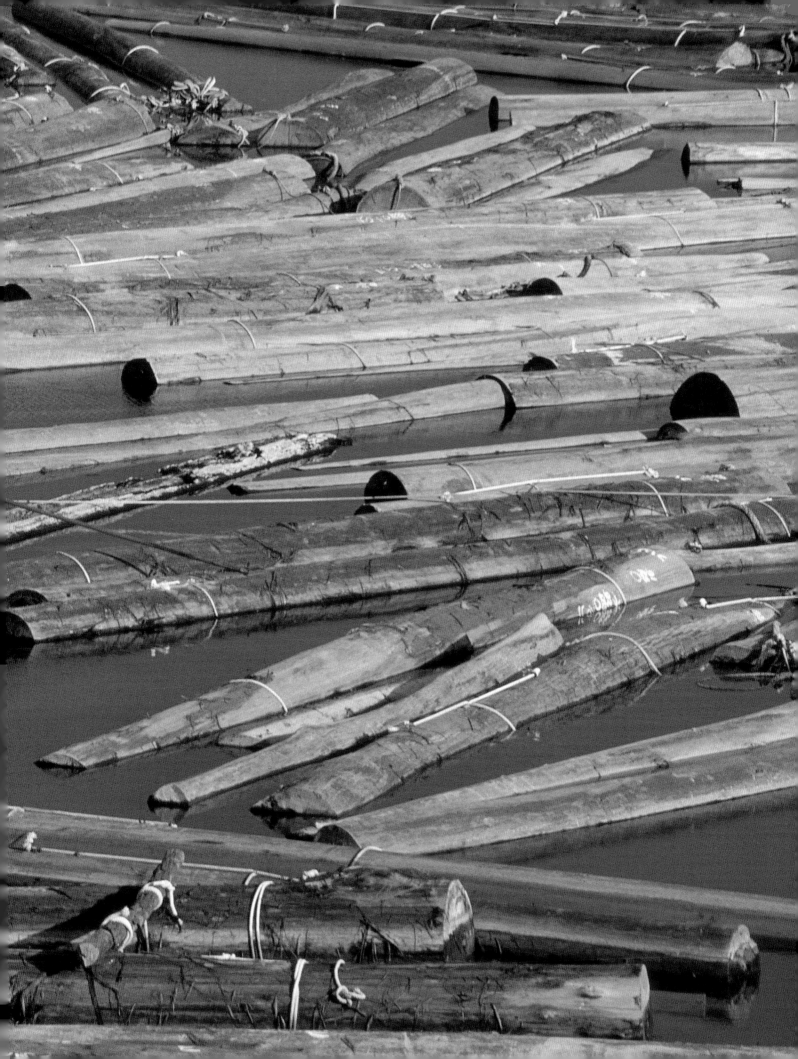

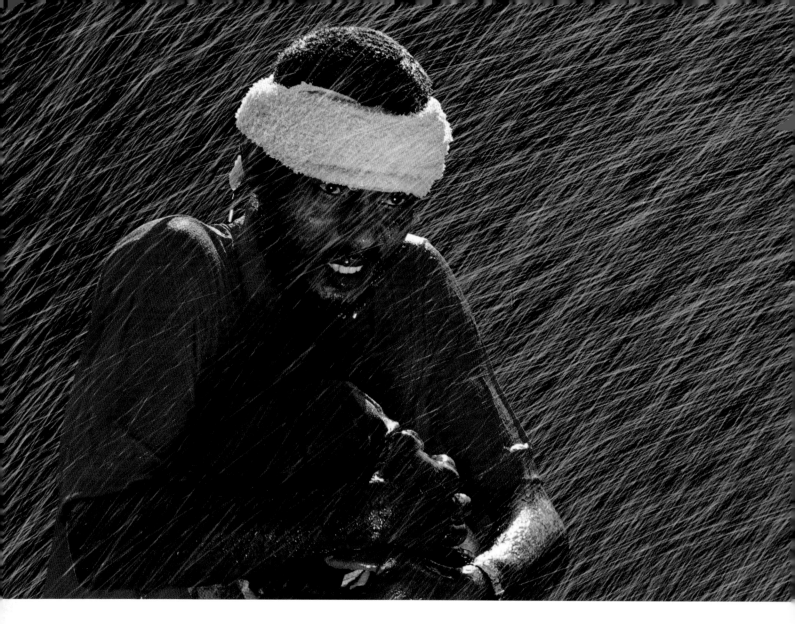

(Above) Ngo Chee Kong/Singapore
A sudden tropical downpour on a sunny day. Sun and rain at the same time is unusual, but it creates a fascinating effect.
Nikon F90, Nikon 80–200mm, Kodak Gold 100

(Top right) Kwok Leung Lam/Canada
Back-lighting shows up the jets of water in this city-centre fountain and conveys the feeling of refreshing cool water on a hot day.

(Bottom right) Klaus Schidniogrotzki/Germany
I love the light in the Canary Isles, although in winter the constant changes can be a challenge for the photographer. I wanted to show the power and violence of the sea: how better than to photograph these Atlantic breakers?
Minolta X 700, Mijnolta 400mm, Fuji Velvia

(Overleaf) Viorel Munteanu/Austria
This solitary swimmer in the pool below my hotel window looked just like a frog in a pond. Careful framing was essential to the success of the shot.
Canon AE1, Canon 24mm lens, Kodak infrared film

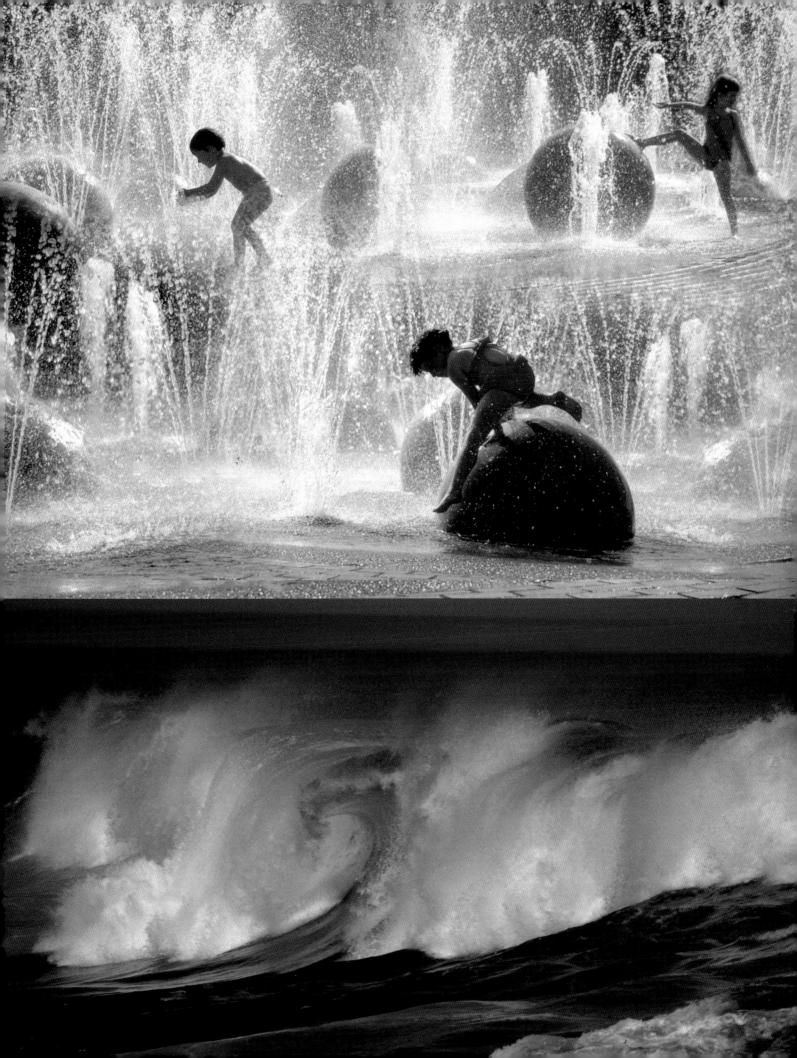

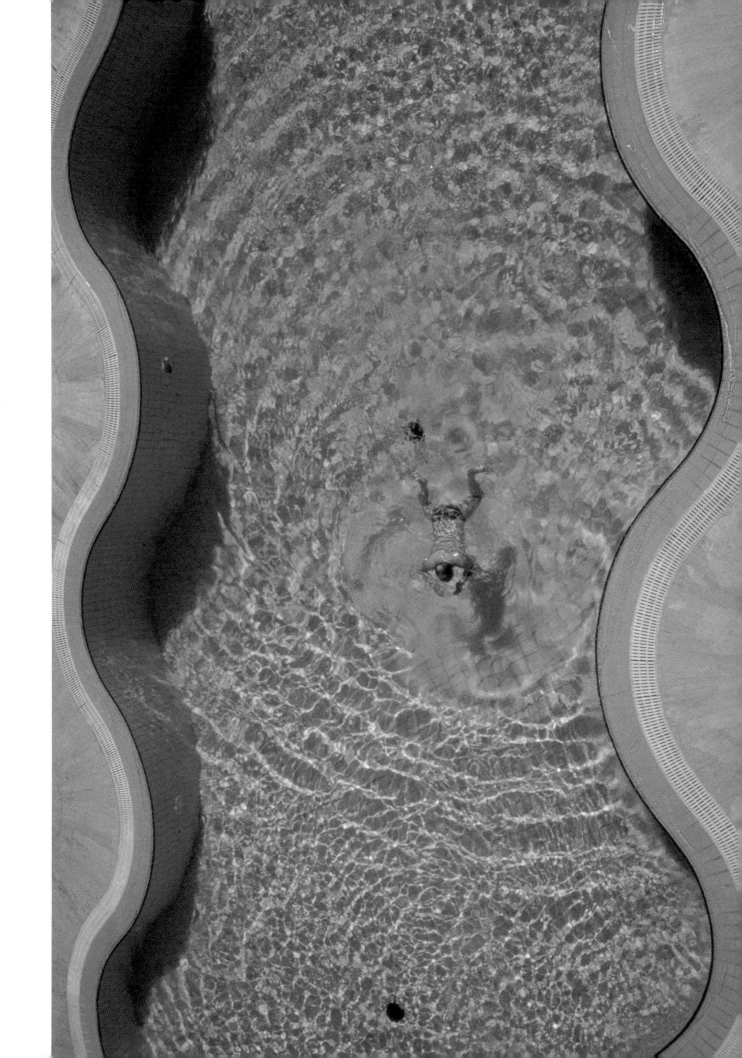

Romualdas Pozerskis
The Joys and Woes of Little Alphonse

Romualdas Pozerskis was born in 1951 in Vilnius, Lithuania. He studied electronics and philosophy, but soon discovered a love of photography. He has worked as a freelance photographer since 1980 and, since 1993, he has also been a lecturer at Kaunas University. His photographs are in many important international collections and his countless exhibitions and publications have established a reputation for him in Europe and the USA. He has won many awards, including the Lithuanian National Art Prize.

Typical of Pozerskis is his engagement with individual subjects over a long period of time. The series shown here, 'The Joys and Woes of Little Alphonse', has occupied him for over ten years.

Pozerskis uses Nikon cameras; his choice of lenses ranges from 24mm wide-angle to 300mm telephoto. Working exlusively in black and white, his preferred films are Ilford FP4, Delta 400 and XP2.

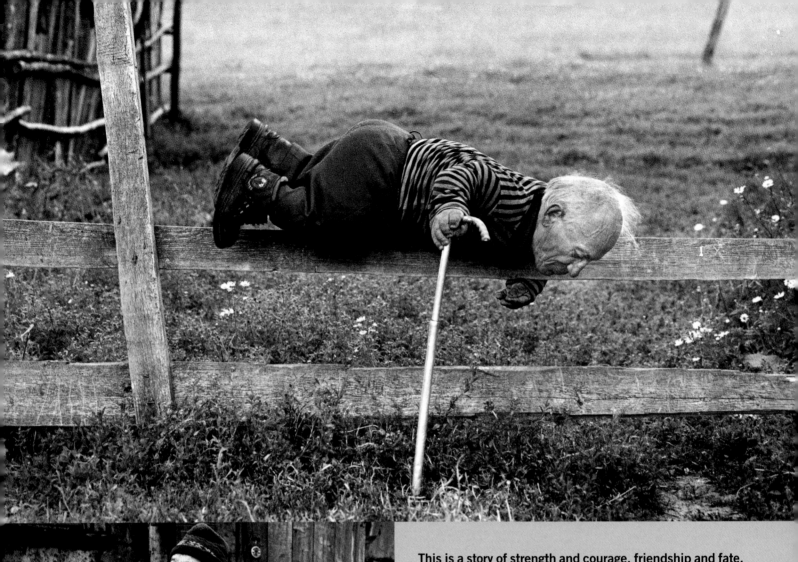

This is a story of strength and courage, friendship and fate.

At 36 inches (90 cm) high, Alphonse is almost certainly the smallest man in Lithuania. Born in 1927 in the village of Siaudvyciai, just over 30 miles (50 km) from the Baltic Sea, he stopped growing in early childhood and believed that it was because a cockerel had jumped on his chest and spread its wings, scaring all future growth out of his body.

His parents tried in vain to give him away, but not even the travelling circus would take him. It was said that he was such a difficult child that even Stalin's local bolshevik officials threatened to send him off to Siberia if he didn't mend his ways.

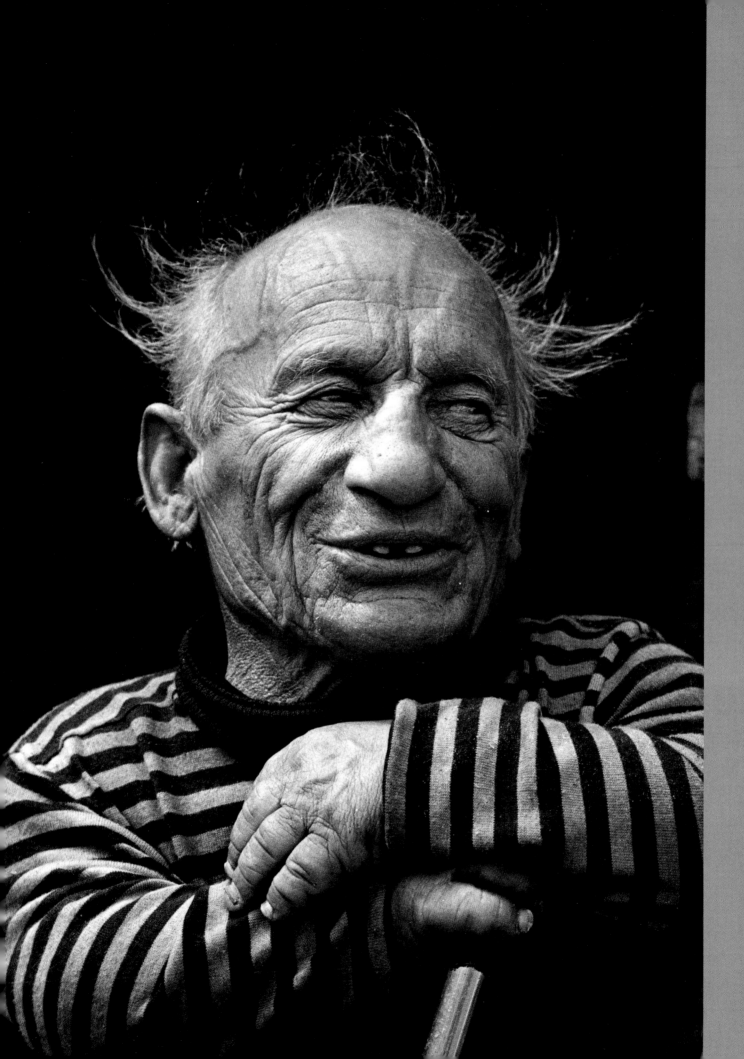

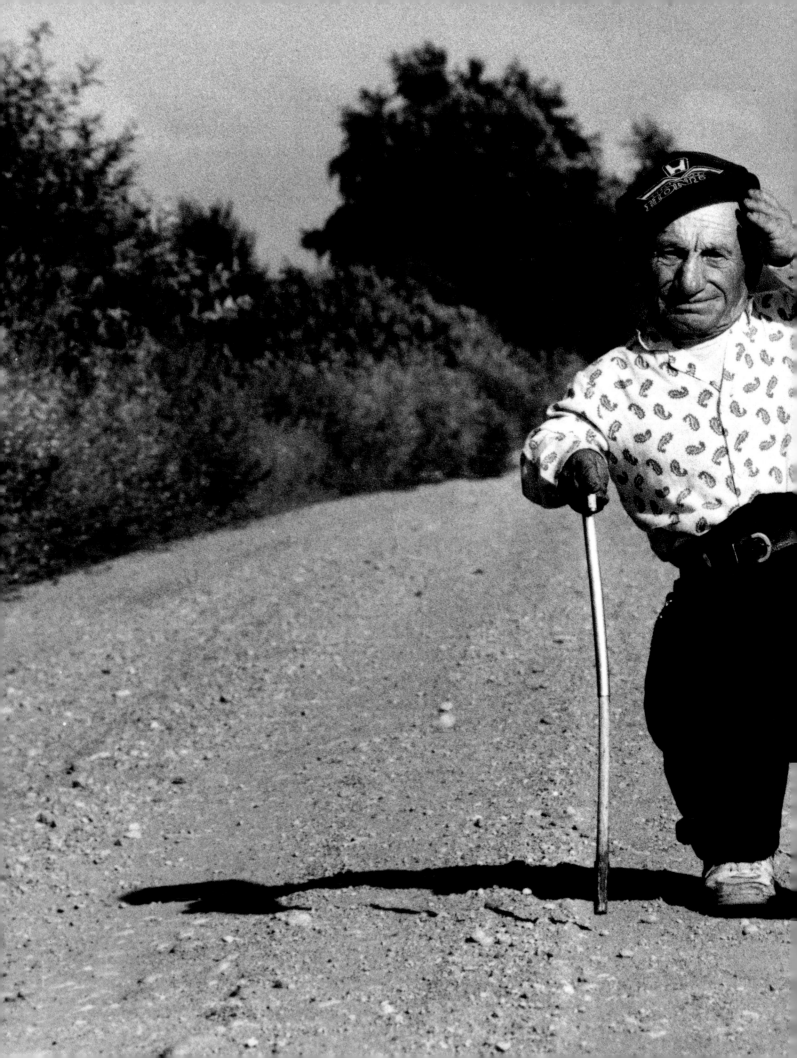

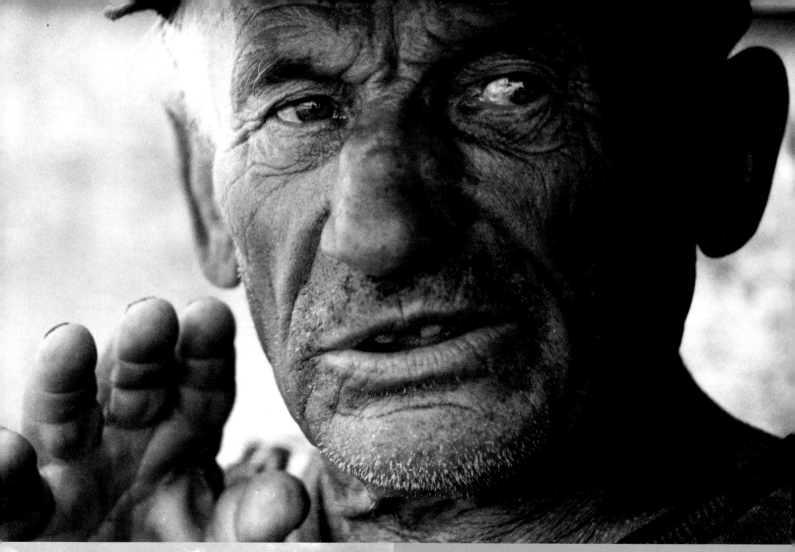

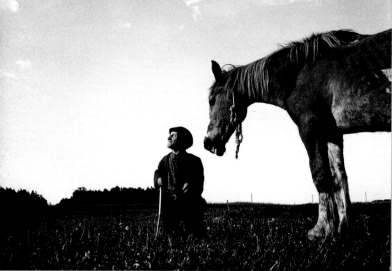

An already difficult childhood became worse as he grew older, his parents and his brother treating him as a hired hand on their tiny smallholding and heaping on to him all the work that no one else wanted to do. He had no schooling and no expectations, and never left his village.

Then, in 1992, his life was transformed by a chance meeting with photographer Romualdas Pozerskis. Seeing Alphonse walking by the road outside his remote village, Romualdas stopped his car and offered him a lift. They talked during the short ride and some years later, unable to forget the encounter, Romualdas tracked Alphonse down and invited him out for a beer.

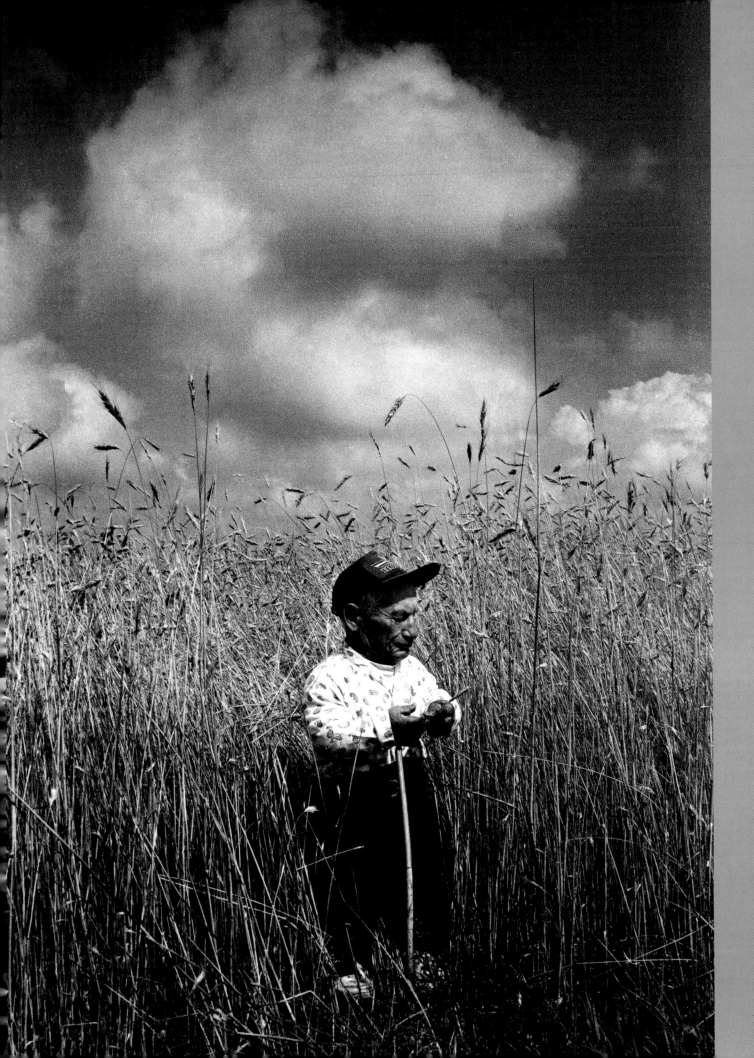

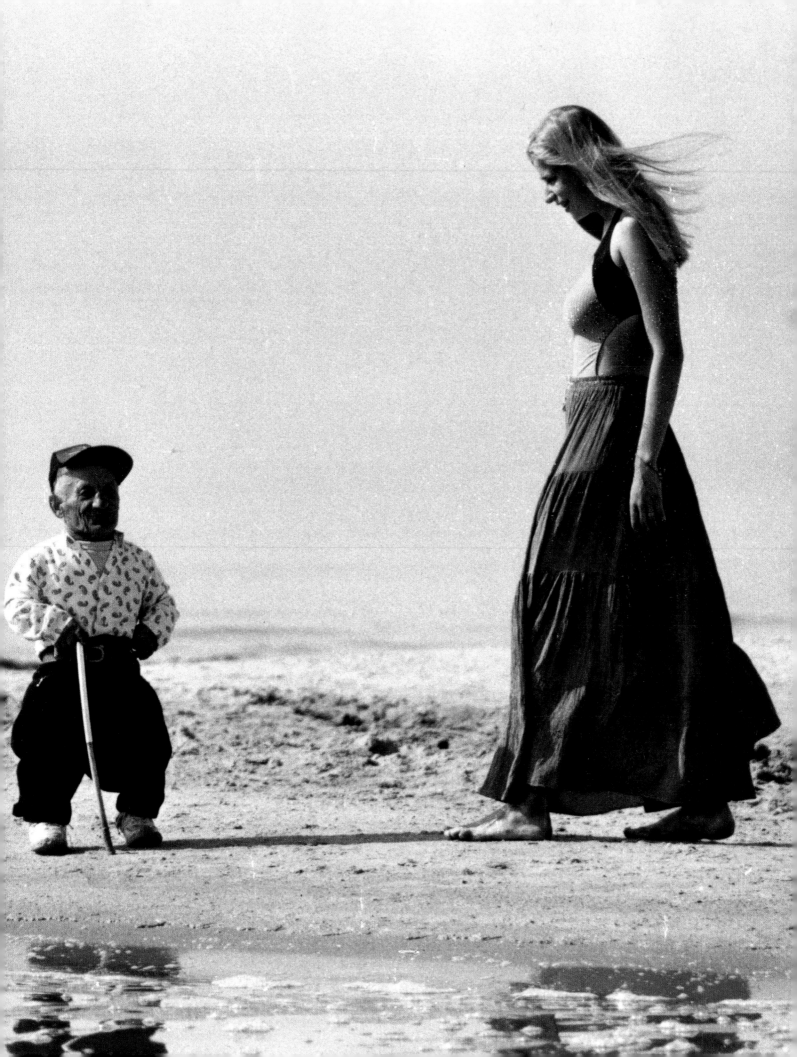

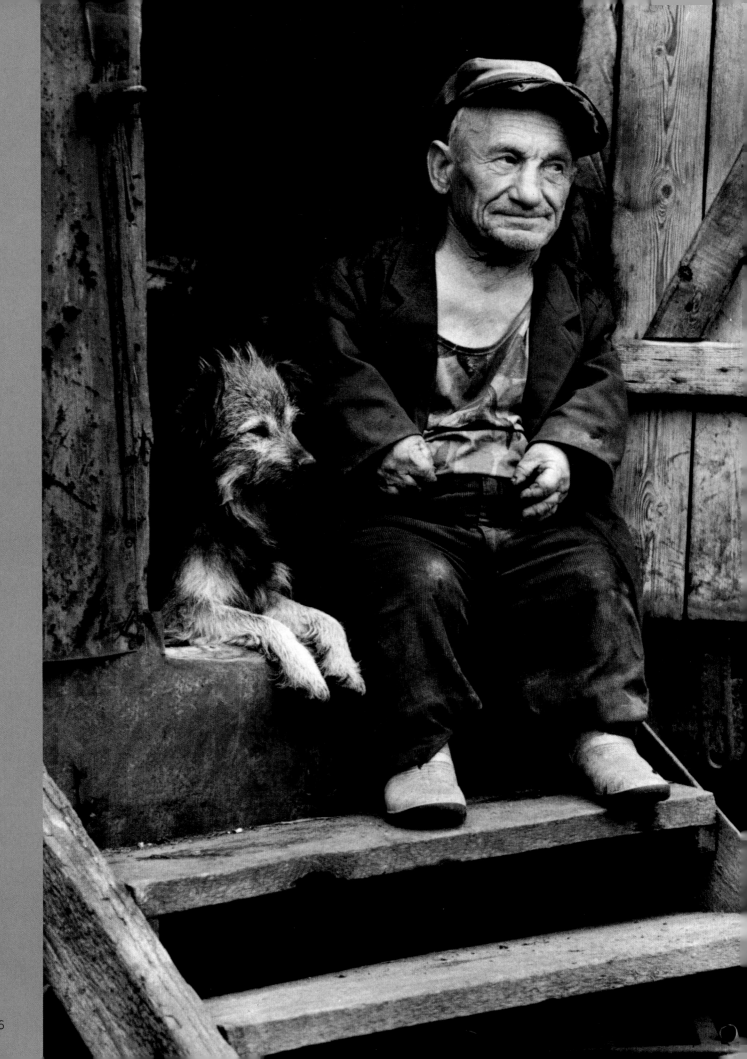

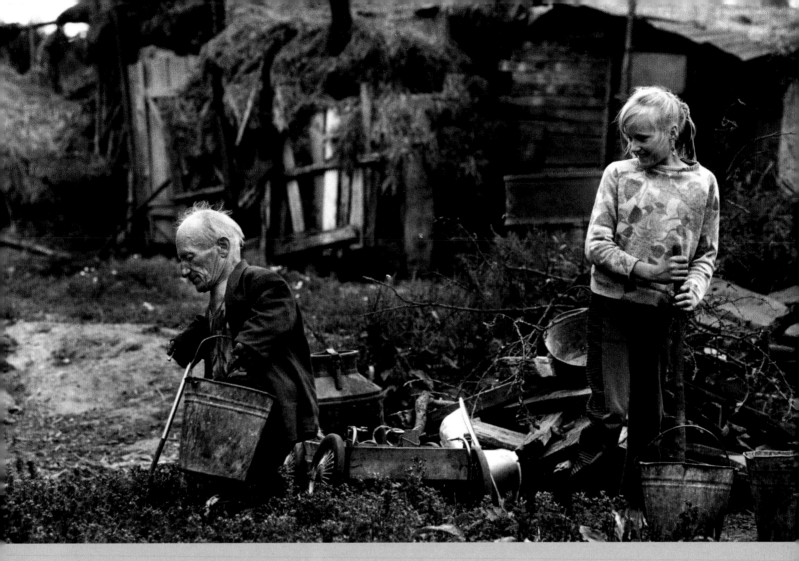

So began an unusual friendship. Alphonse was 70 years old when Romualdas returned. They celebrated that birthday together, just the two of them, with a visit to the seaside. Romualdas asked if he could photograph him and, although he could not understand why anyone would want to do so, Alphonse agreed. This marked the beginning, albeit a late one, of Alphonse's new life.

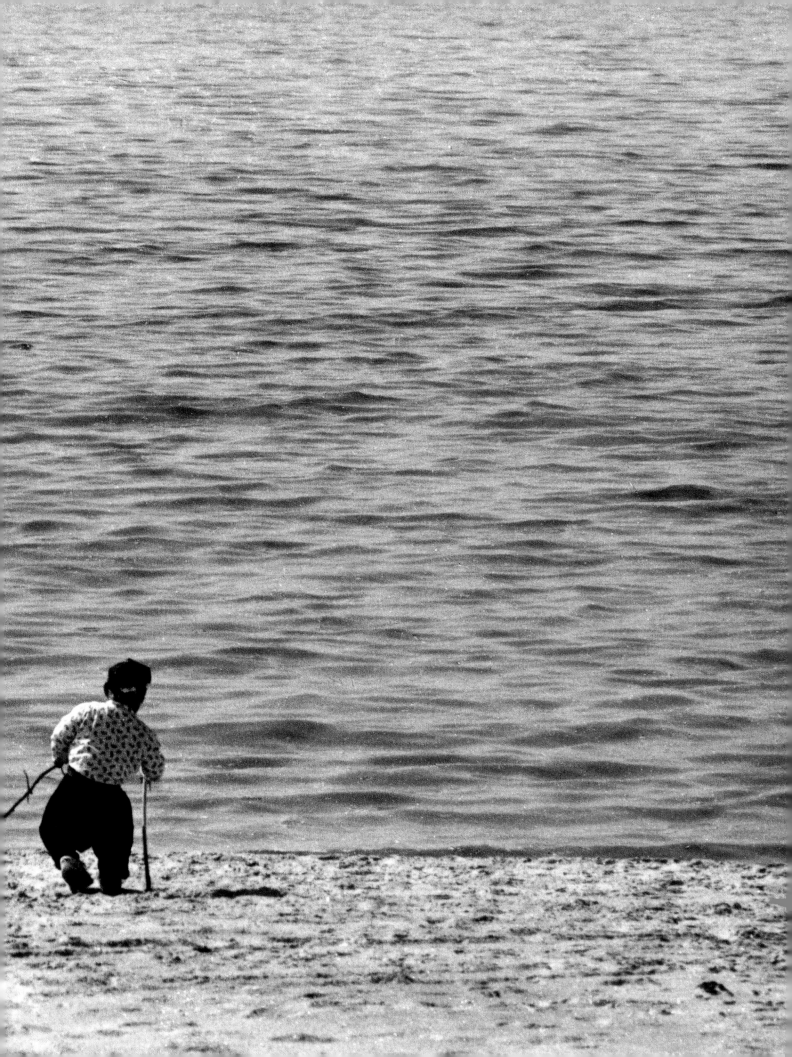

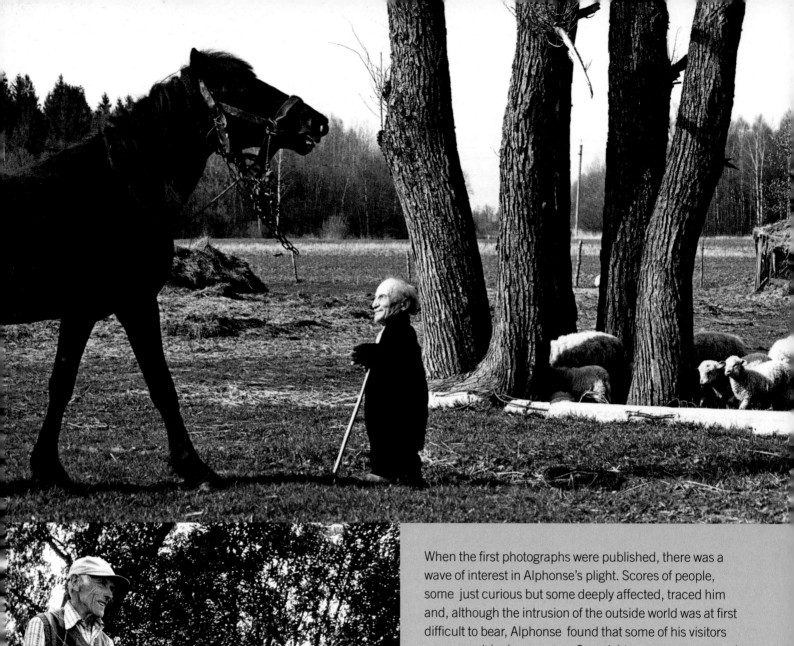

When the first photographs were published, there was a wave of interest in Alphonse's plight. Scores of people, some just curious but some deeply affected, traced him and, although the intrusion of the outside world was at first difficult to bear, Alphonse found that some of his visitors were surprisingly generous. One night a caravan appeared in his garden, a gift from an unnamed benefactor. Soon after that Alphonse met a lady and found himself living with a partner for the first time in a long and lonely life.

Alphonse now has a farm of 20 acres (8 hectares) with pigs, goats, sheep and a wild boar. His ability to live and work with these animals and look after a horse or two is a remarkable testament to a remarkable man.

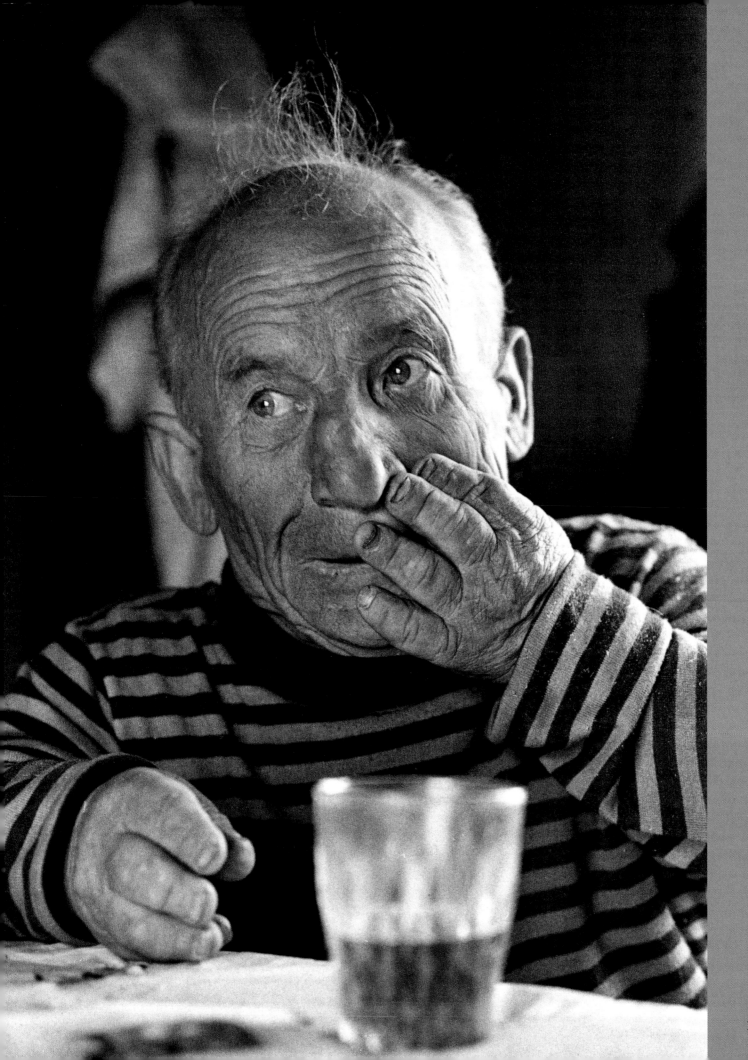

Color
Subtleties and contrasts

The aesthetic effect of color is extremely important, not only in our conscious analysis of a work of art, but also within our subconscious minds. There is no doubt that colors and color combinations have an effect upon our emotions and our moods.

Blue is said to be a cold color, the color of ice, and has a calming influence. Red is the opposite: its associations are passion, heat , aggression – and these fundamental characteristics of red are stored in our subconscious. Yellow, the third of the primary colors, is thought of as warm and friendly; the sun and flowers are good examples.

The combining of different colors is just as significant. We speak of complementary contrasts when a cold and a warm color are juxtaposed: for instance, blue and red, blue and yellow or green and red. Red is much more dominant visually than blue, and our eyes are immediately drawn it.

The combination of psychologically related colors,too, is interesting; grey, green and brown tones work well together, as can be seen in the landscape. The warm shades of red and yellow, which we observe in a sunset, also seem to harmonize well. A photographer may just as effectively use only one dominant color producing an almost monochromatic effect.

Photographers need to understand the emotional effects of color and employ them in their work. Color should, however, be used carefully, not indiscriminately; as the saying goes, this is definitely a case of 'less is more'.

(Above) Ewald Neffe/Austria
Lake Neusiedel, at the border between Austria and Hungary. The pale evening light required a long exposure and the consequent use of a tripod.
Canon EOS 50E, Canon 20–35mm, Fuji Velvia

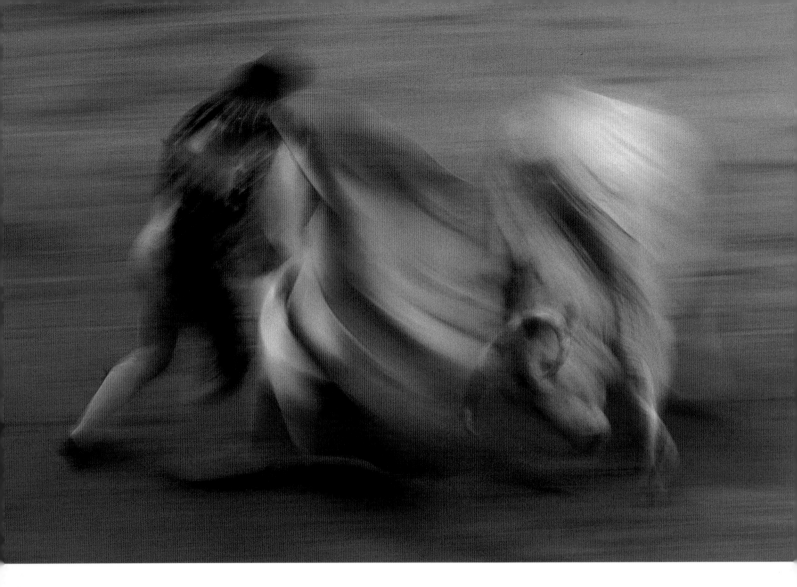

(Above) Michel Poinsignon/France
Sitting in the press box, I had the perfect spot to photograph this bullfight in Spain. I wanted to capture harmony and movement, not bloodthirsty action.
Nikon F5, Nikkor 300mm plus x 1.4 converter, Fuji Sensia

(Top right) Roberto Brolli/Italy
It was a dark, dull day. I was focusing on the boat, using a blue filter, when suddenly the sun broke through the clouds. It was as if someone had trained a spotlight on the yacht.
Pentax SX7, Pentax 70–210mm, Fuji 50

(Bottom right) Karl-Heinz Schleder/Germany
This is a sandwich, with two slides in the same frame. Overexpose each transparency by approximately one stop so that the two appear correctly exposed when combined.
Canon F1N, Canon 17mm, Fuji Velvia

(Overleaf) Tan Cheng Hai/Singapore
I set this scene up in the open air on a sunny day, lighting the dark background and black umbrellas with a spotlight plus some additional lighting. The 'rain' came from a hosepipe.
Nikon FM2, Nikon 80–200mm, Kodak Ektachrome 100

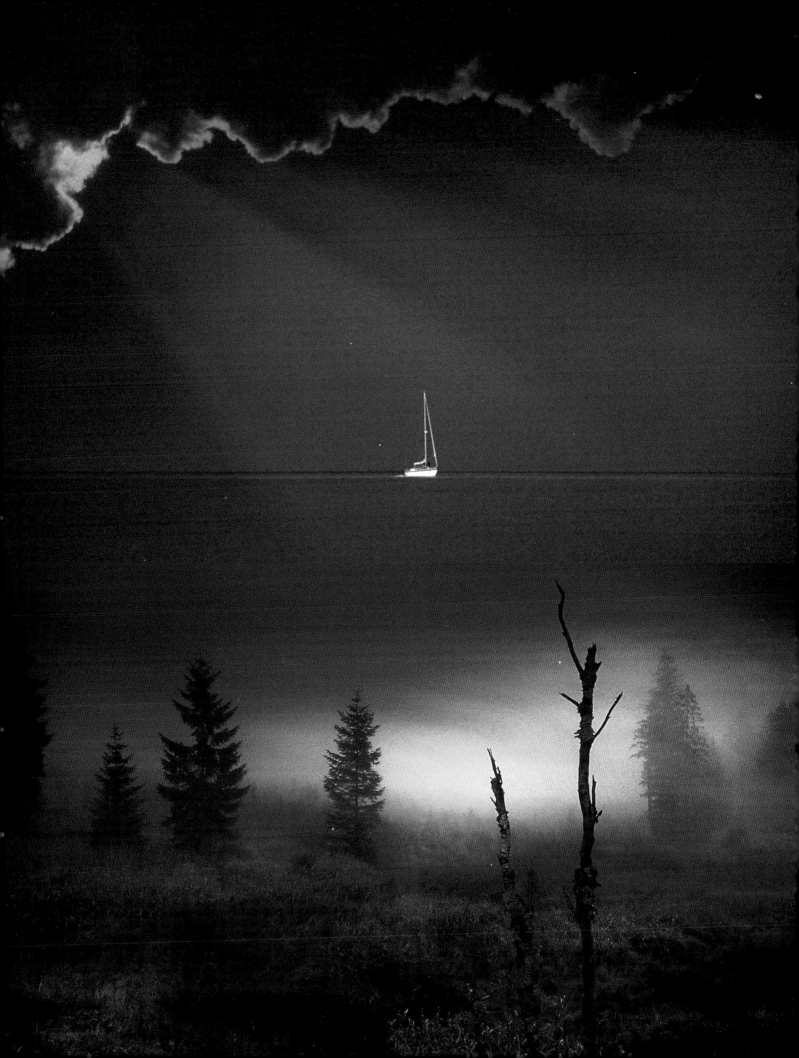

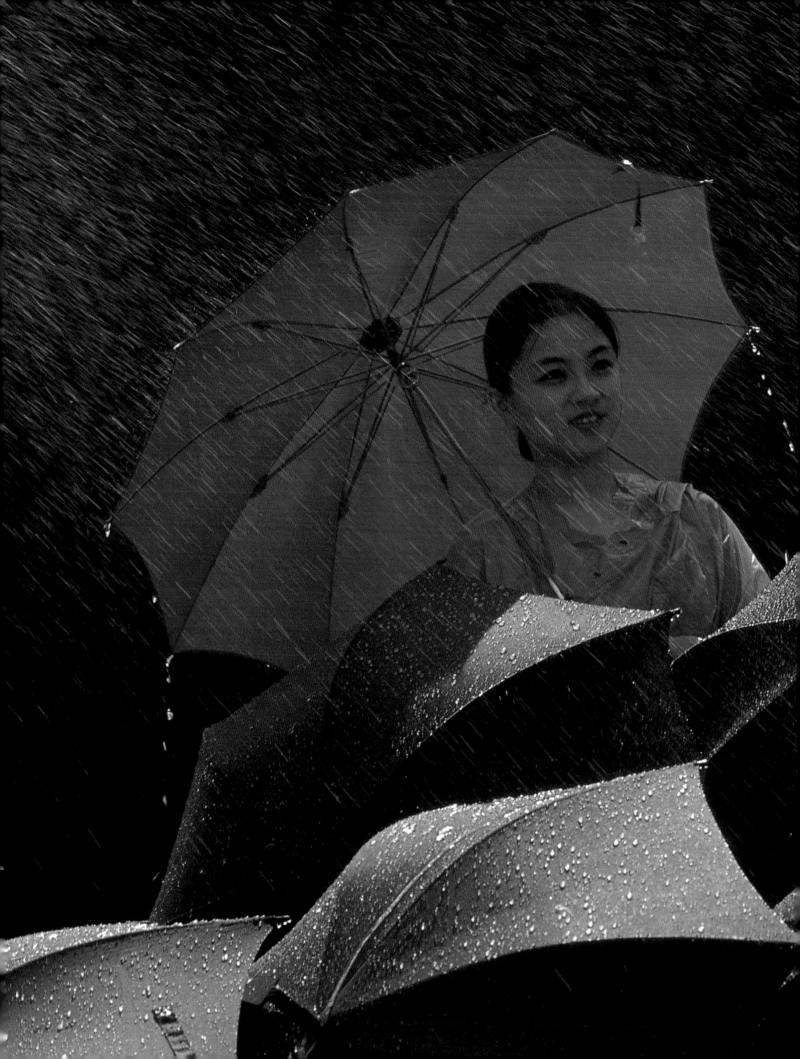

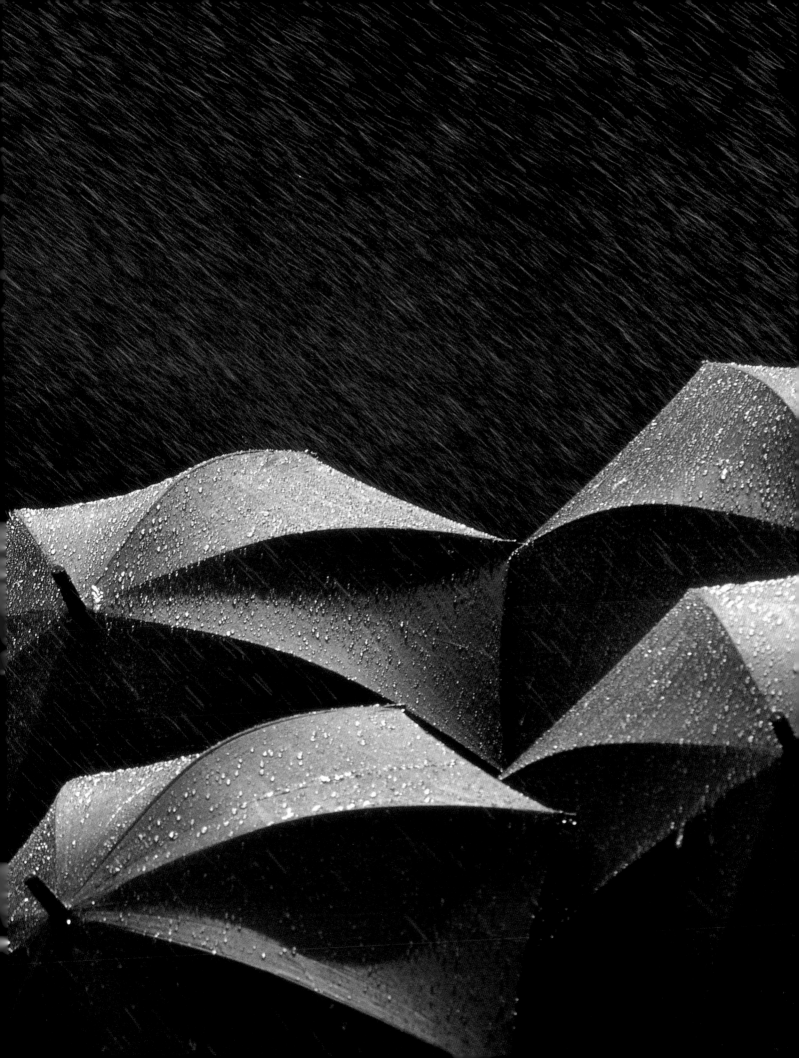

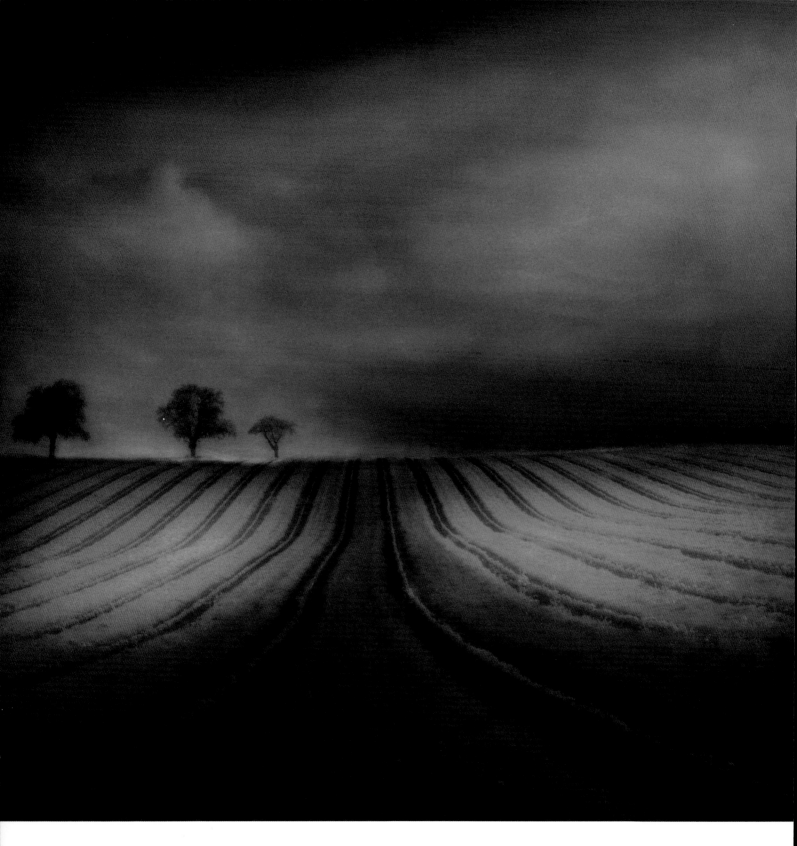

(Above) Edmund Whitaker/England
I originally took this in black and white, but the light was too weak and there was little contrast. Three years later I decided to hand-color it, using tempera colors; the improvement was tremendous.
Hasselblad CM, Hasselblad 80mm, Konica infrared film

(Top right) Edmund Whitaker/England
The right light and weather conditions are essential to a landscape photograph; the color can, if needed, be added later. I adore the art of hand-coloring; it takes me back to the origins of photography in the 19th century.
Hasselblad CM, Hasselblad 80mm, Konica infrared film

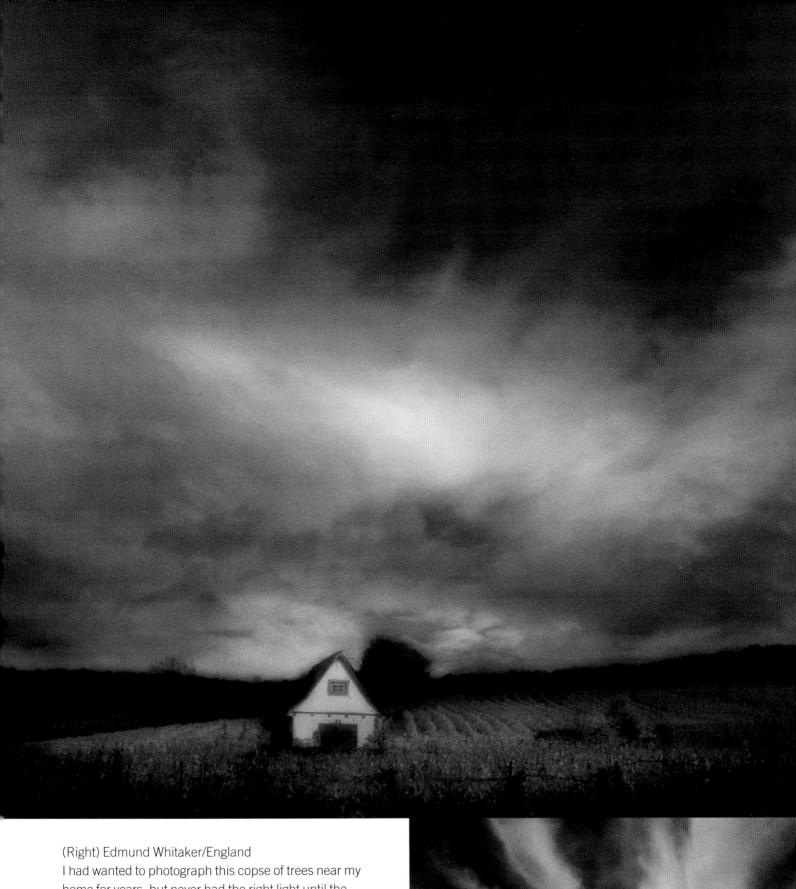

(Right) Edmund Whitaker/England
I had wanted to photograph this copse of trees near my
home for years, but never had the right light until the
summer of 2001. I flipped the negative to have the large
tree on the left, then hand-colored it.
Sigma SA-5, Sigma 28mm, Kodak infrared film

(Top left) Cor Boers/Netherlands
In springtime, the fields around Adam in Holland are filled with rapeseed blossom. The combination of blue and yellow is common in photography and I wanted to bring in red as well. A friend allowed his red umbrella to be caught by the strong wind and, after several attempts, I got the combination of position and movement just as I wanted it.
Pentax ME Super, Takuma 35–70mm, Agfachrome 50

(Bottom left) Paul Exton/England
This tent had been set up as a walk-through work of art. I used it for a series of pictures of a very impressive colorfulness. It is the sunlight shining through the tent that creates the intensity of the color.
Canon EOS 30, Canon 28–80mm, Fuji Sensia 100

(Above) Manfred Kriegelstein/Germany
This is my best-known and most successful photograph and was shot in Lanzarote, in a restaurant built by the architect Cesar Manrique. I achieved the combination of subtle light and perfect clarity of movement by using a tripod and a shutter speed of 1/8 sec.
Leica R4, 28mm, Kodachrome 64

(Overleaf) Guerrino Bertuzzi/Italy
For me this picture radiates the essence of spring. The complementary colors – red and green – positively sizzle with energy and a sense of new growth, while setting the figures slightly to the right brings a dynamism that a completely symmetrical composition would lack.

(Above) Colin Roberts/England
An exercise in color and pattern; placing the lighter-colored leaves on top gives a sense of depth to the image and adds visual interest.

(Right) Sarel van Staden/South Africa
A classic contrast of warm yellow and the cool blue of the surrounding area. I love to use contrast to intensify the effect of strong colors.

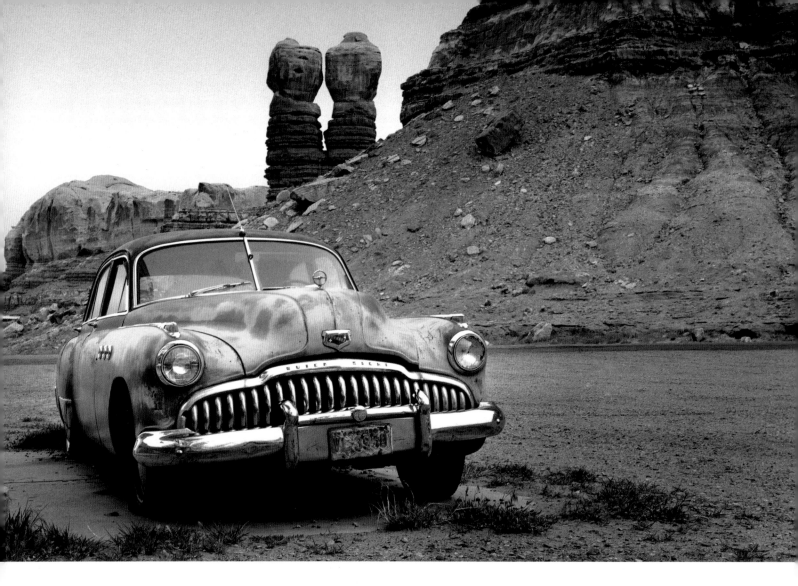

(Above) Tony Worobiec/England
Although it is often assumed that Monument Valley is a National Park it is, in fact, the property of the Native Americans who live there. I felt this shot was more interesting than the usual Monument Valley cliche.
Pentax 67, 45mm lens with orange filter, Kodak T-Max 400, developed normally in T-Max developer; printed on Ilford MG paper and selenium toned

(Top Right) Tony Worobiec/England
Very often the economic well-being of rural American communities can be determined by the condition of the grain-silos: Stanford, North Dakota, is very much in decline.
Mamiya 7, 43mm lens with orange filter, Kodak T-Max 400; sepia toned and hand colored using Kodak E6 dyes

(Bottom Right) Tony Worobiec/England
Devon, Montana, was once a prosperous town on the American Hi-Line with a population in excess of 10,000. It has since dwindled to barely 100.
Pentax 67, 45mm lens with orange filter, Kodak T-Max 400; sepia toned and hand colored using Kodak E6 dyes

(Overleaf) Nico Smit/South Africa
Dynamism, strength and pent-up energy come through in this picture. Background dust and a wide aperture separate the subject from the background. Finally, the red racing colors invite the viewer's gaze to linger on the dog's body.
Canon EOS 3 +PB-E2, Canon EF 400mm f/2.8, Fuji Sensia

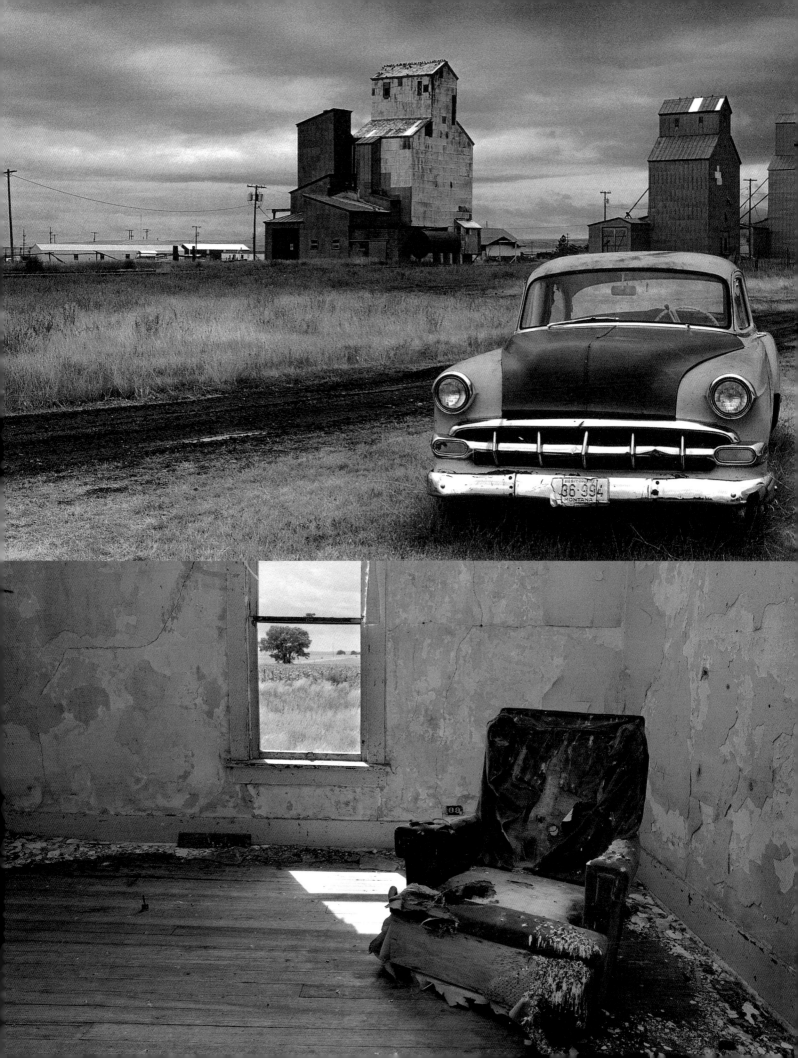

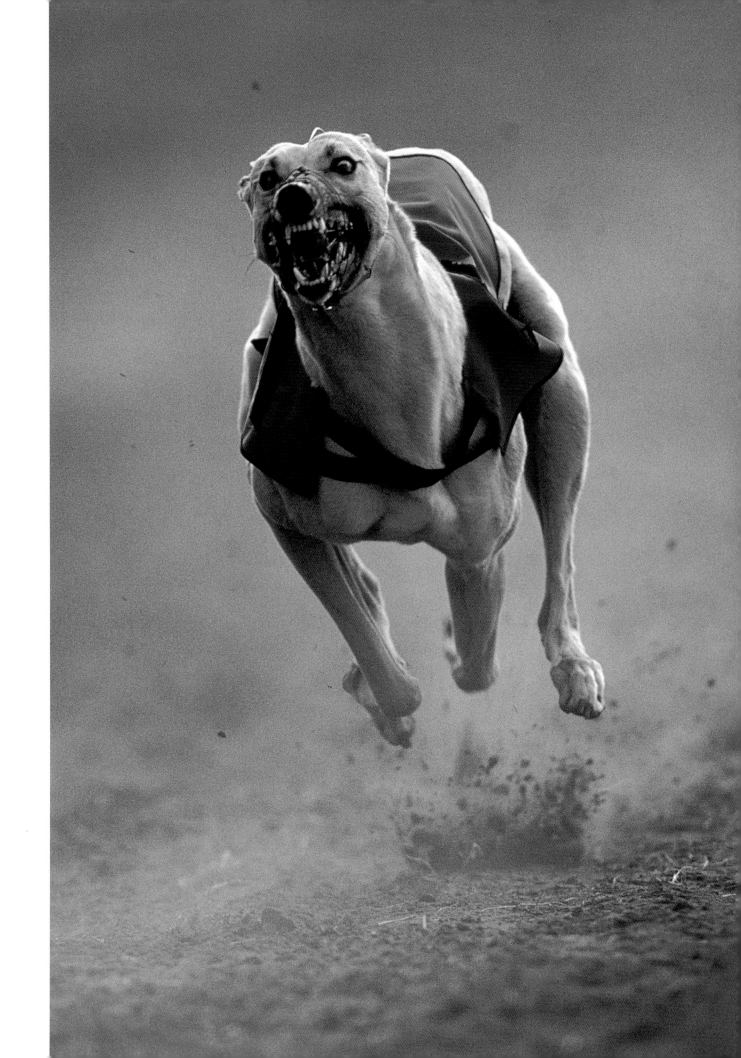

Alfred Preuss
Nature Revealed

'Photographing insects in the studio requires reserves of time and patience...'

Alfred Preuss, from the town of Lohr in Germany, began specializing in insect photography in 1989 and now produces beautiful macro shots, full of color and intricate detail. For field work, he has refined his lighting techniques, reducing the intensity of the flash to prevent the background from being underexposed and appearing dark.

Like many of his peers, Preuss has strong views on the ethics of nature photography. He believes in creating natural-looking shots in keeping with his subjects. 'I always use flowers and leaves that are appropriate to the natural habitat of the insect'.

Above all, Preuss avoids anything that will harm his subjects. He never puts insects in the freezer to slow down their metabolism and make them easier to photograph. If a beetle won't keep still, he inverts a glass over it. 'The beetle will run around in circles until it gets tired or perhaps gets used to its new circumstances. I set up my shot, focusing through the glass, and then gently lift off the glass to get my shot. This nearly always works and does no damage to the insect.'

Although he breeds butterflies in his own insectarium, so that he can photograph them as soon as they emerge from the chrysalis when the wings are perfect and the colors are at their most intense, he always tries to release the butterflies near where he found the caterpillar.

Combining an intimate knowledge of his subjects, technical expertise, and the eye of an artist, Alfred Preuss's photographs offer a fascinating insight into the beauty and diversity of the insect kingdom.

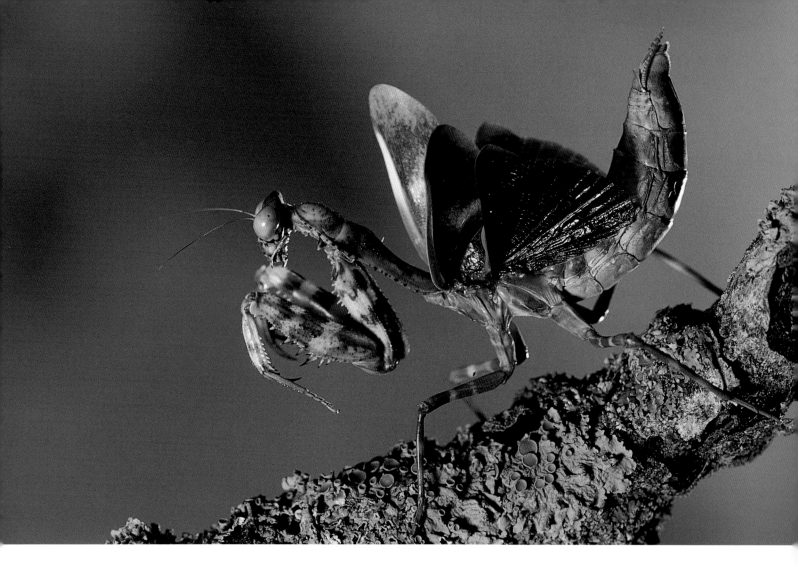

(Below) The *Pseudocrebotra wahlbergii* is a leaf-imatator found throughout East Africa. To get this shot, I had to irritate the male to the point where he adopted this aggressive position. This is quite difficult to achieve with a mantis bred in captivity, as they are used to human beings and don't seem to see their keepers as a threat.
Minolta Dynax 7, Minolta AF 200mm f/4 macro lens, Fuji Velvia

(Above) This mantis (*Parasphendale affinis*) is found in East Africa. The picture shows a female which, despite being left in the insectarium, was very irritable. I shot two rolls of film of her various threatening gestures.
Minolta Dynax 7, Minolta AF 200mm f/4 macro lens, Fuji Velvia

(Right) This dragonfly (*Pyrrhosoma nymphula*) is one of the earliest European species to leave the water in which it has over-wintered. This shot was taken on my garden pond. As soon as the dragonfly begins to feed, its color changes to red.
Minolta Dynax 700si, Minolta AF 100mm f/2.8 macro lens, Fuji Velvia

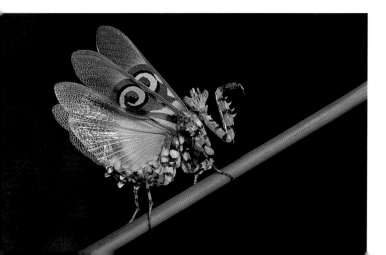

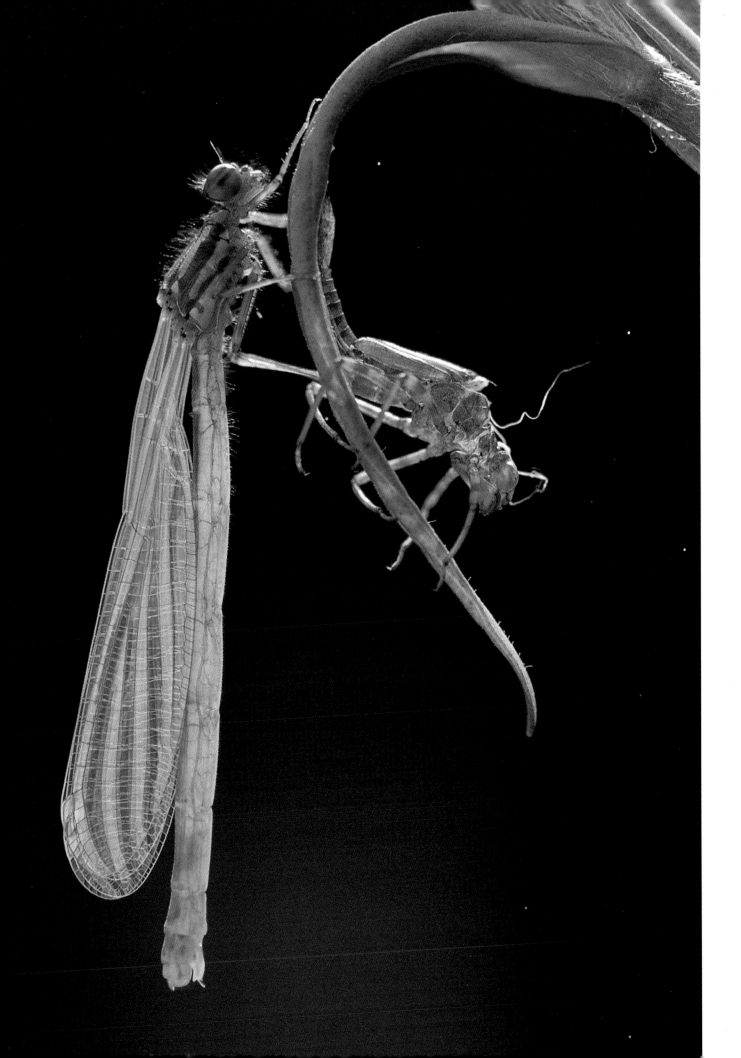

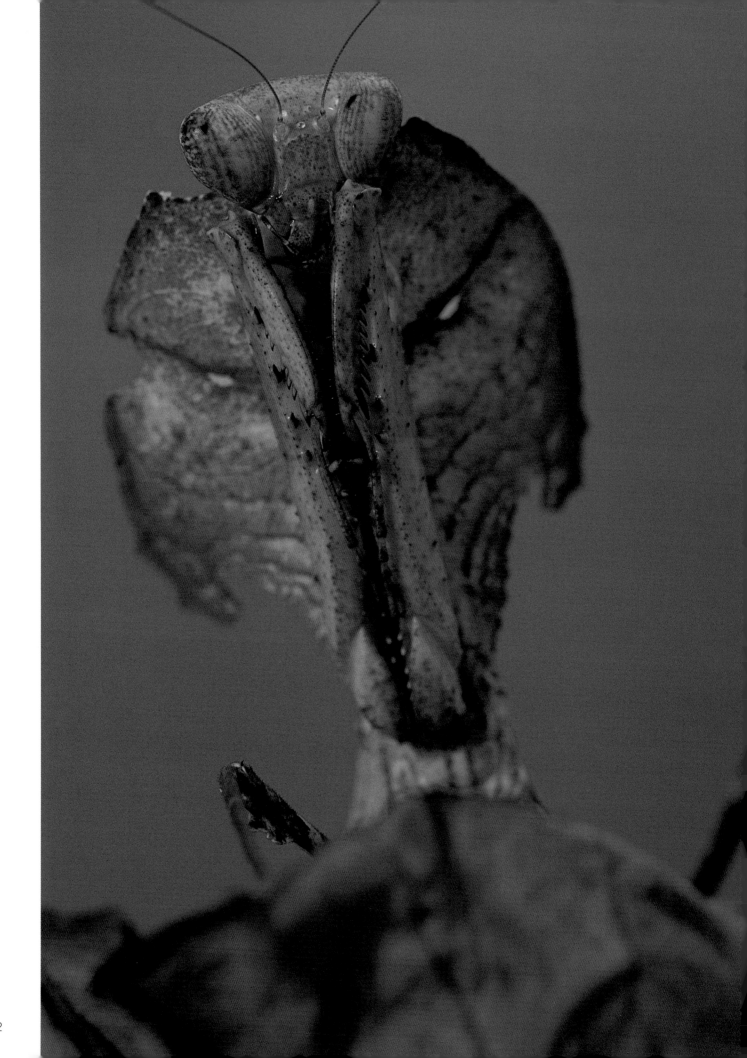

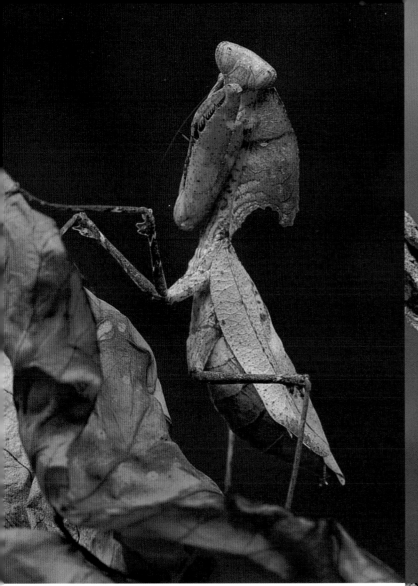

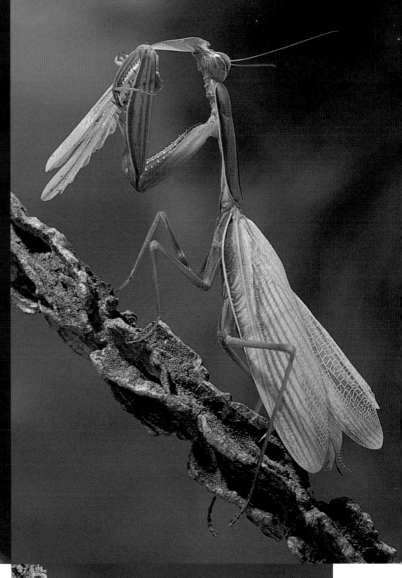

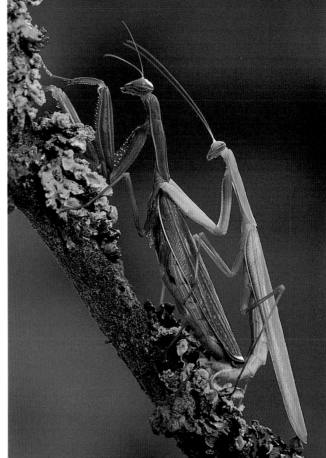

(Above and left) The praying mantis (*Deroplatys desiccata*) keeps completely still while waiting for prey, so there is time to experiment with the lighting and different viewpoints. Minolta Dynax 7, Minolta AF 200mm f/4 macro lens, Fuji Velvia

(Top right) A female *Mantis religiosa* eating a grasshopper. Minolta 7000 I, Sigma AF 180mm f/2.8 macro lens, Fuji Velvia

(Bottom right) *Mantis religiosa*, mating. I had to feed up the female in advance, to prevent her from eating the male! Minolta 7000 I, Sigma AF 180mm f/2.8 macro lens, Fuji Velvia

(Overleaf) I set up these beetles (*Eudicella gralli*) in the studio to photograph their territorial behaviour. Minolta Dynax 700si, Sigma AF 180mm f/2.8 macro lens, Fuji Velvia

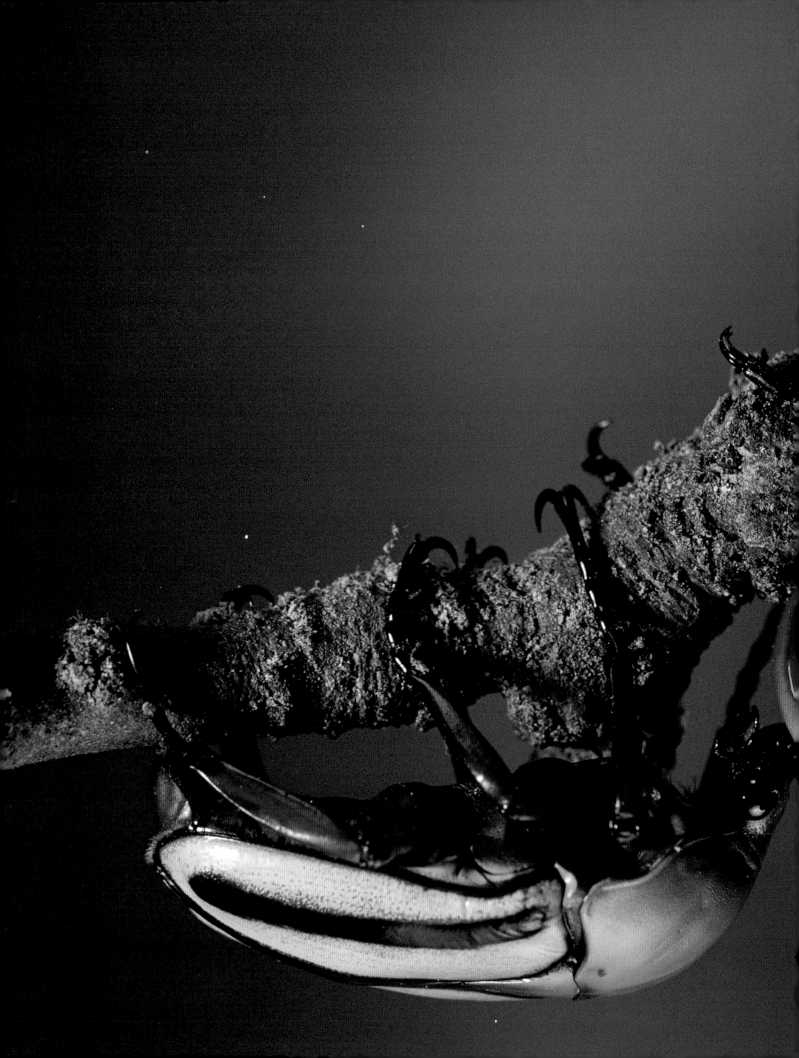

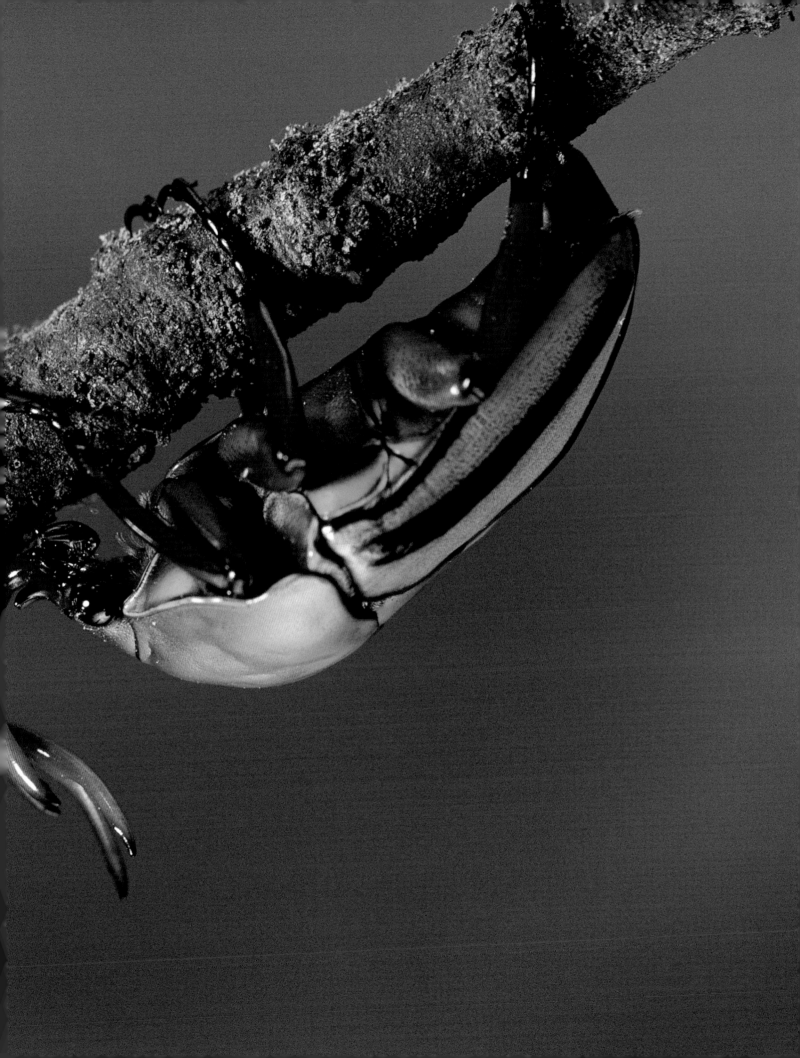

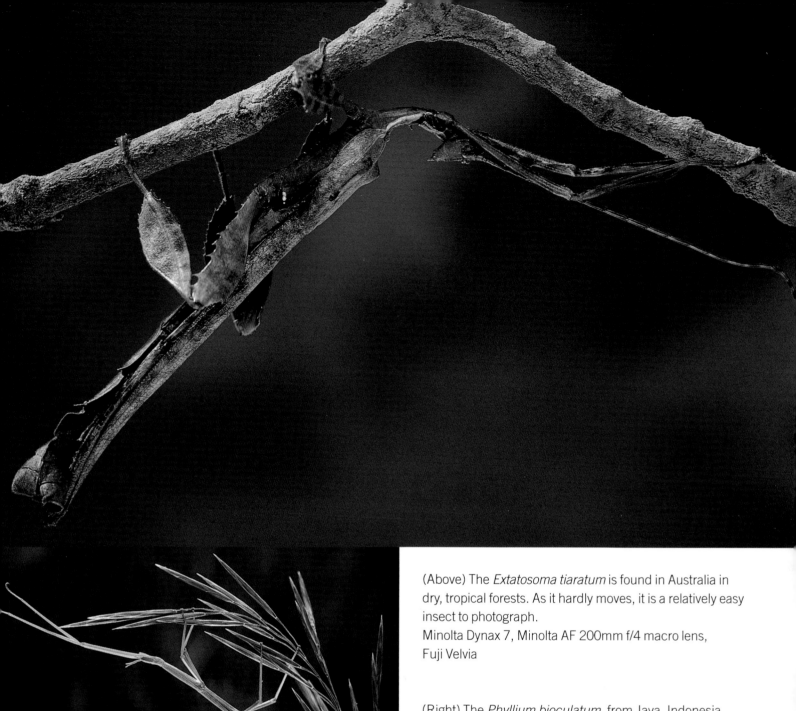

(Above) The *Extatosoma tiaratum* is found in Australia in dry, tropical forests. As it hardly moves, it is a relatively easy insect to photograph.
Minolta Dynax 7, Minolta AF 200mm f/4 macro lens, Fuji Velvia

(Right) The *Phyllium bioculatum*, from Java, Indonesia, has an astonishing camouflage, perfectly mimicking a leaf. It is so good that the insect is sometimes consumed by mistake by leaf-eating predators. For this shot, I photographed a young insect (its wings are not fully formed) using flash against a black cardboard background.
Minolta Dynax 700si, Sigma AF 180mm f/2.8 macro lens, Fuji Velvia

(Above) Although this *Bacillus rossii* is normally a tropical species, I came across it while on holiday in the Costa Brava and had to photograph it without using my usual flash equipment.
Minolta Dynax 700si, Minolta AF 200mm f/2.8 macro lens, Fuji Velvia

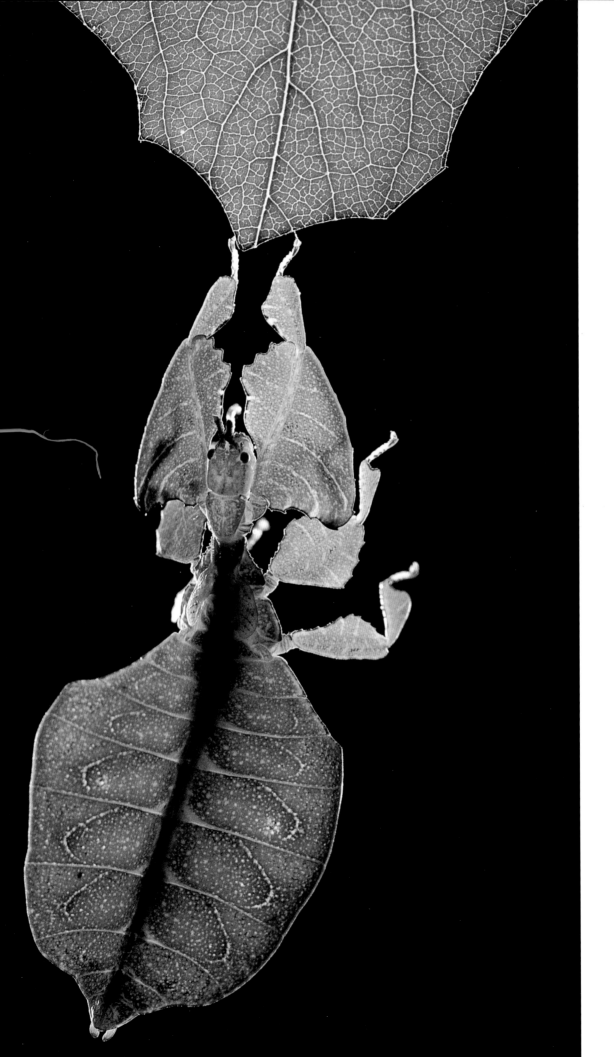

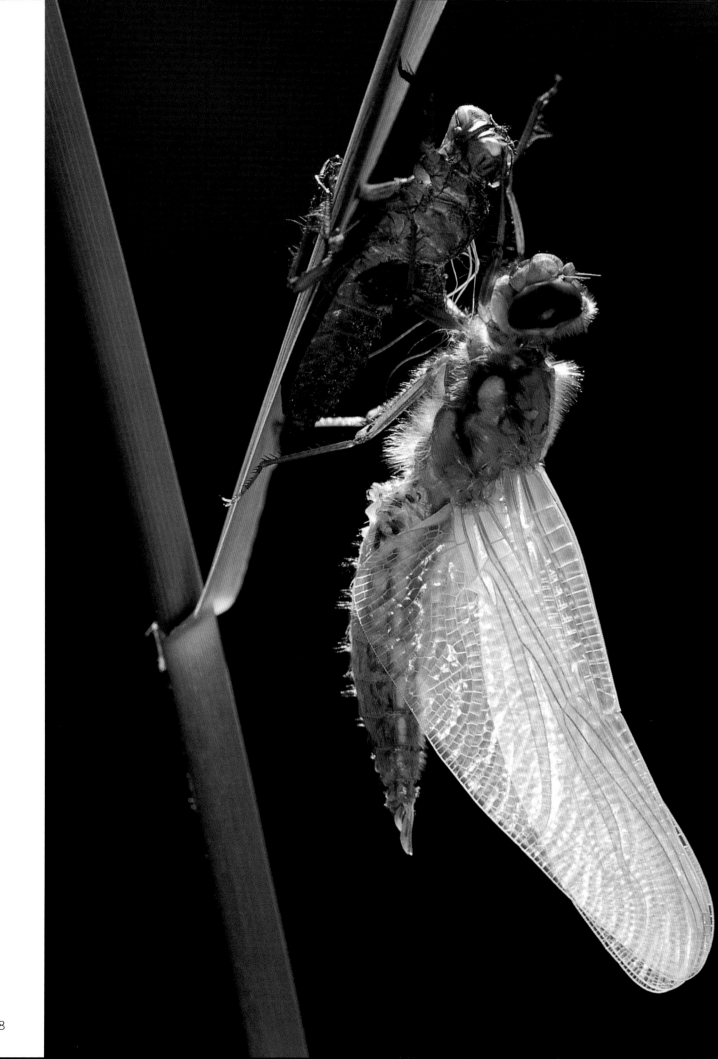

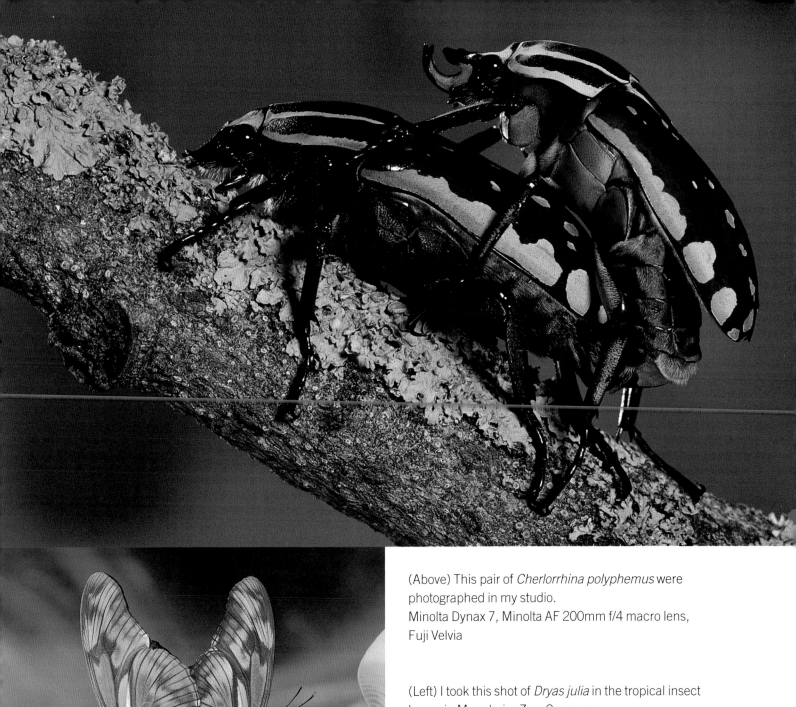

(Above) This pair of *Cherlorrhina polyphemus* were photographed in my studio.
Minolta Dynax 7, Minolta AF 200mm f/4 macro lens, Fuji Velvia

(Left) I took this shot of *Dryas julia* in the tropical insect house in Mannheim Zoo, Germany.
Minolta Dynax 7, Minolta AF 200mm f/4 macro lens, Fuji Velvia

(Overleaf) The *Hyles euphorbiae* caterpillar lives on the poisonous *Euphorbia* plant. It only turns red at a late stage, but is ignored as food by birds as it is itself poisonous.
Minolta Dynax 700si, Minolta AF 100mm f/2.8 macro lens, Fuji Velvia

(Left) I get six species of dragonfly on my garden pond. On a good day there might be ten insects slipping out of their chrysalis at any one time. I like to photograph against the light, using a white cardboard reflector to light the subject.
Minolta Dynax 700si, Minolta AF 100mm f/2.8 macro lens, Fuji Velvia

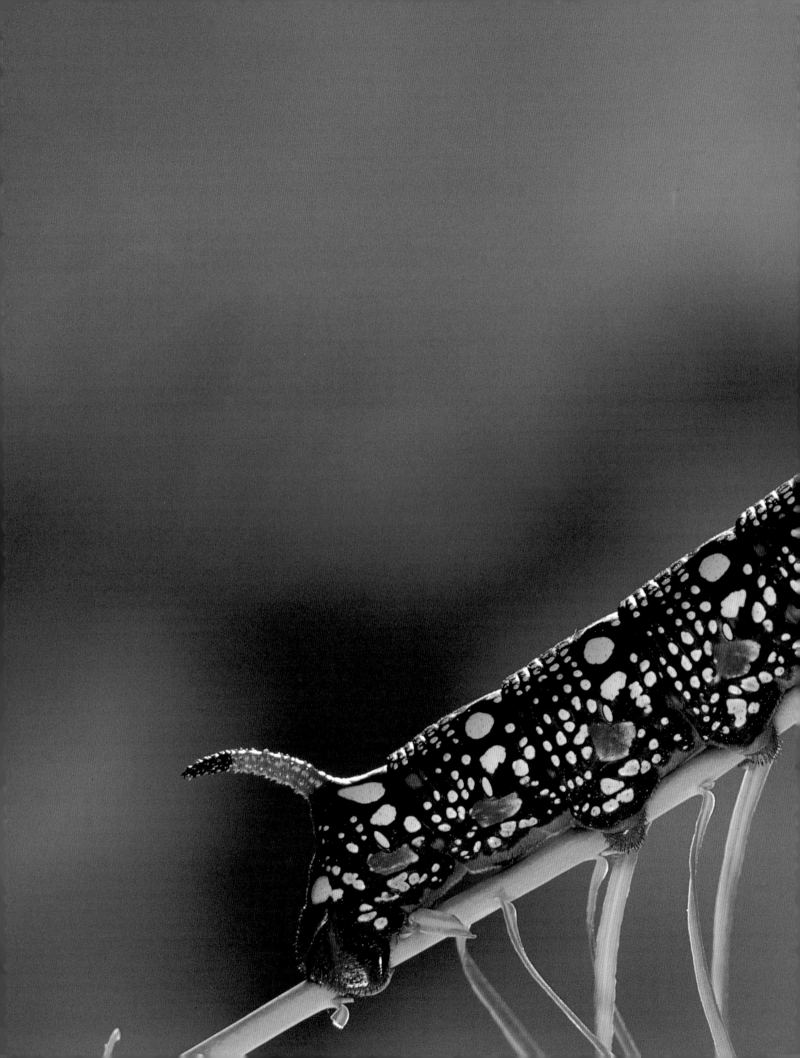

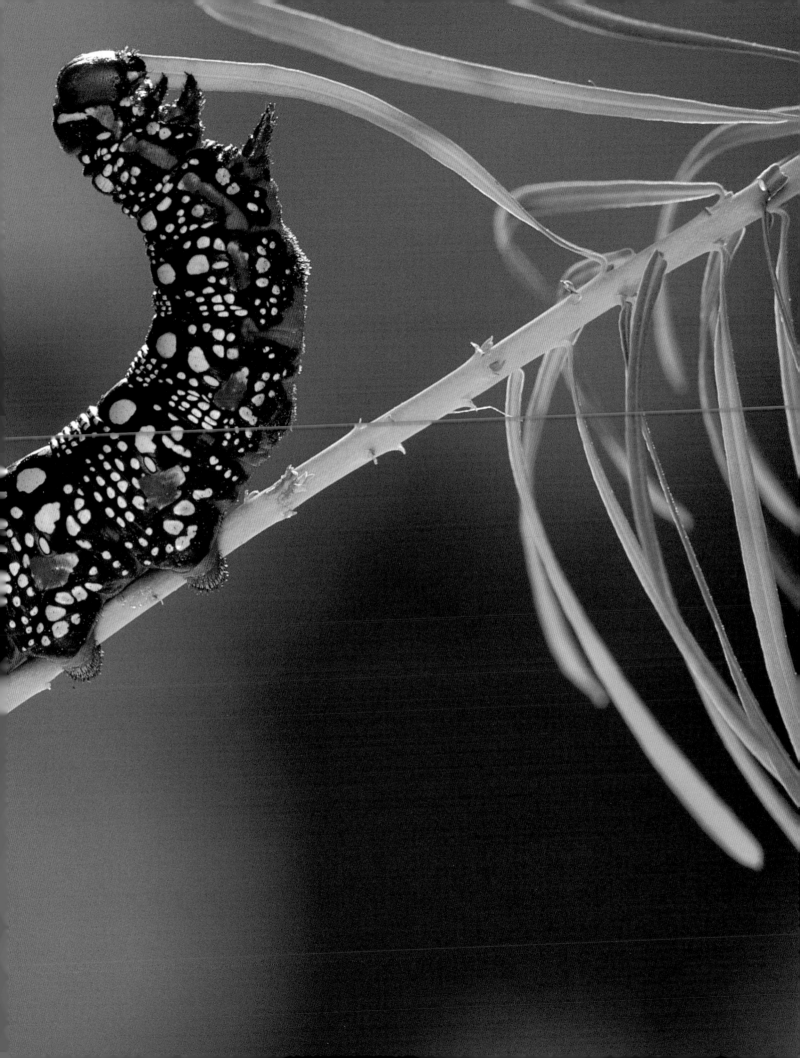

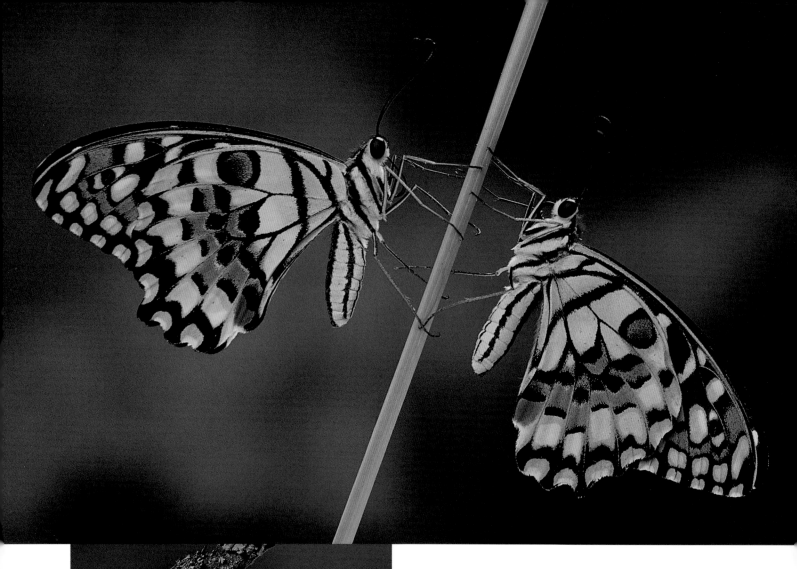

(Above) The caterpillar of this *Papilio demoleus* butterfly lives on citrus leaves in India and Australasia.
Minolta Dynax 7, Minolta AF 200mm f/4 macro lens, Fuji Velvia

(Left) The *Cethosia biblis* is found from northern India to China, Indonesia and the Philippines.
Minolta Dynax 7, Minolta AF 200mm f/4 macro lens, Fuji Velvia

(Right) *Limenitis camilla*; the caterpillars live on honeysuckle leaves.
Minolta Dynax 700si, Sigma AF 180mm f/2.8 macro lens, Fuji Velvia

(Overleaf) *Tabanus bovinus*. This insect tried to sting me. I hit out at it; as it lay there stunned, I noticed the rainbow colors of the eyes and photographed it at twice life size.
Minolta Dynax 700si, Minolta AF 100mm f/2.8 macro lens with x2 converter, Fuji Velvia

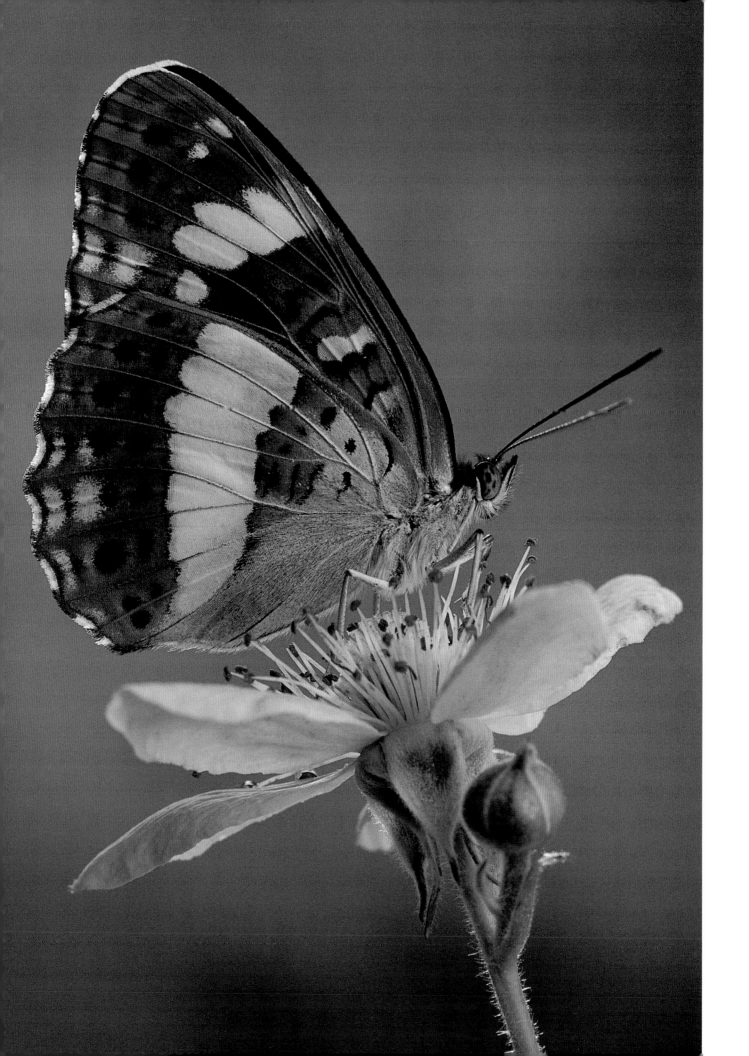

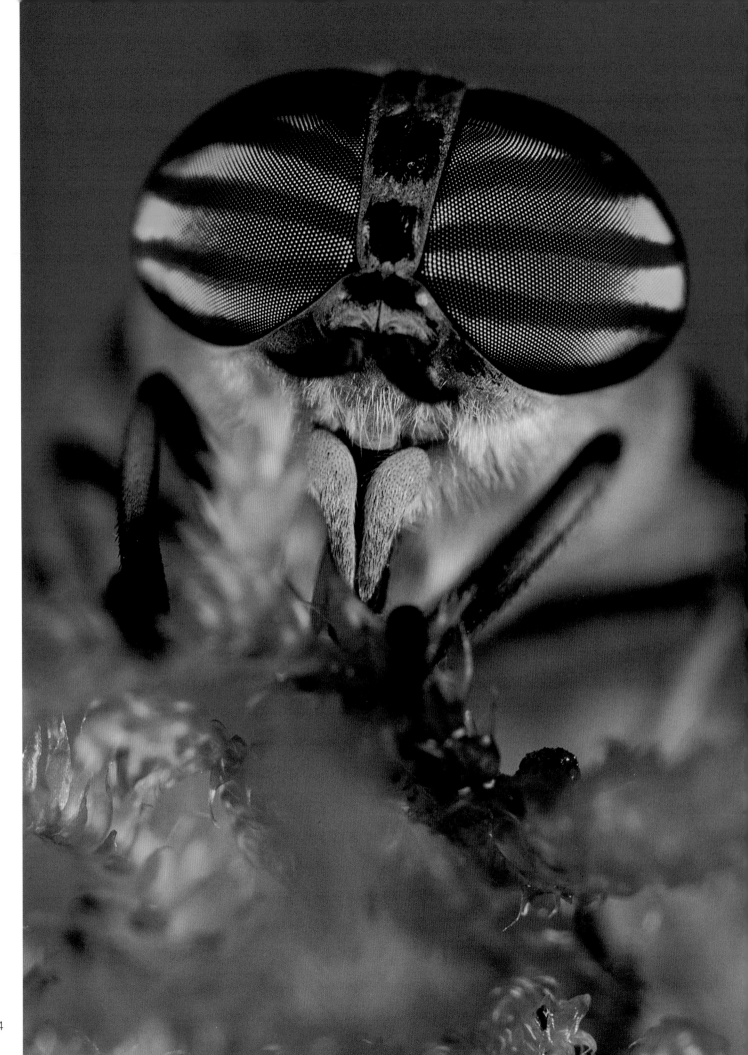

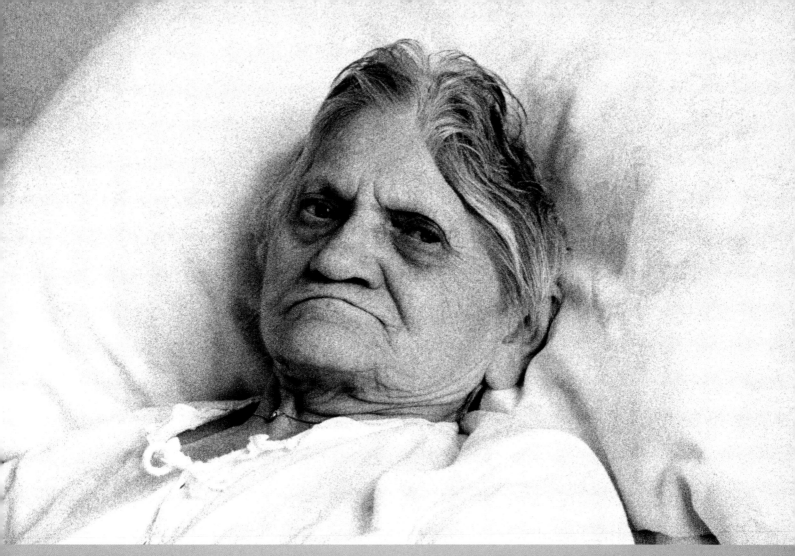

Emotions
Feelings, sensations, moods

Photography is unique among art forms in being able to capture fleeting expressions and convey the emotion of the moment as it occurs. Sometimes the feelings it captures are so raw and painful that they sear themselves into the mind of the viewer for ever more: no one who has seen them will ever forget George Rodgers's shots of the liberation of Belsen, or Nick Ut's harrowing photograph of a terrified young Vietnamese girl, hit by napalm, running down a dusty track towards the camera. And the images that flashed around the world on September 11, 2001, are all the more haunting for the way they captured the reactions of New Yorkers as the tragedy unfolded.

At the other extreme, of course, photographs can capture moments of tenderness and intimacy (think of Robert Doisneau's photographs of young Parisian lovers embracing), joy, or sheer exuberance.

But whatever the emotion being conveyed, the one thing that successful photographs have in common in the photographer's 'seeing eye', his or her ability to pick up on feelings and react almost instinctively to capture the moment on film. The photographs in this section, which cover the full gamut of human emotion, are a testament to that ability.

(Above) Ilona Feher/Germany
I was visiting my mother in an old people's home in Berlin; she was clearly not happy and glowered at me as I photographed her.
I developed the picture in Agfa Rodinal, enlarged it on Agfa MCP 310, and finished it off with a selenium toner.

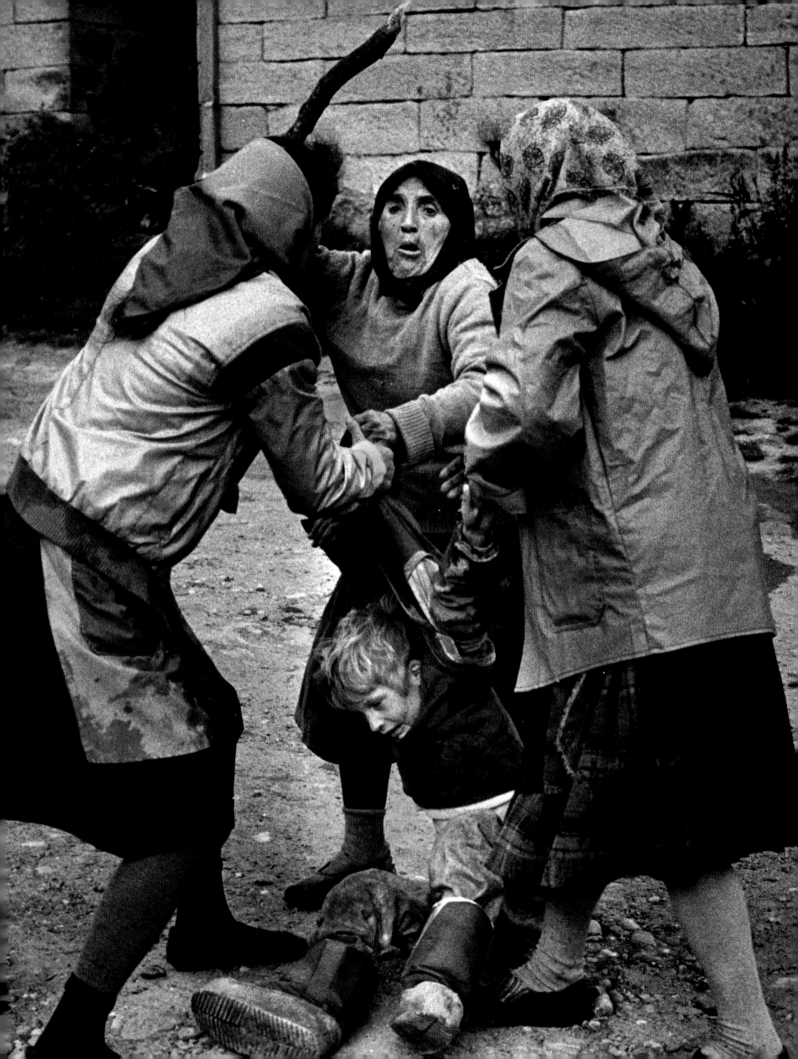

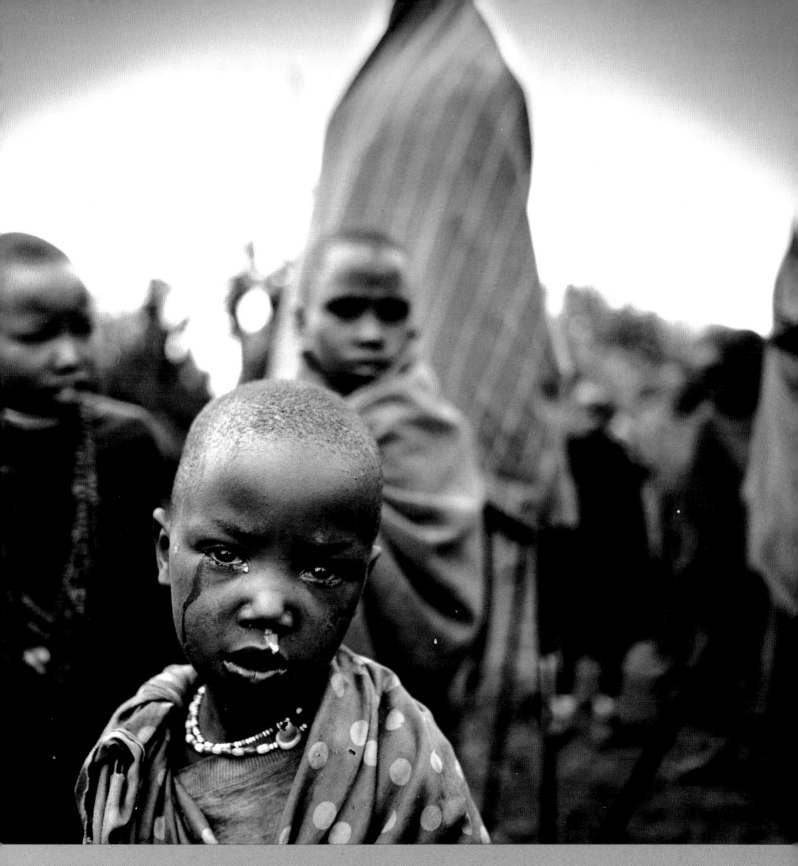

(Left) Dragan Ilic/former Yugoslavia
In the Serbian village of Vidrovac, an old woman tries to defend her grandson, a victim of ethnic violence. I had to react quickly, and the picture is probably stronger as a record of feeling than as a technically perfect composition.
Nikon F3, Nikon 50mm, Ilford HP5

(Above) Jesus Jaime Mota/Spain
This is one of a series of shots that I took in different Masai villages. Among the Masai, only girls cry; boys are brought up to be tough. To see this boy breaking the taboo was an emotional moment worth capturing.
Pentax 67, Pentax 135mm, Ilford FP4 Plus

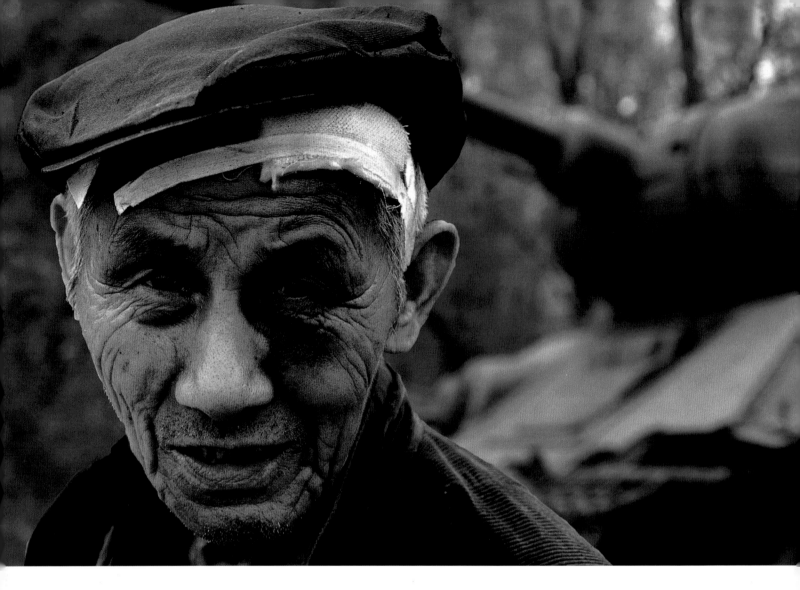

(Above) Dr Wolfgang Laimer/Austria
I was travelling in China and came across this man by the River Li. He had clearly been beaten, but didn't object to my photographing him. His gaze and the helpless silent accusation in his expression moved me deeply.
Canon EOS 3, Canon 35–50mm, Fuji Sensia

(Top right) Sayyed Nayyer Reze/Pakistan
This old lady is our neighbour in Lahore, Pakistan. Almost every day she comes to our house and spends time with my small daughter. I saw them playing in the garden like two small children and took this picture. My motor drive gave me three shots per second, and one of them turned out to be perfect.
Nikon F4s, Nikkor 35–105mm, Ruji Reala 100

(Bottom right) Manfred Kriegelstein/Germany
I looked down from a pedestrian bridge in Berlin's Bauhaus Museum and saw these two punks kissing. With a bit of direction from me, they adjusted their position a little – and I got my picture. Their embrace, forming a circle, emphasizes both their self-contained independence and their position as outsiders in society.
Leica R4, 100mm, Kodachrome 64

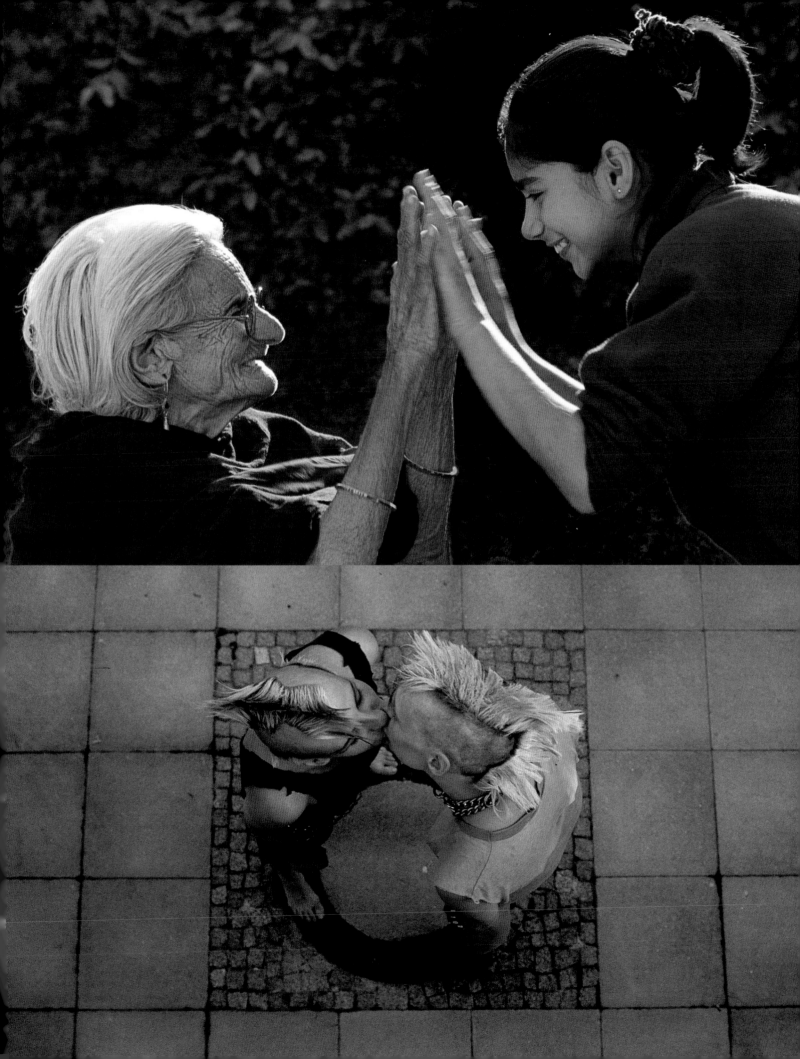

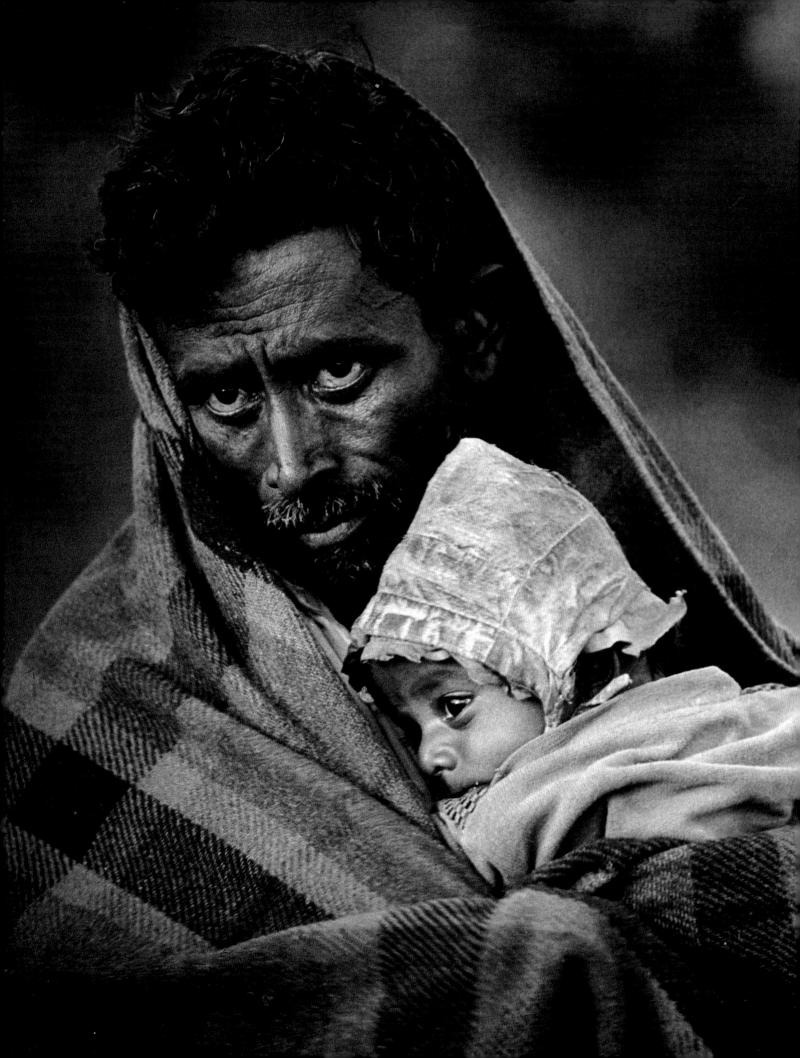

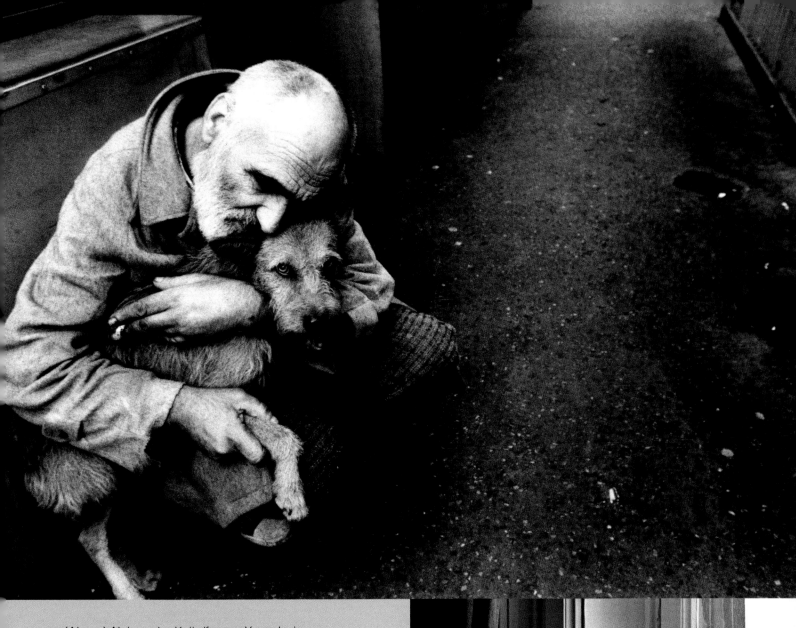

(Above) Aleksandar Kelic/former Yugoslavia
I saw this old man and his dog in the marketplace in
Belgrade. The love between man and beast was so strong
that I had to shoot a few quick frames. With snapshots, a
good result is due as much to luck as to skill!
Nikon F3, Nikon 24mm, Fomapan 400

(Left) B.S. Sundaram/India

(Right) Istvan Toth/Hungary
For thirty years I have documented the lives of
contemporary Hungarian artists, photographing them in
their studios and homes. Most of them can barely survive
through their art alone. This old man in his tiny flat was also
lonely and, as the pigeon settled on the window ledge, it
seemed the right moment to take the picture.

(Overleaf) Mohammed Eslami Rad/Iran

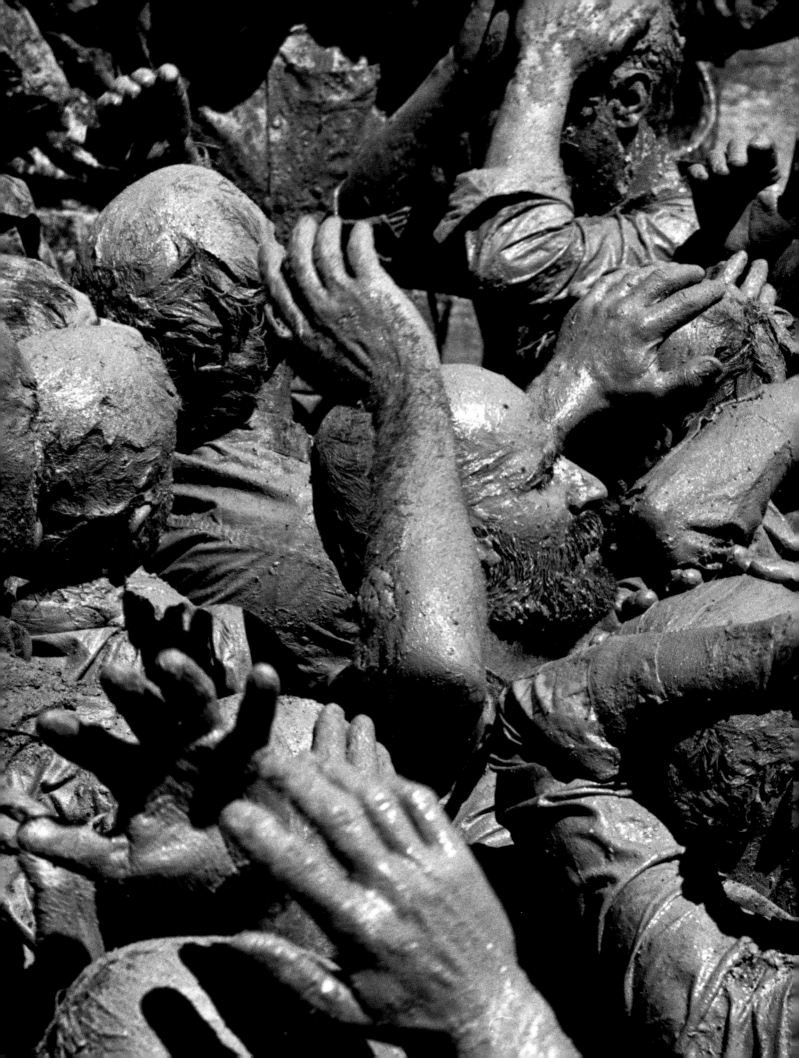

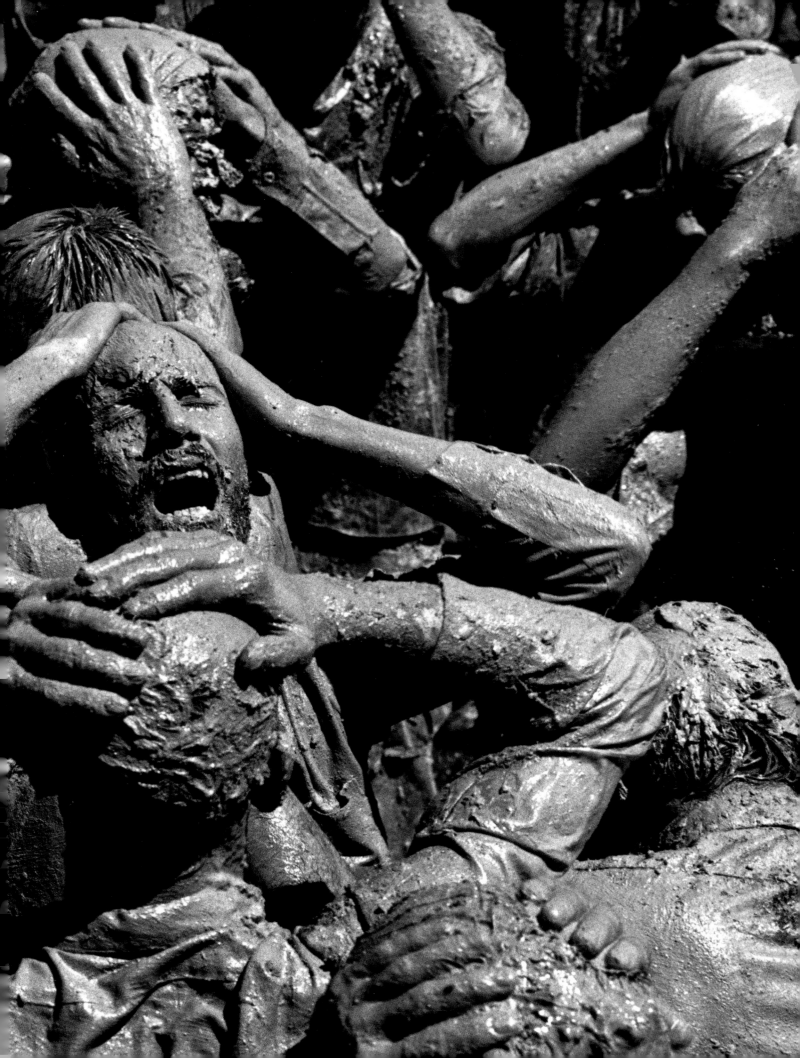

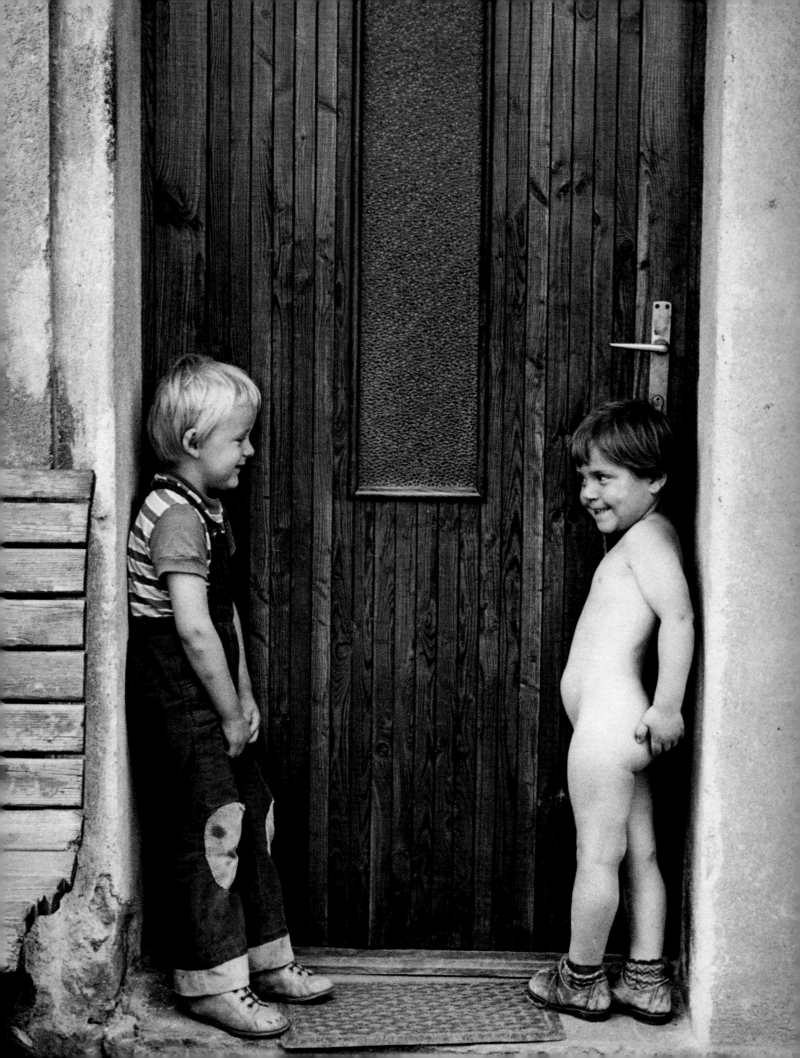

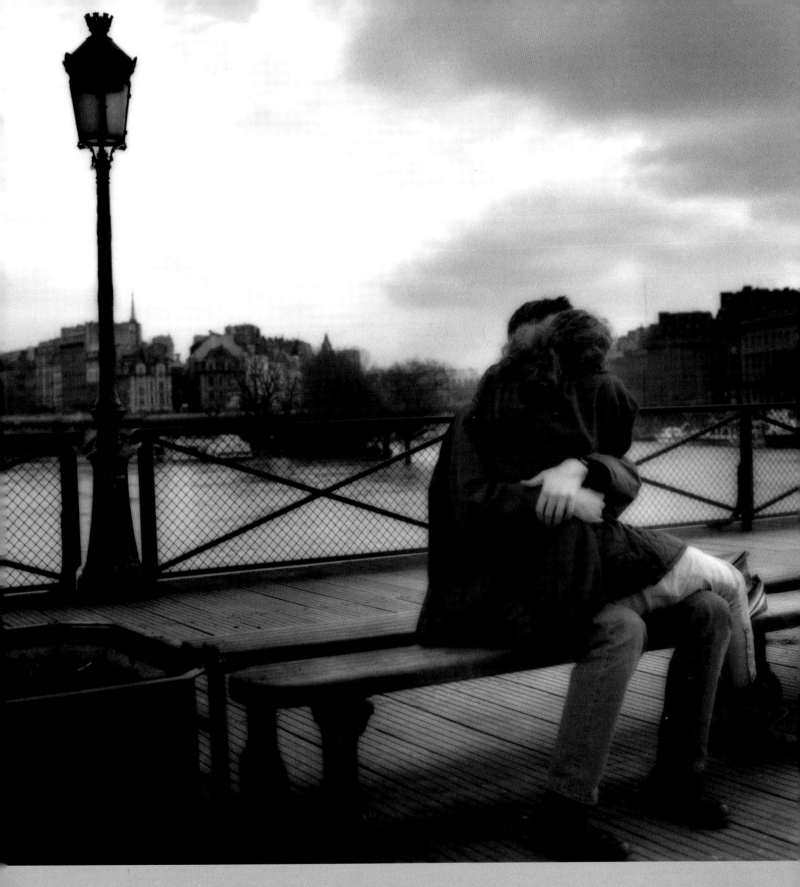

(Left) L.B. Feresovi/Czech Republic
The two children were in a doorway in Prague. It was
summer and they were learning to flirt. The girl's look was
pure Hollywood and she was quite unaware of its effect on
the boy, falling in love for the first time, and on me.
A successful snapshot.

(Above) René Thirion/Belgium

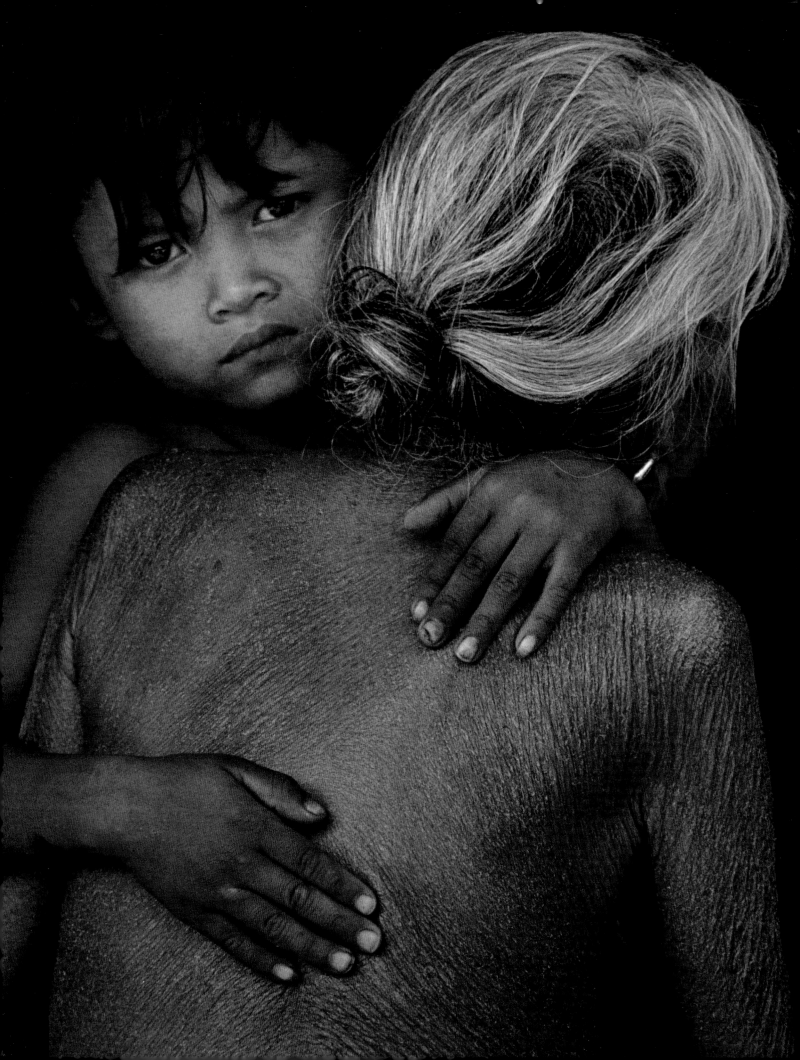

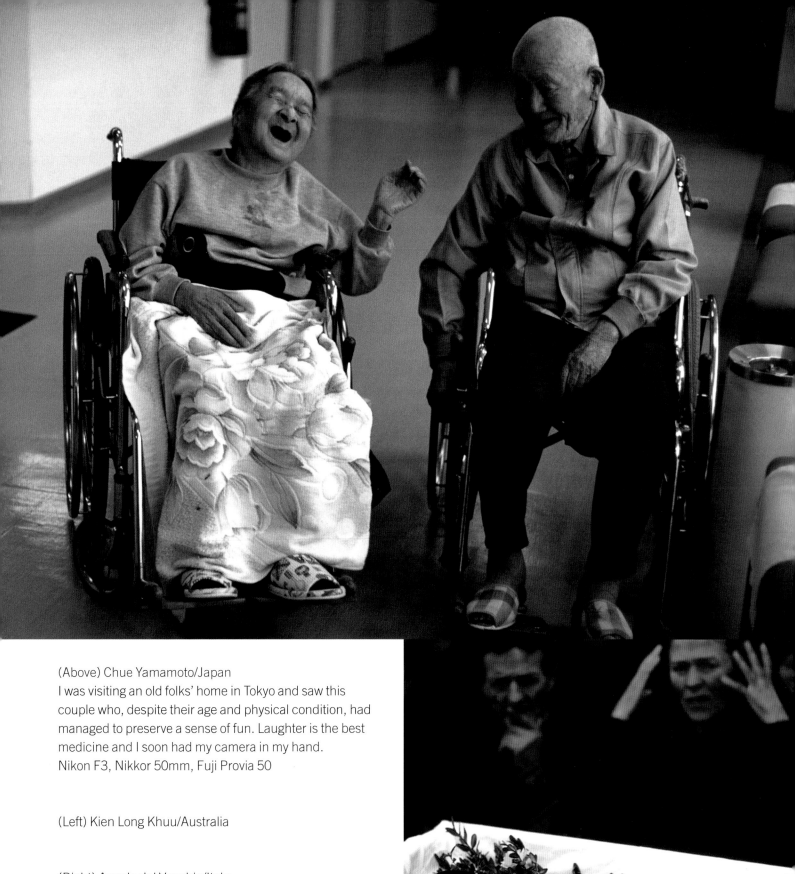

(Above) Chue Yamamoto/Japan
I was visiting an old folks' home in Tokyo and saw this couple who, despite their age and physical condition, had managed to preserve a sense of fun. Laughter is the best medicine and I soon had my camera in my hand.
Nikon F3, Nikkor 50mm, Fuji Provia 50

(Left) Kien Long Khuu/Australia

(Right) Angelo del Vecchio/Italy
The subject of death is one of our society's taboos and it's therefore rare to see photographs of moments of private mourning. Despite this, I took my courage in my hands at this burial in southern Italy. I tried not to be intrusive and was looking not to be gratuitously shocking, but rather to capture the outpourings of grief in the presence of death.

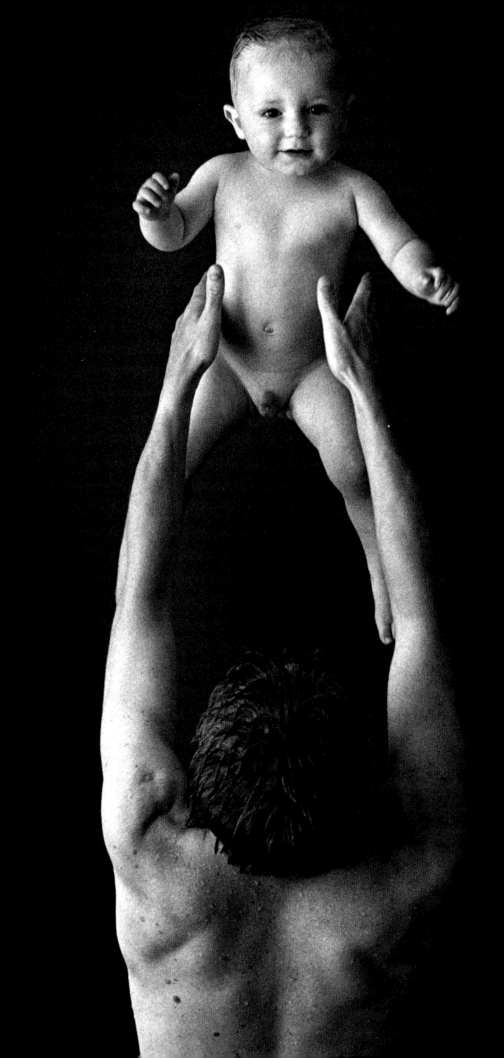

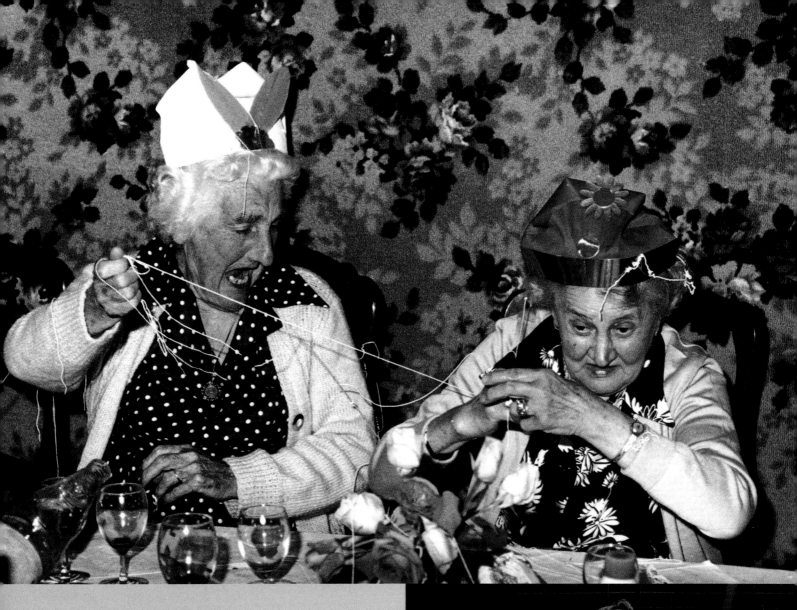

(Above) Marcel Bouvet/France
Who says that wedding photos have to be predictable shots of the happy couple? I like to keep an eye on what is going on all around and get most of my best pictures this way.
Nikon 801S, Nikon 24–120mm, Ilford FP4

(Left) Manfred Zweimüller/Austria
I set up this shot of my son and me, but my wife released the shutter. Photography can communicate feelings to other people with tremendous immediacy.
Canon T90, Canon 50mm, Ilford Delta 400

(Overleaf) Gabriele Rigon/Italy
Re-creating passion in a photograph is not easy, particularly when – as here – it is staged. I deliberately overexposed the pictured and continued overexposure at the printing stage to create a tender, high-key image.
Leica M6, 50mm, Kodak T-Max 400

(Above) Jan Hendrik van der Veen/Netherlands
First impressions can deceive: this is not a group of ecstatic winners at the horseraces, but a group of actors playing ecstatic winners. But they did it so well...
Nikon F90, Nikon 80–200mm, Kodak T-Max

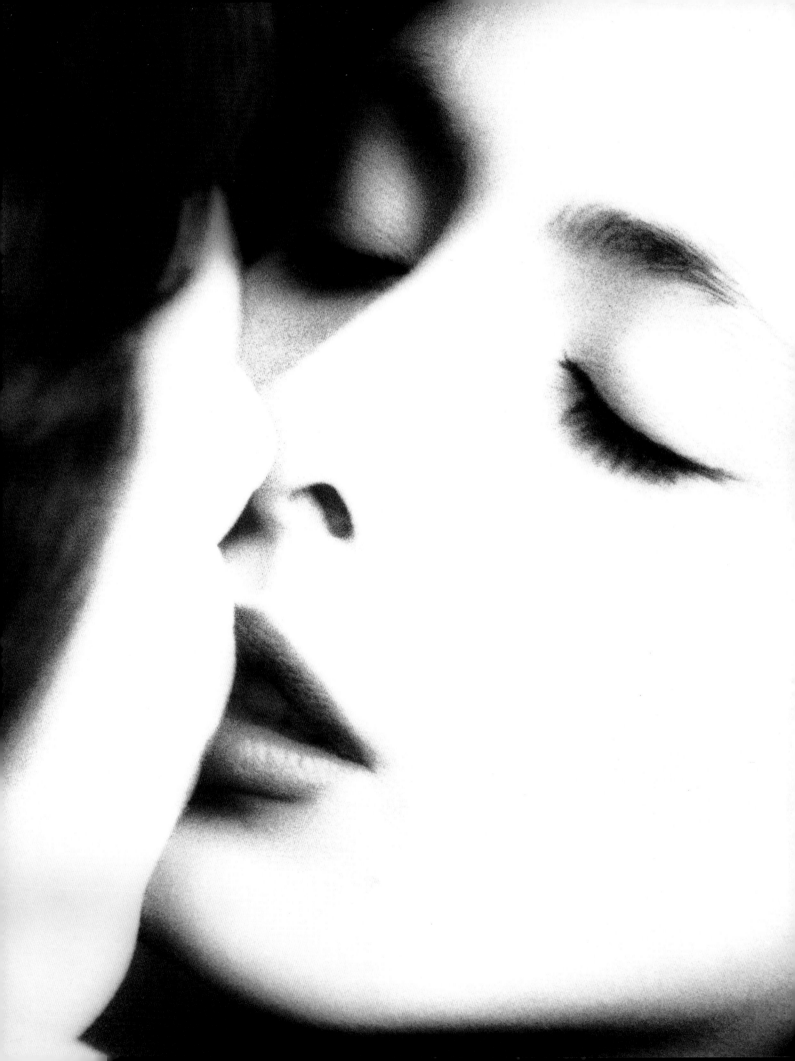

Malcolm Hey
Under the Surface

'... the beauty and magic of the wonderland under the sea's surface is worth all the trouble.'

Malcolm Hey lives in North Yorkshire, England. Although he did not learn to swim until he was 23 years old, or to scuba dive until he was in his early forties, Hey is now a leading underwater photographer with many international awards to his credit.

He uses Nikon F90X camera bodies; a selection of Nikon lenses – 16mm fisheye, 18–35mm zoom, 28–70mm zoom, 60mm macro and 105mm macro, and occasionally a teleconverter added to the 105mm lens; Subal housings for the cameras; twin flashguns – amphibious Sea & Sea YS120 and a pair of Sea & Sea YS90. Nearly all his photographs are taken using Fuji Velvia film.

Hey is often asked by land photographers what the differences are between underwater and land photography techniques. 'Air is relatively clear,' he says, 'so I could take a photograph of, say, a bird or animal at a distance of 10m, or maybe even 400m by using a telephoto lens. Sea water contains plankton and sediment, and if there is any between the lens and my subject it will interfere with the image, so I must get as close as I can. Most of my macro photographs are taken with lens-to-subject distances of 15–25 cm (6–10 in).

'Water movement is perhaps the greatest difficulty I experience. Even "still" water is constantly on the move. There is no way of getting a stable footing; we must not damage the reef. Tripods are impractical under water and cable releases cannot be used. With depth of field down to just a few millimetres (a fraction of an inch), inevitably I am often unable to hold the subject in focus. And of course I cannot change my film, or the lens, under water!

'Color is absorbed by water, so as one descends not only does it get darker but the colors are lost – reds first, then through the range of the spectrum to blue. Hence flash must be used to restore the colors. Only the blue of the sea water is captured without flash.'

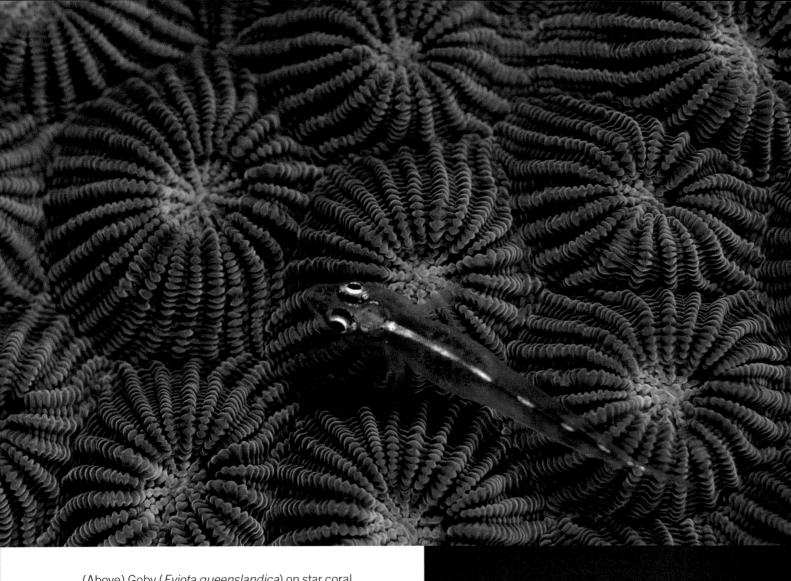

(Above) Goby (*Eviota queenslandica*) on star coral, Manado, North Sulawesi, Indonesia.

(Right) Green turtle (*Chelonia mydas*), Sipadan, Sabah, Borneo (Malaysia)

(Far right) Emperor shrimp (*Periclimenes imperator*) on Spanish dancer nudibranch (*Hexabrancus sanguineus*), Manado, North Sulawesi, Indonesia

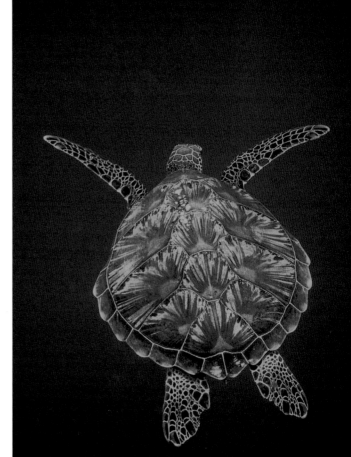

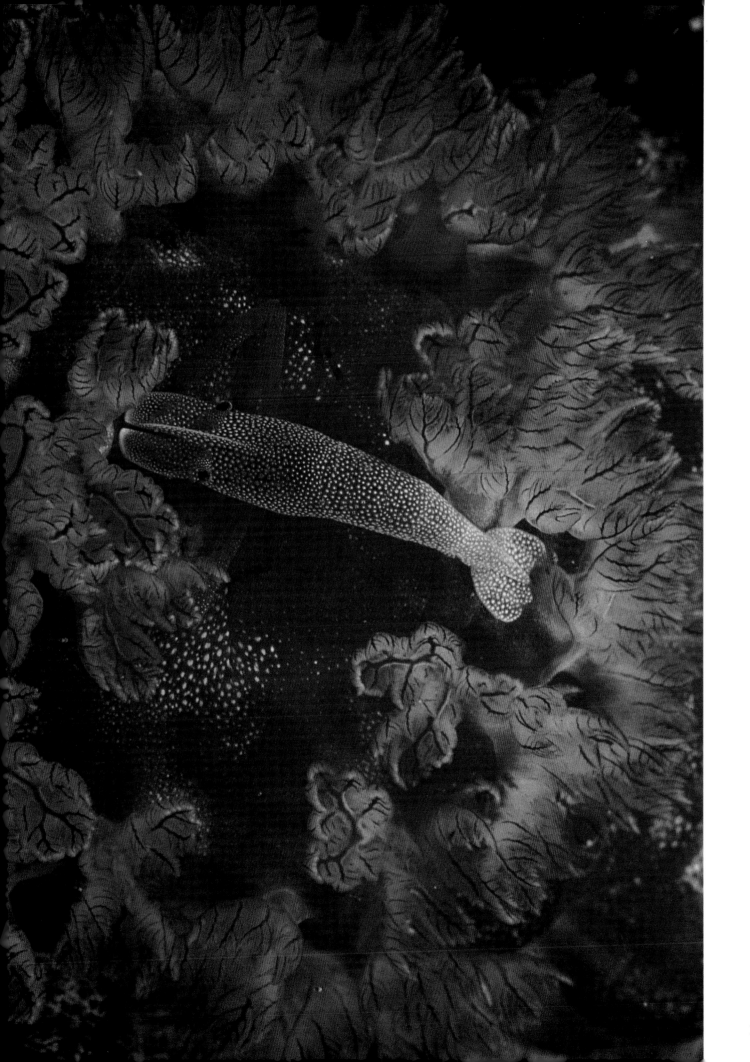

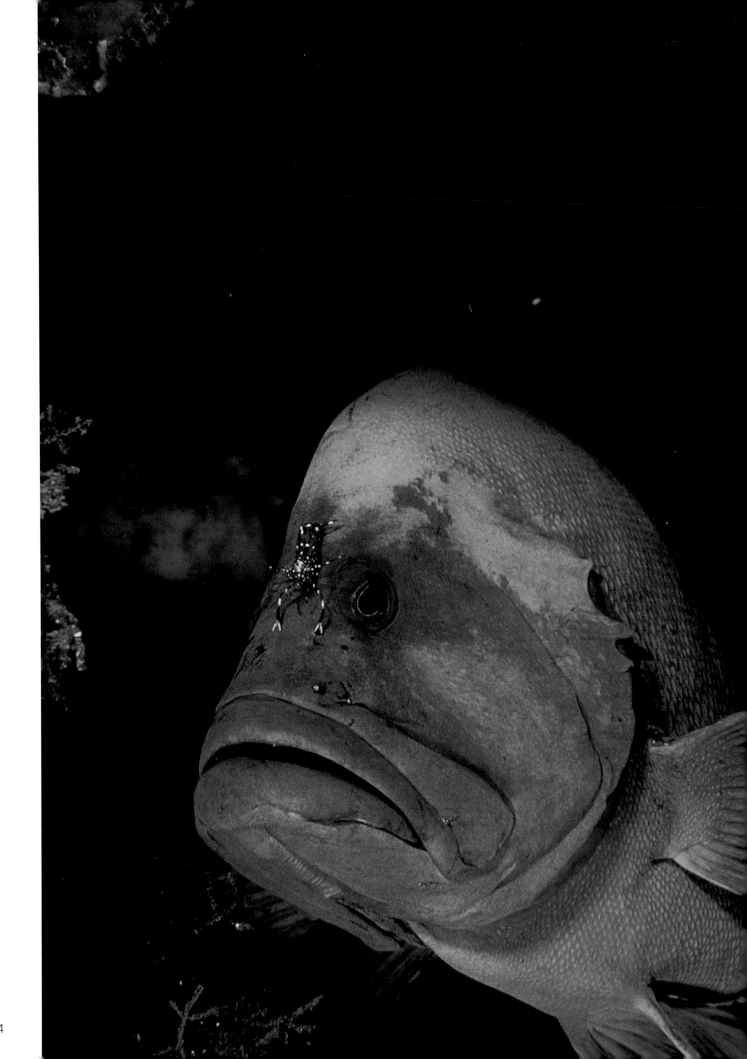

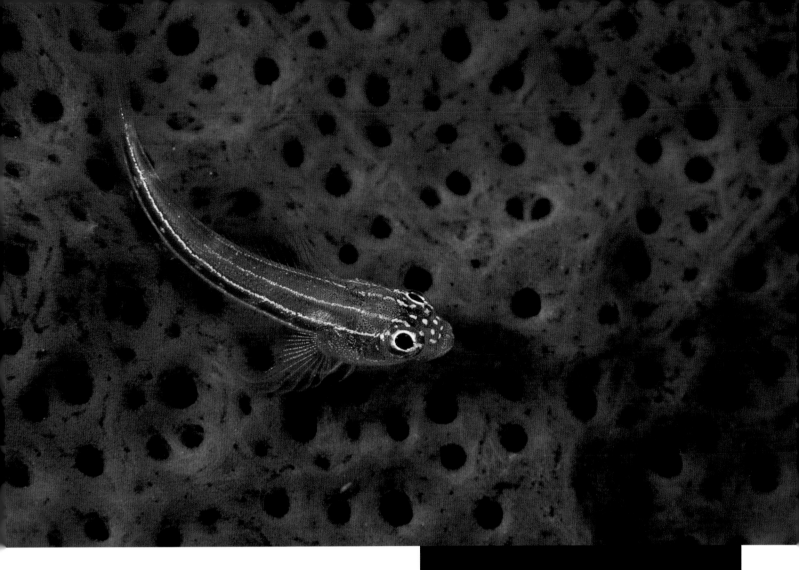

(Above) Neon triplefin (*Helcogramma striata*)
on sponge, Manado, North Sulawesi, Indonesia

(Left) Redmouth grouper (*Aethaloperca rogaa*)
carrying shrimp, Bali, Indonesia

(Right) Giant frogfish (*Antennarius commerson*),
Lembeh Strait, North Sulawesi, Indonesia

(Overleaf) False clown anemonefish
(*Amphiprion ocellaris*) in host anemone, Lembeh Strait,
North Sulawesi, Indonesia

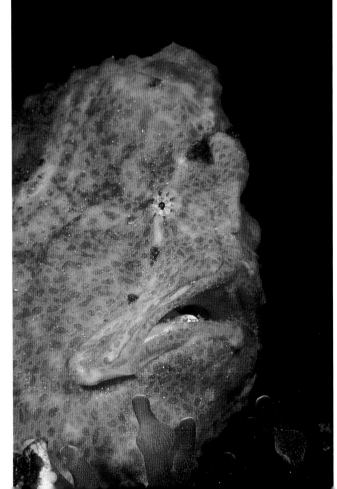

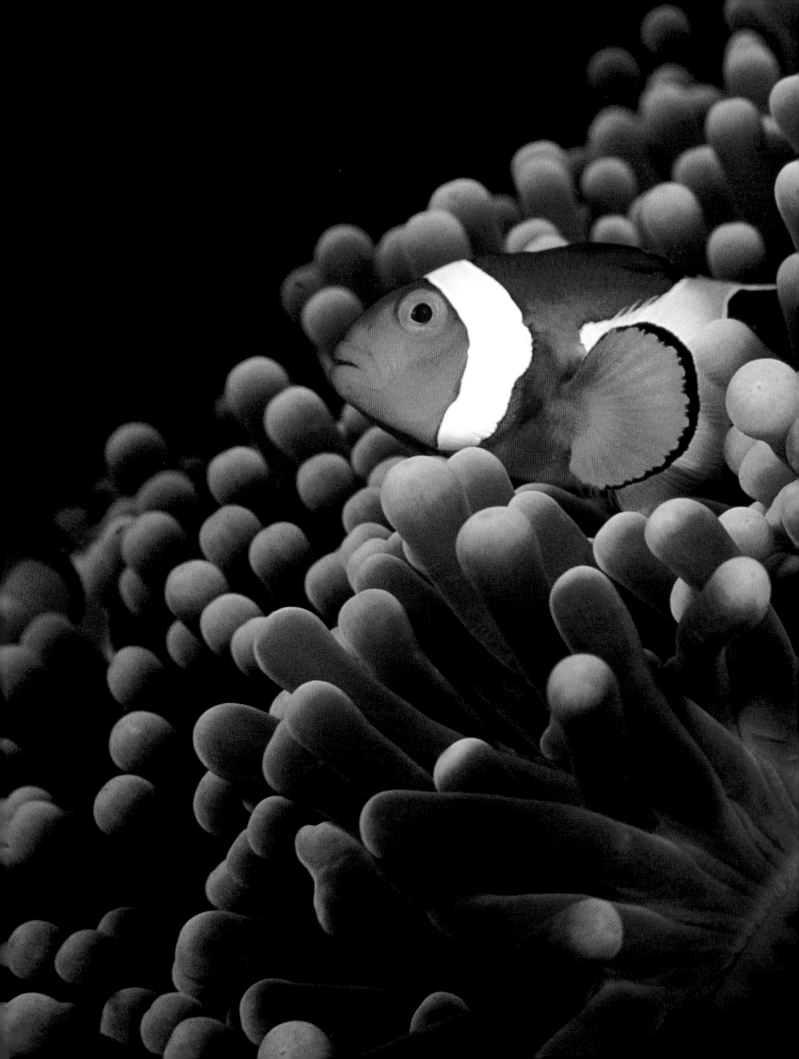

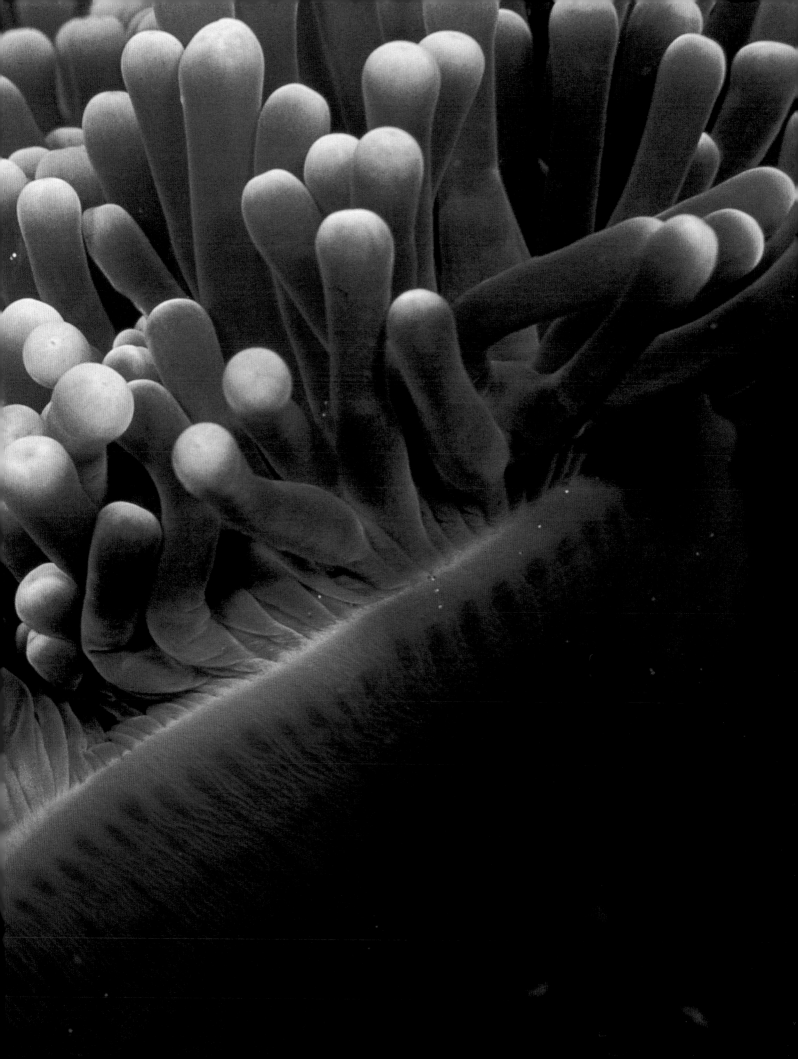

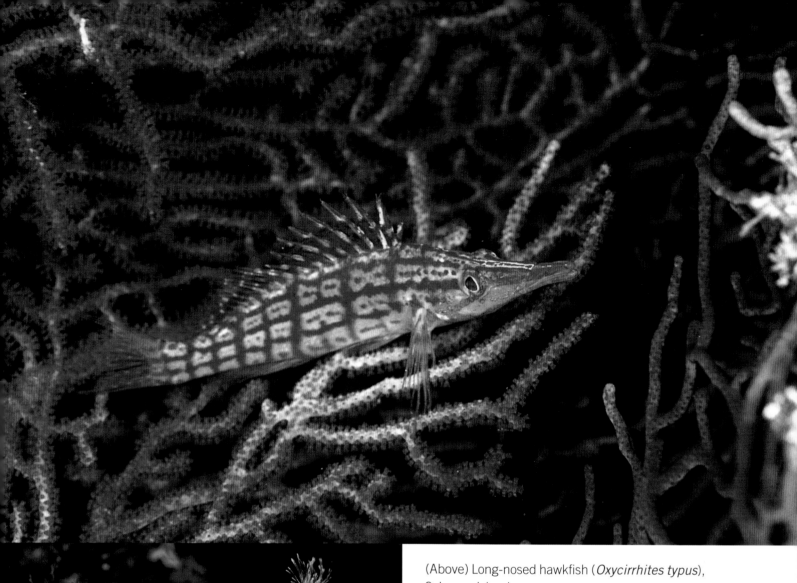

(Above) Long-nosed hawkfish (*Oxycirrhites typus*), Solomon Islands

(Left) Saron shrimp (*Saron* sp.), Manado, North Sulawesi, Indonesia

(Top right) False clown anemonefish (*Amphiprion ocellaris*) in host anemone, Manado, North Sulawesi, Indonesia

(Bottom right) Spinecheek anemonefish (*Premnas biaculeatus*) in host anemone, Ambon, Indonesia

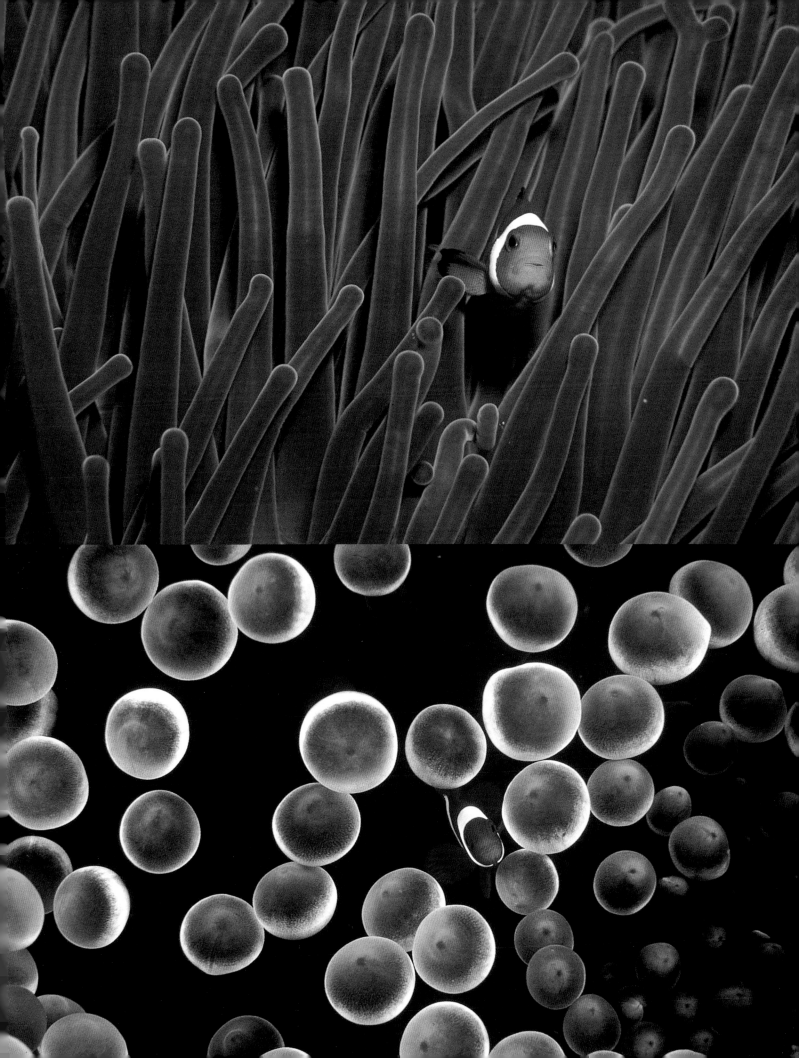

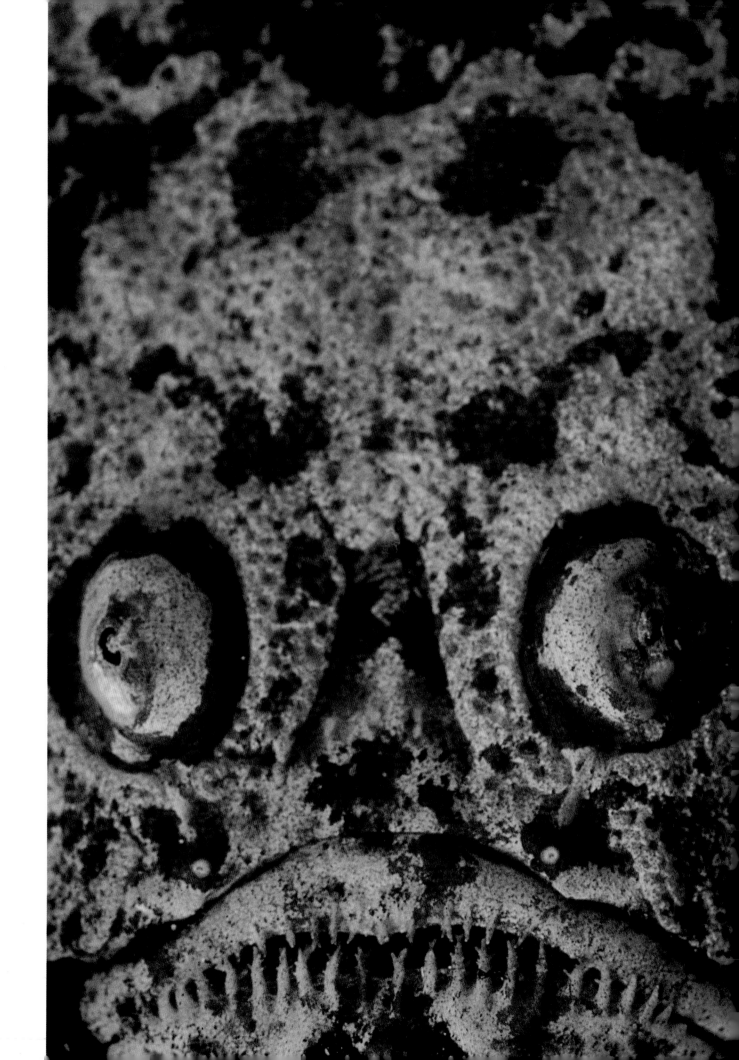

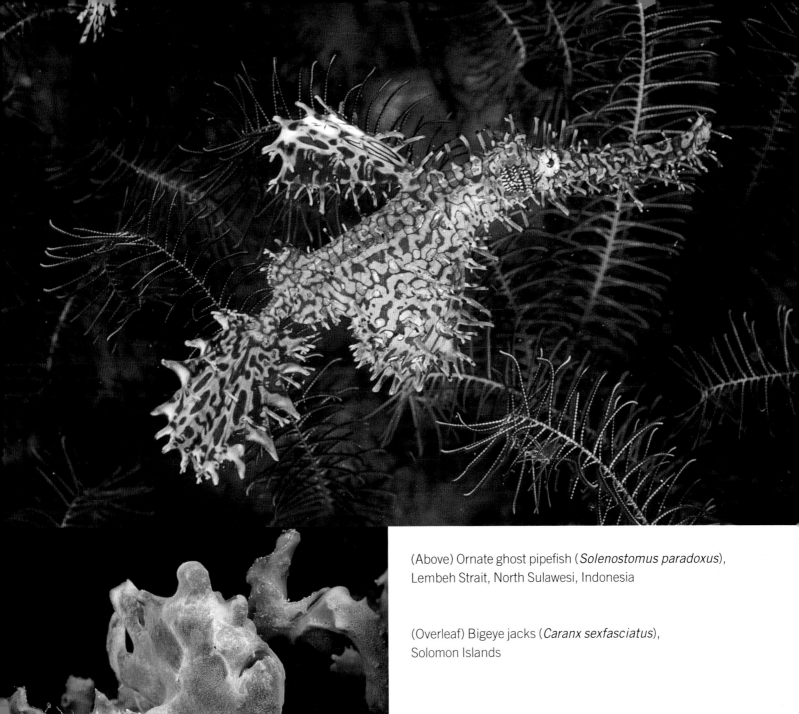

(Above) Ornate ghost pipefish (*Solenostomus paradoxus*),
Lembeh Strait, North Sulawesi, Indonesia

(Overleaf) Bigeye jacks (*Caranx sexfasciatus*),
Solomon Islands

(Above) Pink fish camouflage, giant frogfish (*Antennarius
commerson*) on sponge, Mabul, Sabah, Borneo (Malaysia)

(Left) Stargazer (*Uranoscopidae* sp.), Lembeh Strait,
North Sulawesi, Indonesia

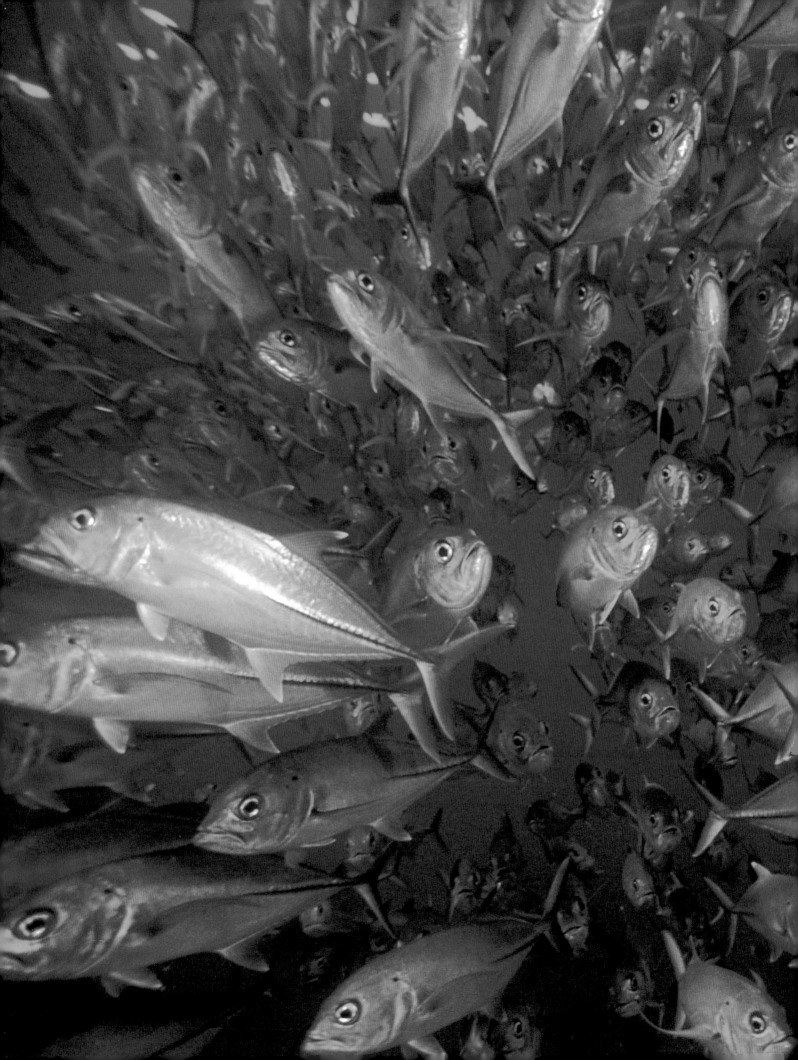

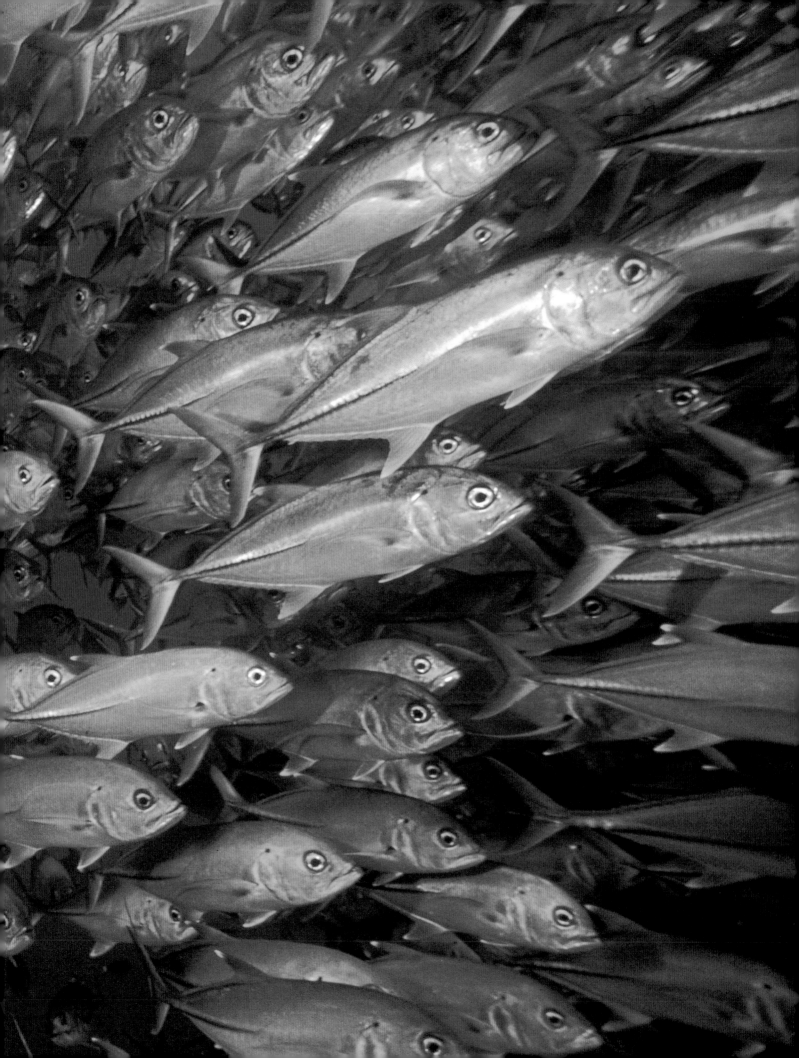

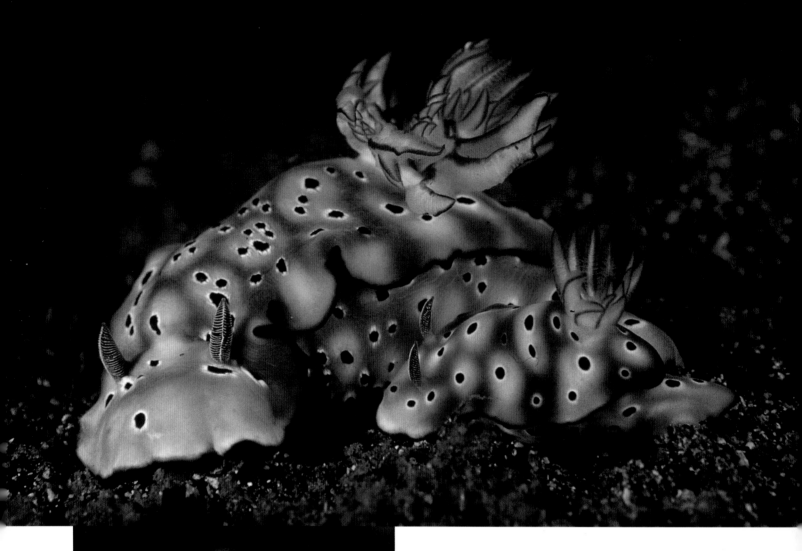

(Above) Nudibranch (*Risbecia tryoni*), Lembeh Strait, North Sulawesi, indonesia

(Left) Combtooth blenny (*Ecsenius granieri*), Eilat, Israel

(Right) Bicolor blenny (*Ecsenius bicolor*), Mabul, Sabah, Borneo (Malaysia)

(Overleaf) Pygmy seahorse (*Hippocampus bargibanti*), Lembeh Strait, North Sulawesi, Indonesia

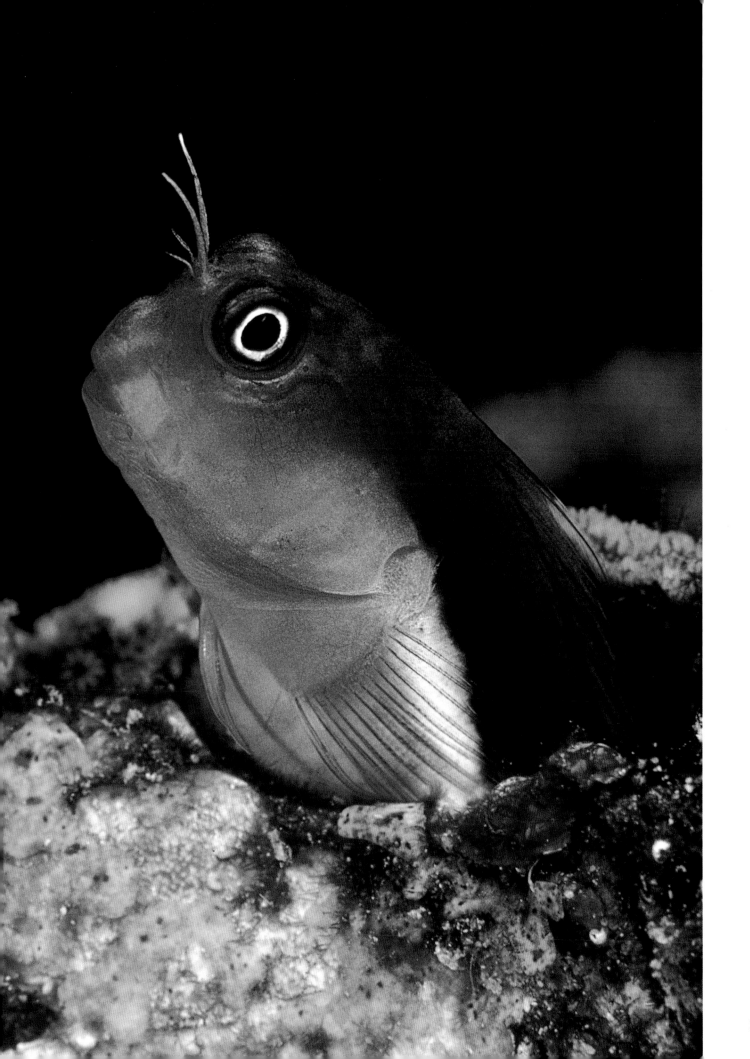

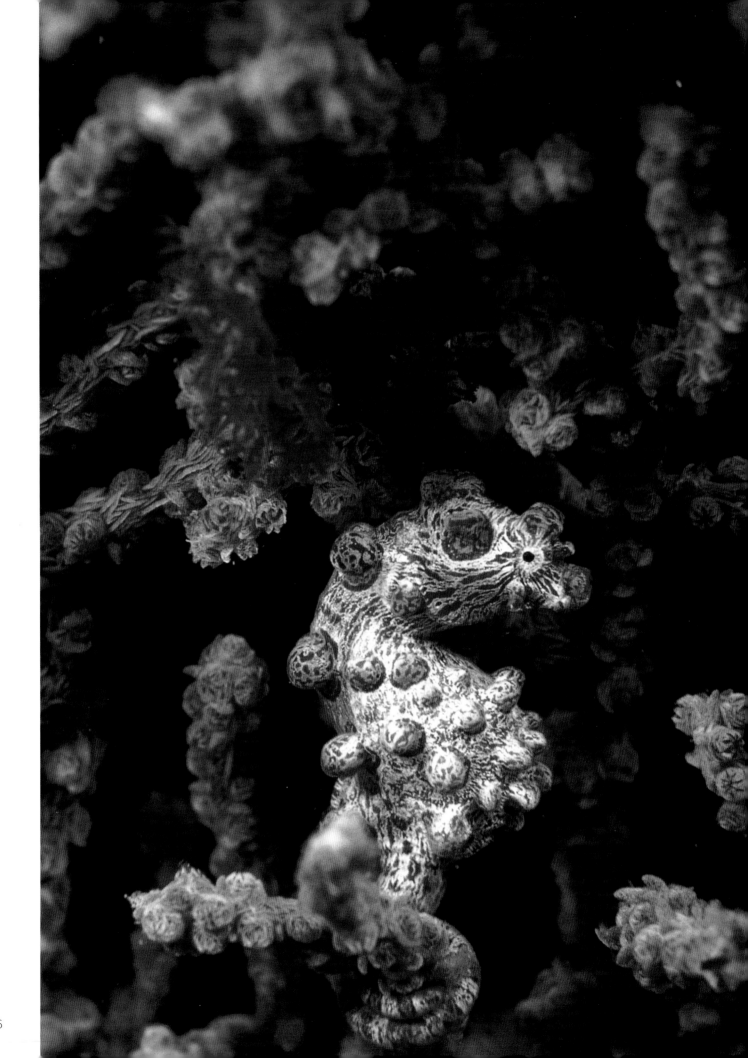

Roland Mayr/Sepp Friedhuber
Home and Away

'... however well you think you know them, animals never behave as you expect them to. Patience and stamina are an integral part of success in this business.'

Africa, with its huge variety of exotic and impressive wildlife, is often thought of as the holy grail of the wildlife photographer. But the more mundane domestic environment of central Europe can also offer spectacular photo opportunities for those prepared to seek them out. In this portfolio we introduce two professional photographers from Austria, whose work shows what can be achieved in very differing locations.

Roland Mayr, born in 1950, has been fascinated by nature since his earliest childhood. 'I can still remember my early adventures through the woods and along the brooks around our home. Even then, I was fascinated more by stags and wild boar than by lions or elephants – and those childhood preferences have stayed with me right through my adult life.'

Mayr now works as a warden in Austria's Kalkalpen National Park, where he has every opportunity to study animals in their natural environment. 'The local animal kingdom is still my favourite subject,' he explains. 'I can observe the local fauna through every change of the seasons in a way that would not be possible on even a number of expeditions to the savannah.'

Sepp Friedhuber, born in 1948, works as a biologist and came to photography via mountaineering. After making a number of mountaineering films for Austrian television, he took up wildlife photography in the late 1980s. 'Whenever I see animals in their natural surroundings, I want to capture them on film for those who won't get to see the real thing.'

Friedhuber won international acclaim for his part in a research project which placed the original source of the Amazon in the middle of the Sahara desert. The accompanying film received the Romy Prize for Most Original Nature Film of the Year.

From the Alps to Kilimanjaro, from the familiarity of central Europe to the exotic wilds of Africa, this portfolio showcases the work of two masters of the craft of nature photography, each in his own way engaged in the on-going fight to protect and conserve our natural environment.

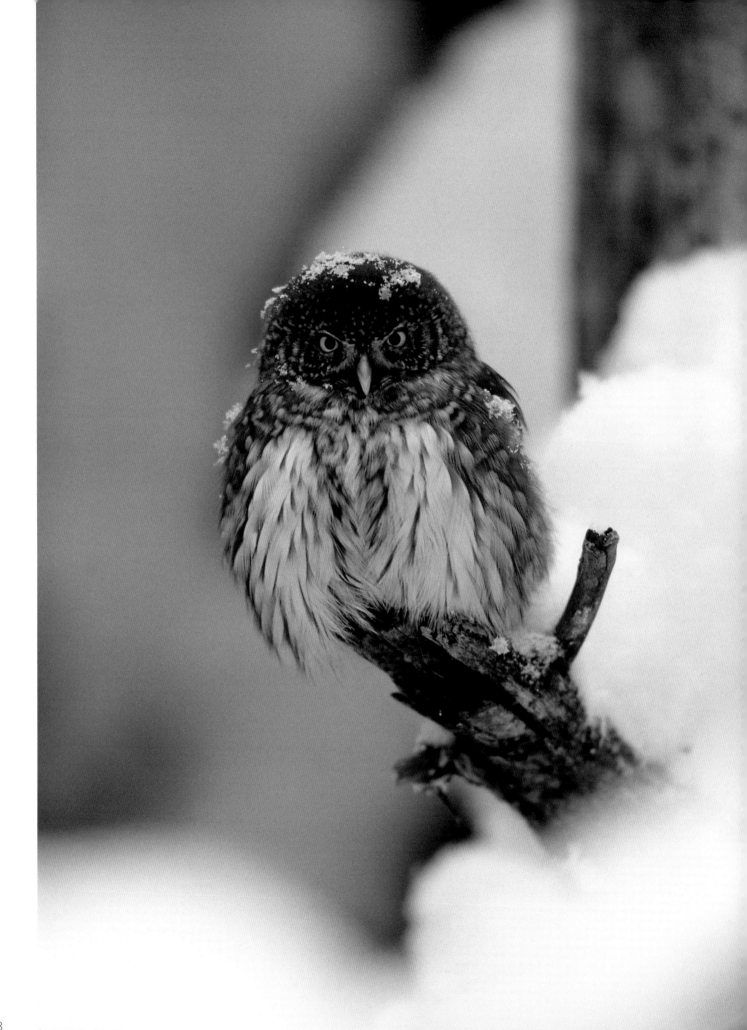

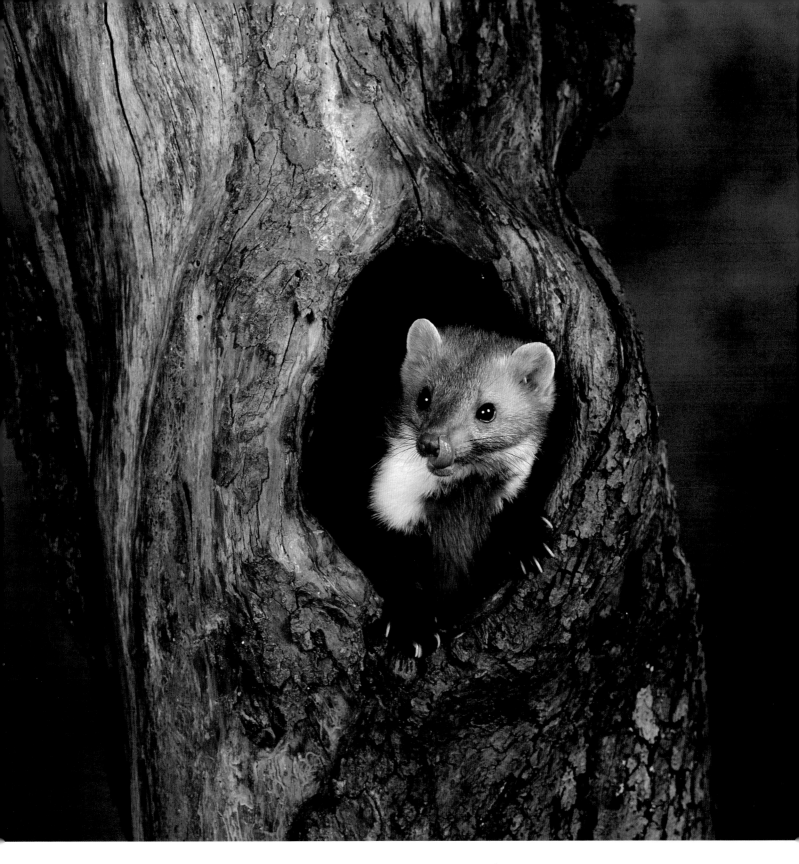

(Left) Deep winter snows had forced this pygmy owl, the smallest central European owl, into the lower elevations of the forest in search of food. The pygmy owl hunts by day and spends hours looking out for mice feeding on deer droppings. Once he spots one, it stands little chance…
Canon EOS IV, EF 400mm f/2.8 L USM IS with
EF x 1.4 extension tube, Fuji Sensia II

(Above) The beech marten uses the hours of darkness to grub around for food in any space it can get at. I spent every night for three weeks putting titbits into this old tree stump in Kalkalpen National Park until, after many failures, I was rewarded with this shot.
6 x 6 Rolleiflex 6008 professional, Sonnar 150mm f/1.4 HFT PQ lens, Fuji Velvia 120

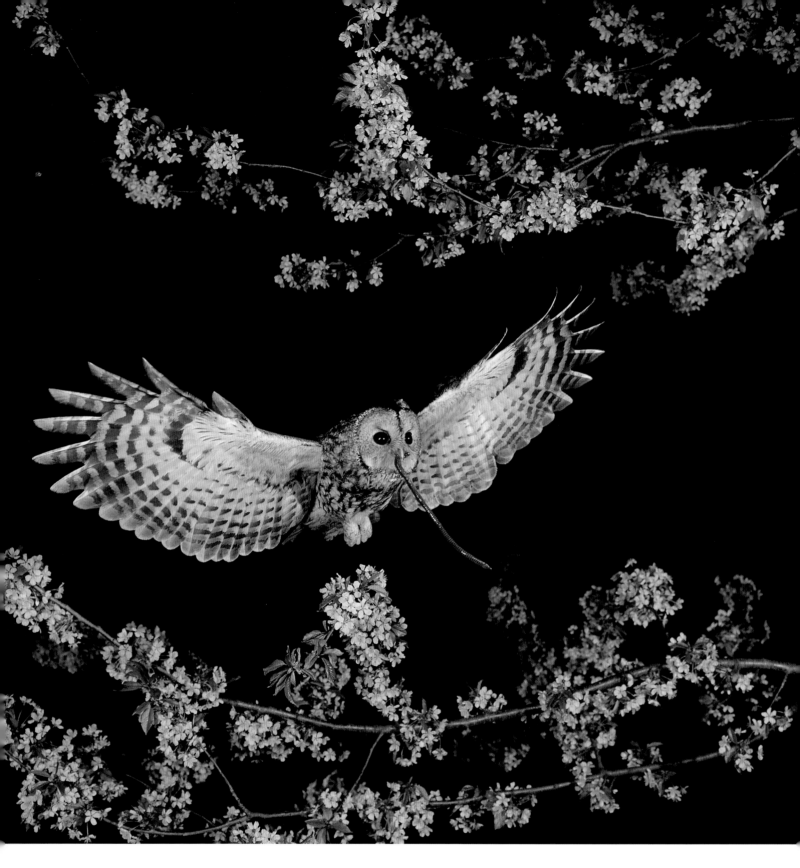

(Above) This tawny owl automatically triggered the shutter on its way back to the nest. I built up the equipment slowly, leaving gaps of two or three days, and then gradually increased the intensity of the automatic flash.
6 x 6 Rolleiflex 6008 professional, Planar 80mm f/2 HFT lens, Fuji Velvia 120

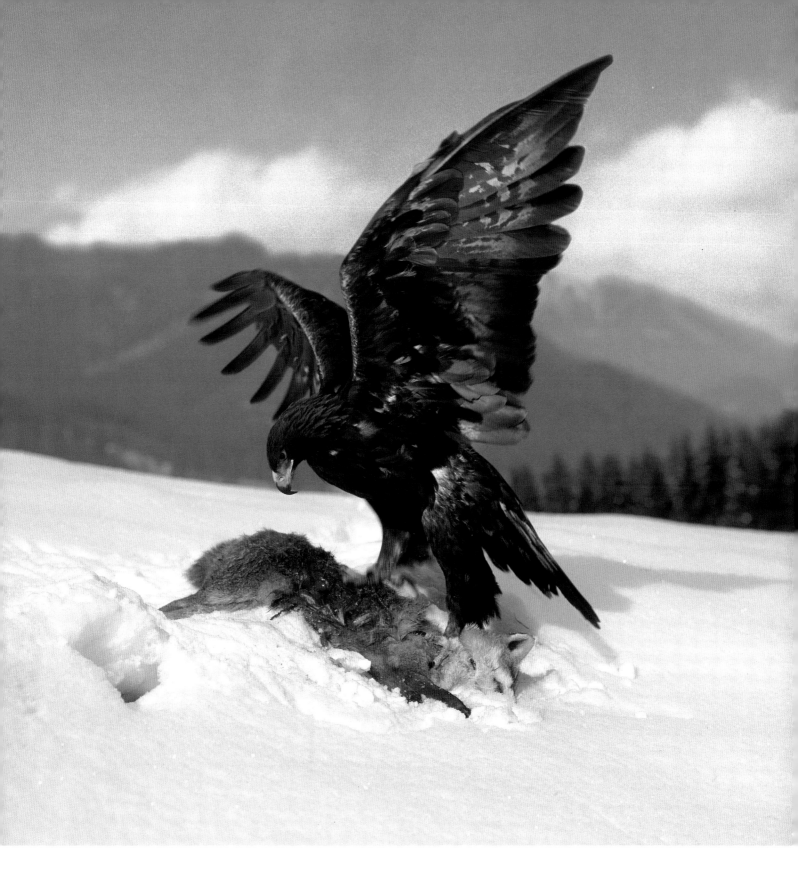

(Above) Although this picture was shot in February, I started building my hide the previous November, under a fallen tree. Every other day I laid out food for the golden eagle but it was always taken by a raven, a magpie or a fox. After almost three months, snowstorms forced the eagle down to lower levels. Once I realized he was taking an interest in my bait, I went into the hide – and suddenly there he was.

6 x 6 Rolleiflex 6008 professional, Schneider 300mm f/4 plus x 1.4 converter, Fuji Velvia 120

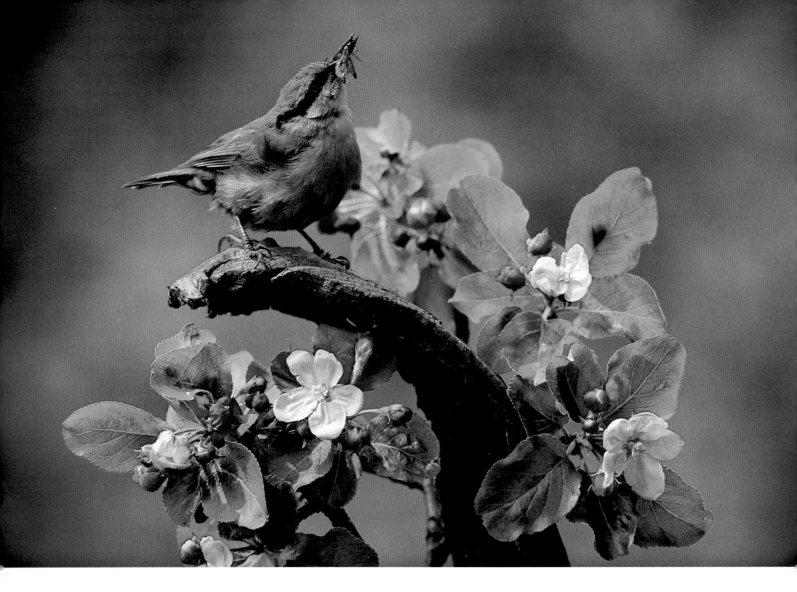

(Above) A nuthatch seeks out its food amongst the fresh apple blossoms. Having set up a well-camouflaged tent in its territory, it takes only takes a little patience to achieve some fine pictures.
Canon T90, Canon 150–600mm f/5.6, Fuji Velvia

(Top right) Many wild animals feel safer in rain than in sunshine. Rain produces a delightful haze in this photo of a stag.
Canon EOS IV, EF 400mm f/2.8 L USM IS with EF x 1.4 extender, Fuji Sensia II

(Bottom right) Wild boar like to be near, or even in, water. I set up my hide near a pond. It had to be well camouflaged but also of windproof material, as the boar has an excellent sense of smell.
Canon EOS IV, EF 100–400mm f/4.5–5.6 L USM IS, Fuji Sensia II

(Overleaf) As an icy wind blew fine crystals of sparkling snow up the mountain, a young buck chamois appeared. I had just seconds to get my picture.
Canon EOS 1N, EF 300mm f/2.8 lens with x 1.4 extender, Fuji Velvia

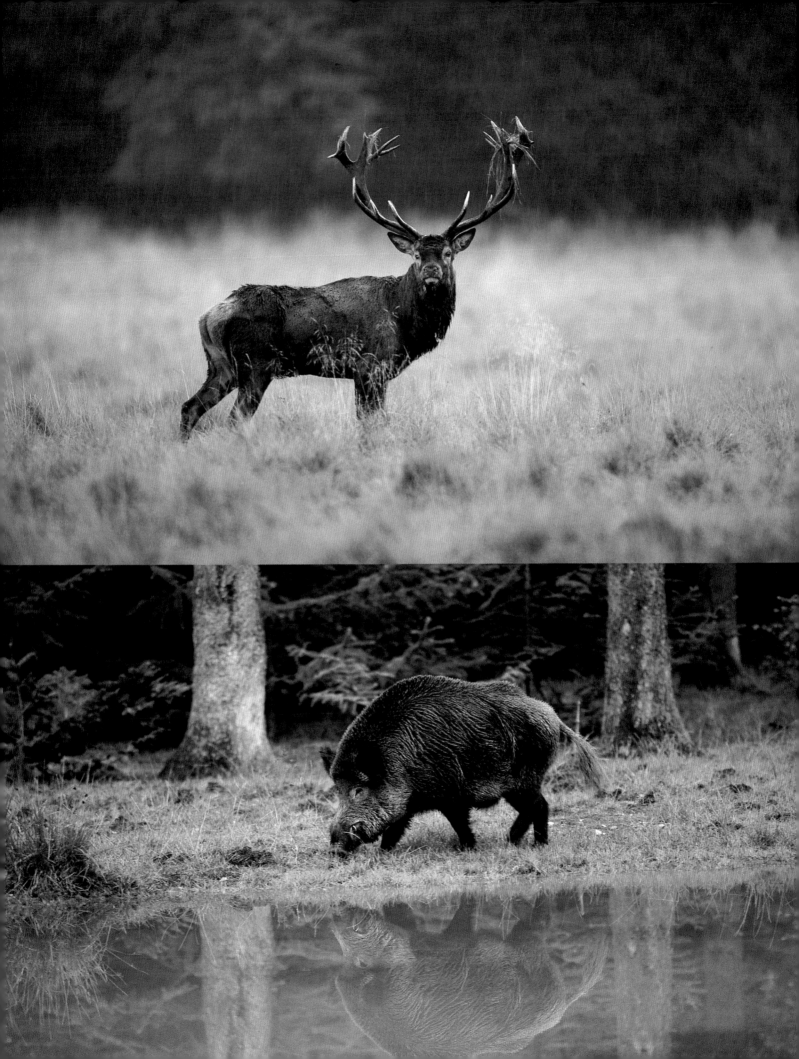

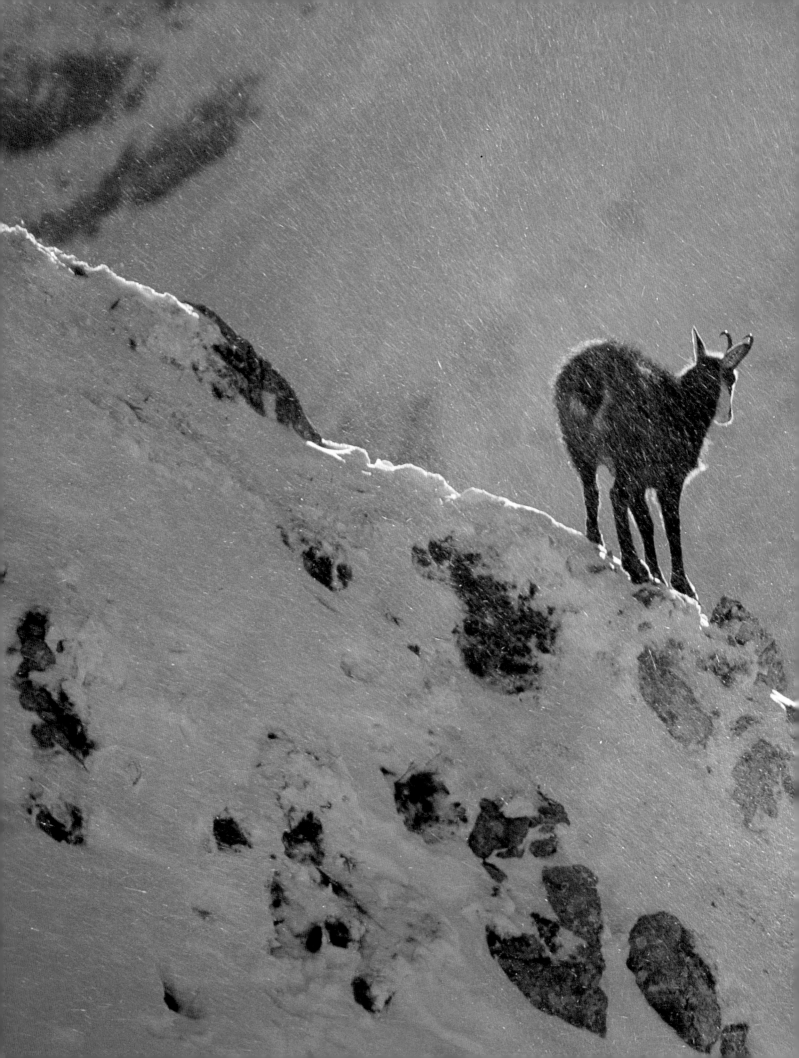

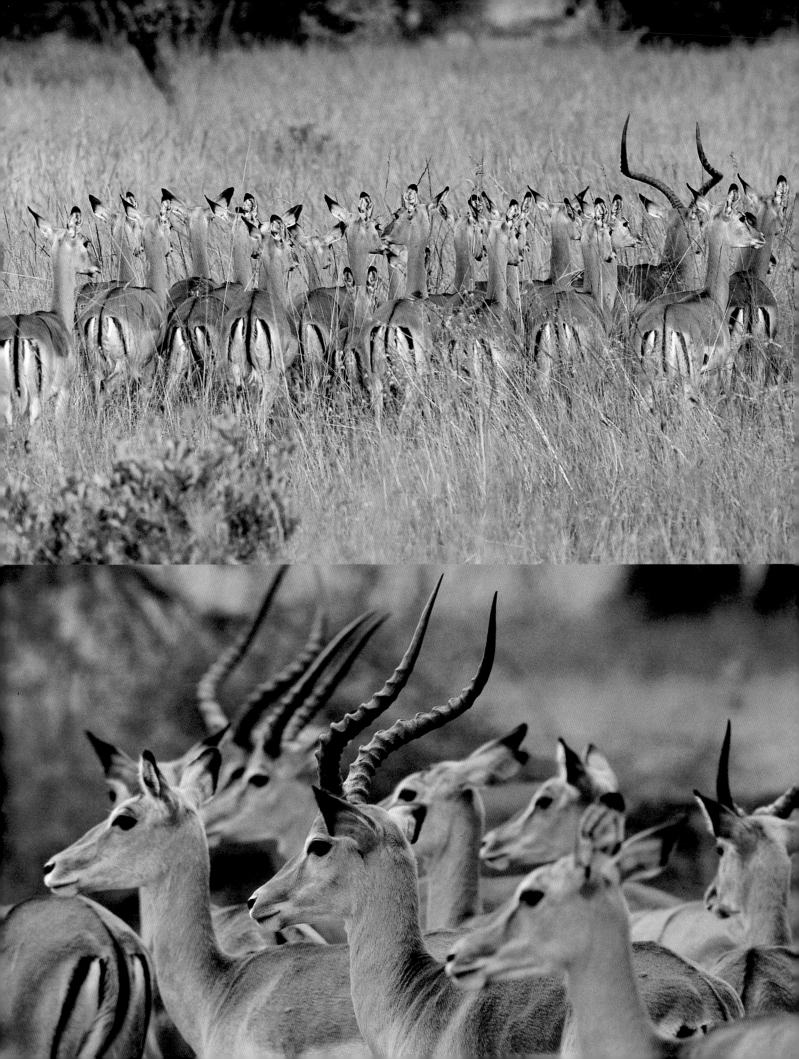

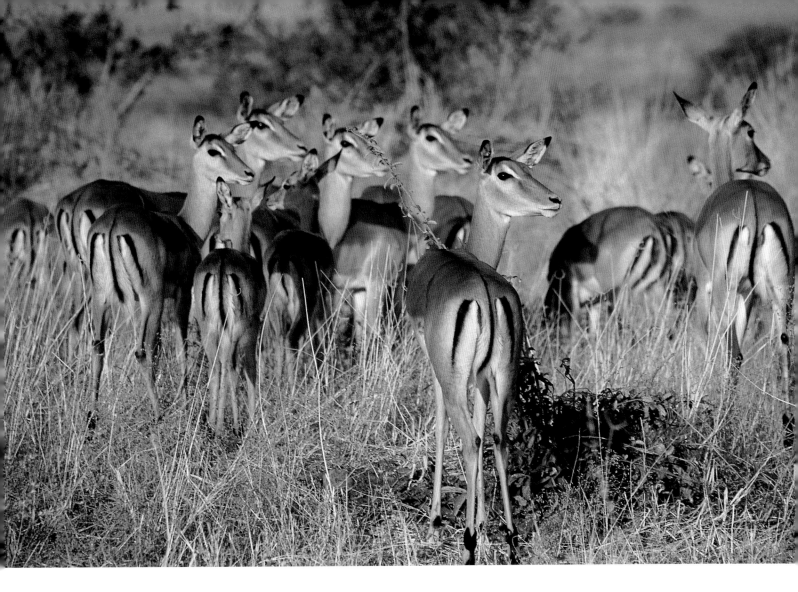

(Top left, bottom left and above) Impalas are common in the savannah, though photographing herds of animals is actually quite difficult as the constant movement makes composition a problem. It's all too easy to chop off a head or a tail, or to find that some distracting element has made its way into the frame...
Canon EOS 1, 300mm lens, Kodak Ektachrome 100SW

(Overleaf) In early January 2001, I visited the famous Ngorongoro crater in Tanzania. It was the end of the rainy season and everything was a luscious green. Ostriches stay together as a group for only a moment or two at a time, so I was forced to 'shoot from the hip'; another few seconds and they were on their way.
Canon EOS 3, 300mm lens, Fuji Provia 100F

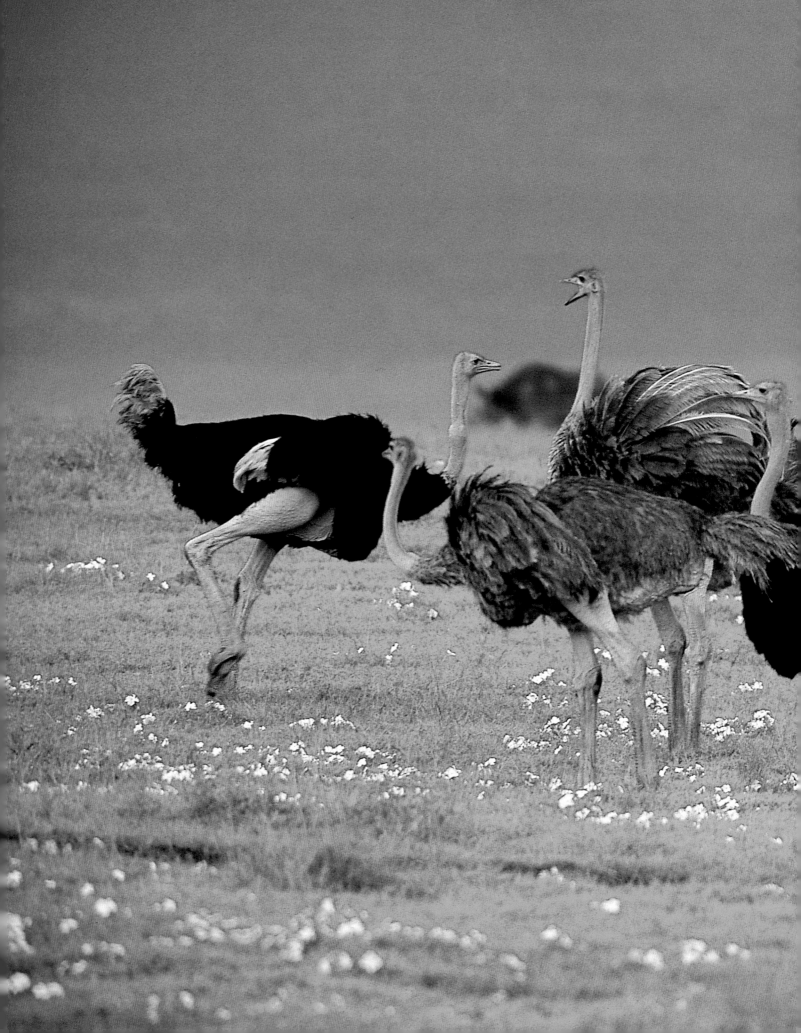

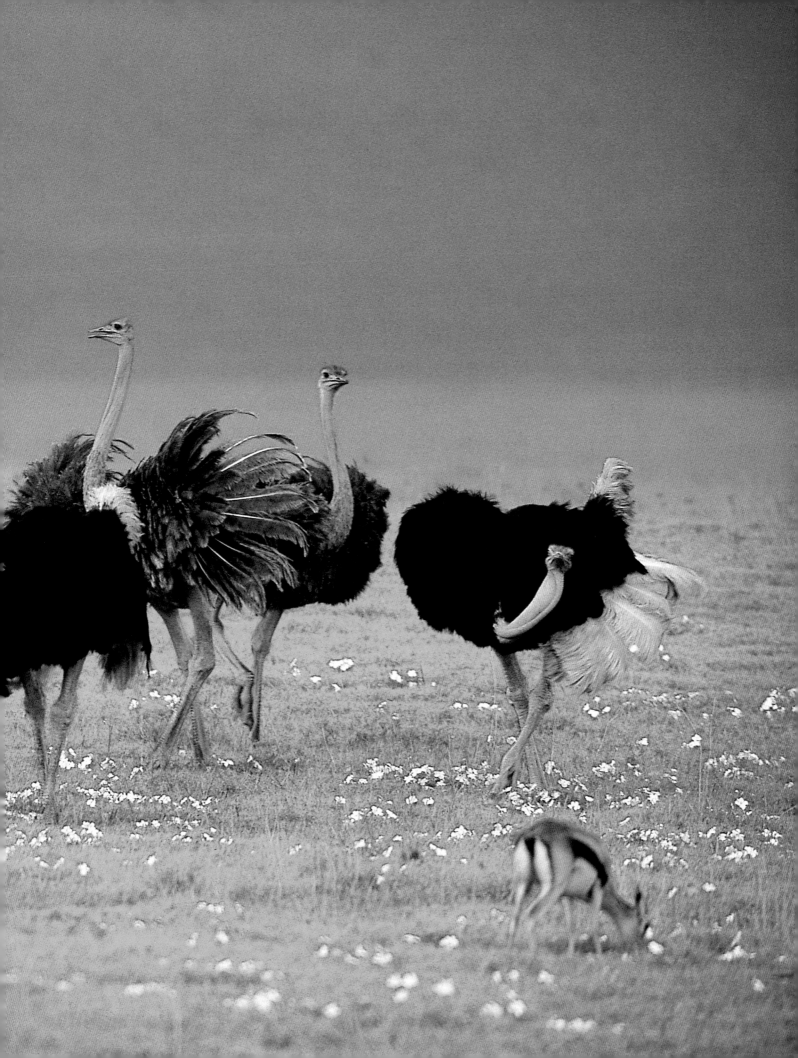

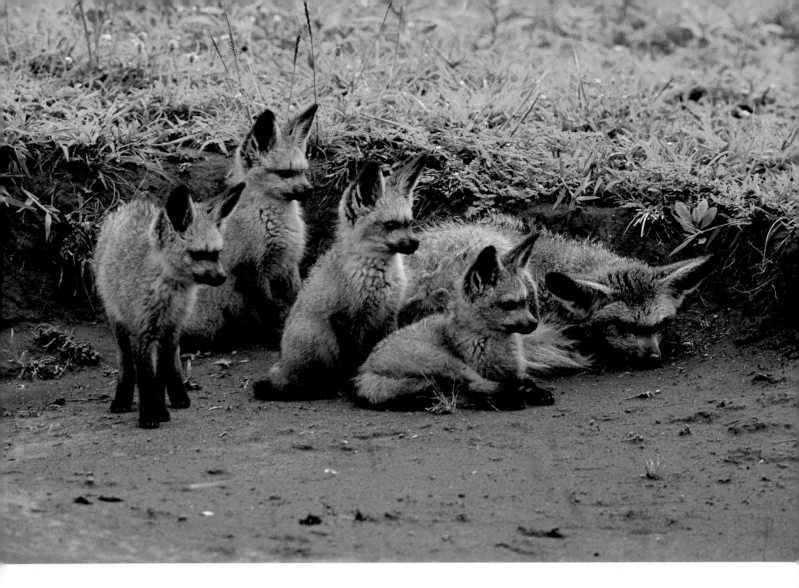

(Above) On the edge of the Serengeti, I came across a bat-eared fox lying in the grass with her cubs. These are extraordinarily shy creatures so we drove particularly slowly, stopping the car every few metres (yards) so that they would get used to our presence. When we were about 30 metres (yards) away, the group metamorphosed into a jumble of eyes and conical ears, perfect for me as a photographer.
Canon EOS 3, 300mm lens, x2 converter, Fuji Sensia

(Top right) We'd been tracking this cheetah and her cubs for days when, late one afternoon, we found her lying on a termite-hill with youngsters asleep below. Suddenly one of the cubs awoke and started towards its mother. I pressed the shutter and the frame of the cub with its tongue sticking out was no. 36 on the roll; I had only this one frame left.
Canon EOS 1 300mm lens, Kodak Ektachrome 100 SW

(Bottom right) Photographing a herd means imposing structure on a disorderly group; on the other hand, zebras do have a gratifyingly graphic quality.
CanonEOS 1N, 300mm f/2.8 lens, Fuji Velvia

(Above) Late one afternoon we were driving alongside the Samburu river in Samburu National Park (northern Kenya). Suddenly an elephant crashed out of the brush. We stopped the car and as the rest of the herd followed I was ready. I really like the happy and contented atmosphere that seems to pervade this picture.
Canon EOS 1, 300mm lens, Kodak Ektachrome 100SW

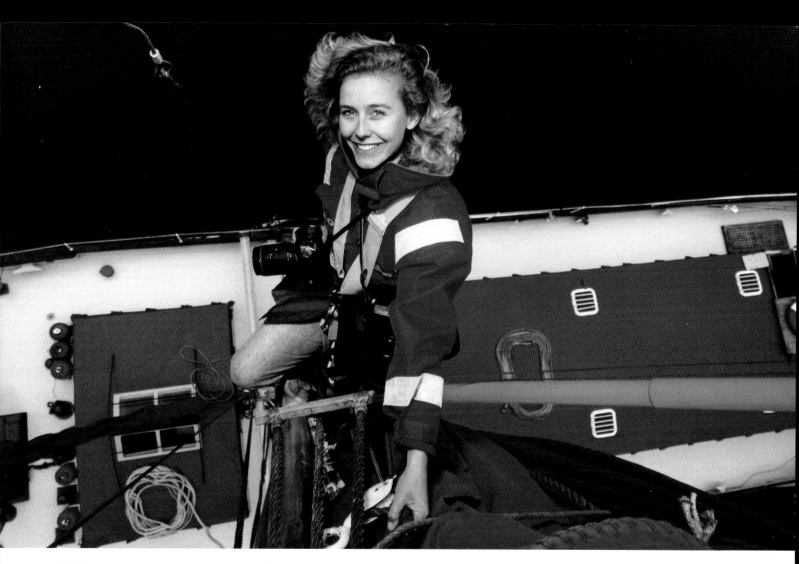

Kos
All at Sea

'The mast moves some 20–30 feet from side to side – you have to try and take a picture without your feet in the shot.'

Kos graduated from the London College of Printing in 1980 with an Honours degree in photography, film and television, specializing in sport. It is for her coverage of international yacht racing that she is perhaps best known.

After twenty years of photographing on the water, Kos has developed a number of ways of getting the best possible pictures of the events she covers, including working with a specific helicopter pilot and photoboat driver to get the angles she wants. She owns a powerboat called a Surfrider Interceptor, which is spectfically designed for filming on the water sometimes just a few inches from the bow of a racing yacht. 'When taking this kind of image you have to brief the helmsman, otherwise he will try to take evasive action!' Her dramatic camera angles and ability to capture the drama of the moment have brought her widespread critical acclaim.

She earns great respect from other photographers for being prepared to climb masts as high as 180 feet (55 metres) to obtain shots from a literally breath-taking viewpoint. After one particularly exciting session she said, 'I have to say that after taking these images my legs were trembling when I got to the deck. If anything had happened, there would not have been much that anyone could have done to rescue me.'

Kos uses Canon EOS 1 and EOS 1V bodies with the whole range of Canon lenses and, for underwater work, a Nikonos 5 with Seacam underwater housing. She uses Fuji Provia and Velvia films exclusively.

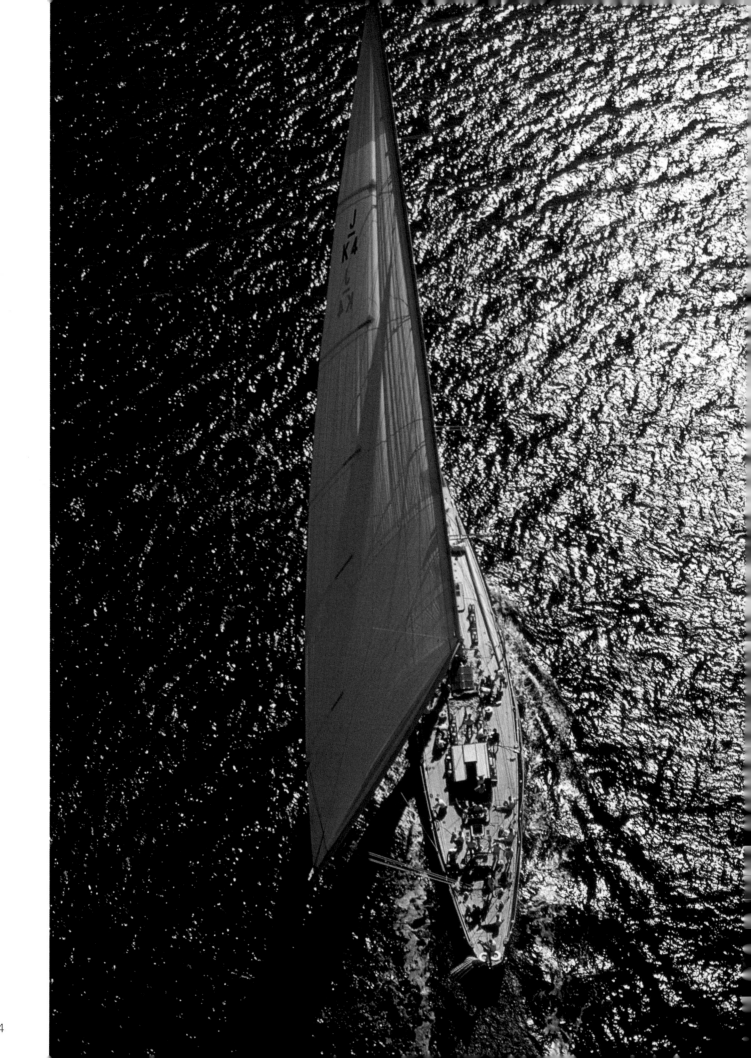

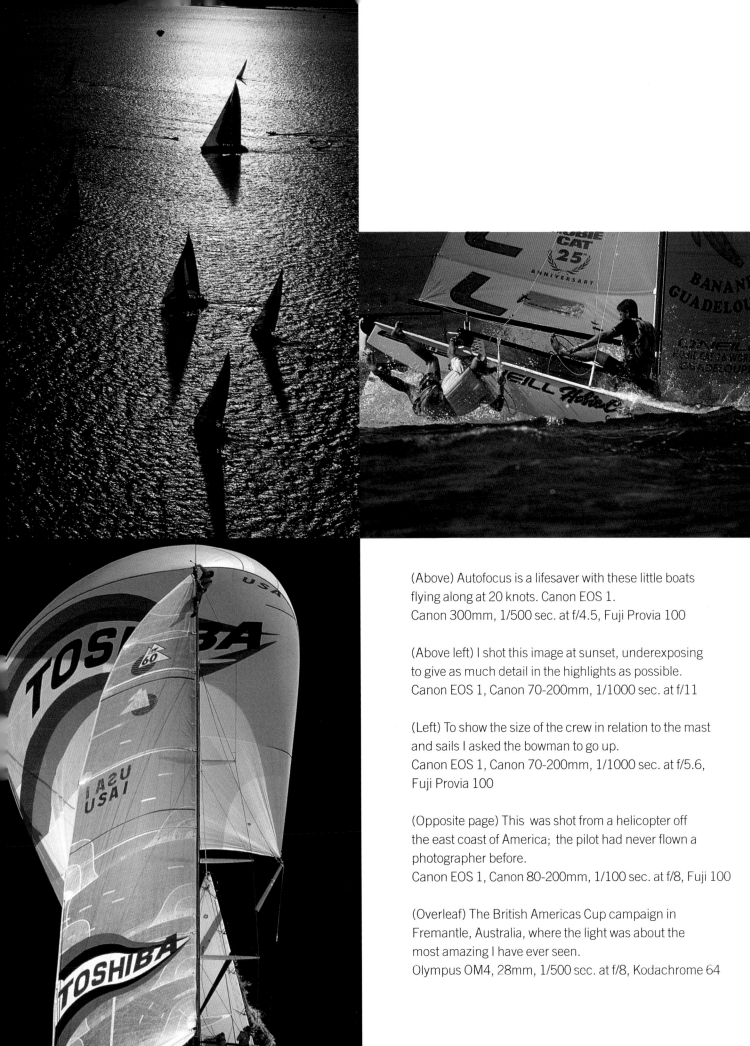

(Above) Autofocus is a lifesaver with these little boats flying along at 20 knots. Canon EOS 1.
Canon 300mm, 1/500 sec. at f/4.5, Fuji Provia 100

(Above left) I shot this image at sunset, underexposing to give as much detail in the highlights as possible.
Canon EOS 1, Canon 70-200mm, 1/1000 sec. at f/11

(Left) To show the size of the crew in relation to the mast and sails I asked the bowman to go up.
Canon EOS 1, Canon 70-200mm, 1/1000 sec. at f/5.6, Fuji Provia 100

(Opposite page) This was shot from a helicopter off the east coast of America; the pilot had never flown a photographer before.
Canon EOS 1, Canon 80-200mm, 1/100 sec. at f/8, Fuji 100

(Overleaf) The British Americas Cup campaign in Fremantle, Australia, where the light was about the most amazing I have ever seen.
Olympus OM4, 28mm, 1/500 sec. at f/8, Kodachrome 64

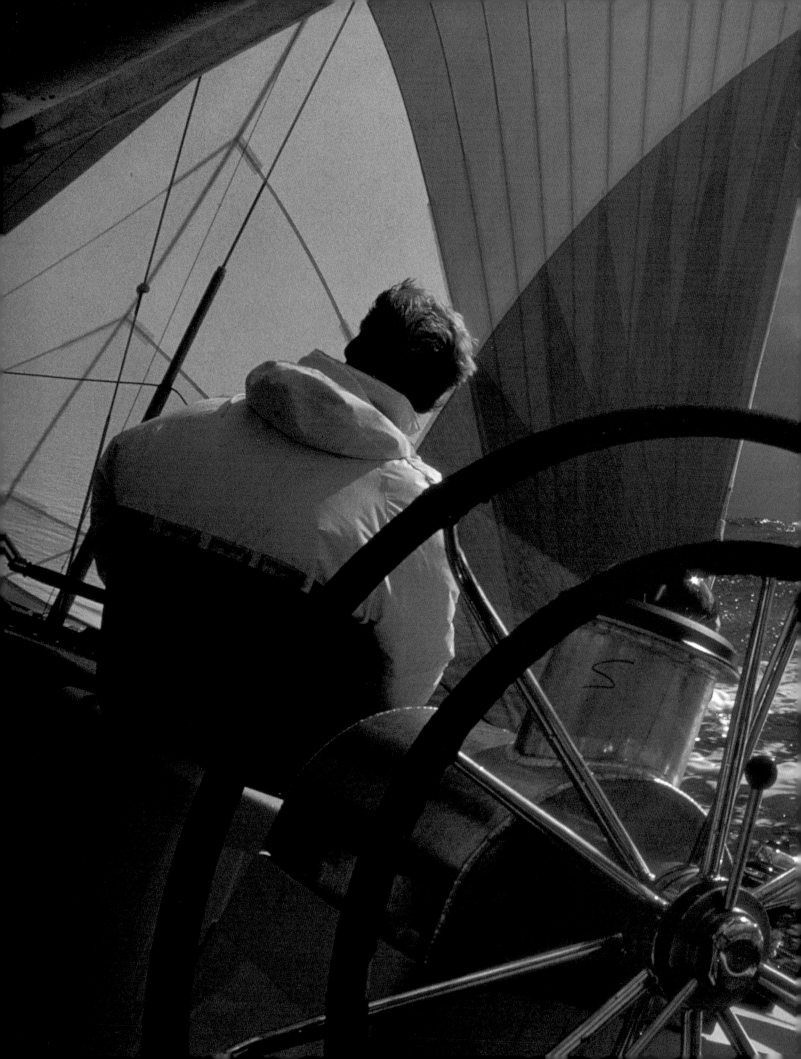

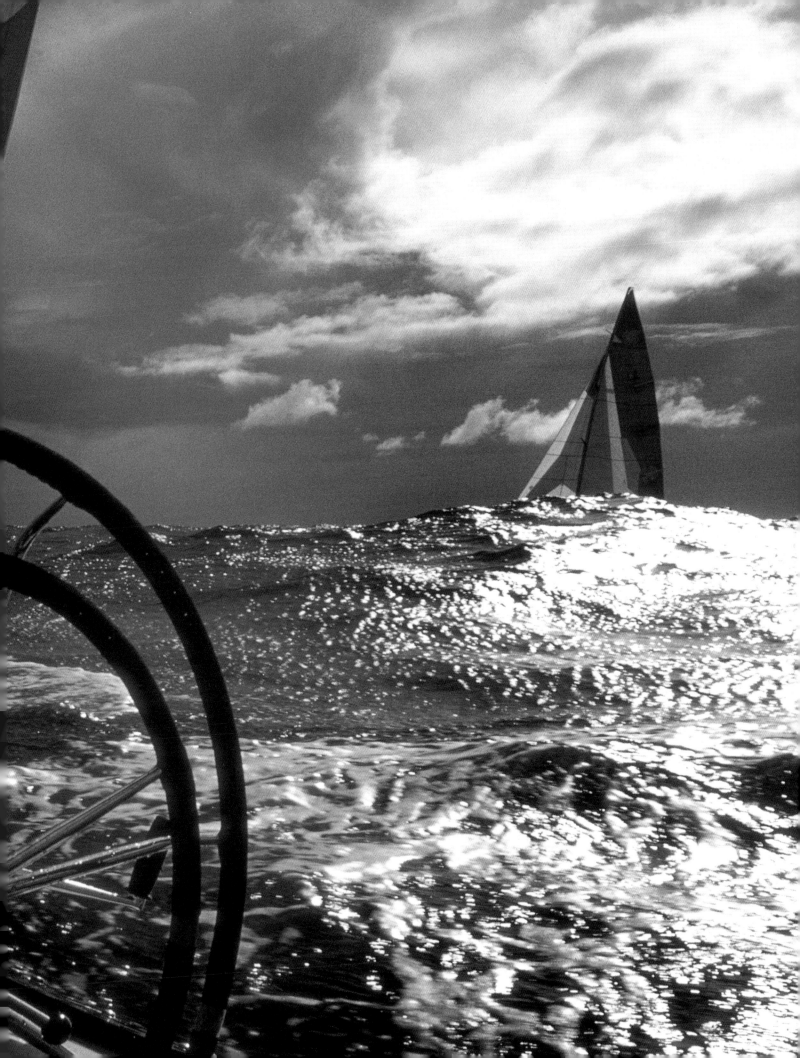

(Below) We flew to meet the racing yachts at
sunrise and sunset to try to achieve the best shots.
Canon EOS 1, 75-200mm, Fuji Provia 100

(Top right) Here was Alexei hanging over the water
while I lay on the bottom of my photo boat using a 15mm
fisheye lens.
Canon EOS 1, 15mm fisheye, 1/500 sec. at f/11, Fuji Velvia

(Bottom right) I used a long lens to compress this image
and waited for a large swell to take the bow of the boat out.
Canon EOS 1V, 300mm, 1/1000 sec. at f/4.5,
Fuji Provia 100

(Opposite page) Using a long lens, I was able to
compress the image to create the feeling of this huge
tanker battling through a sea of yachts.
Canon EOS 1, 300mm, 1/1000 sec. at f/8, Fuji Velvia

(Overleaf) I look for the incidents to present
themselves and hope that a wave does not pop up
between me and the image.
Canon EOS 1, 400mm, 1/500 sec. at f/5.6

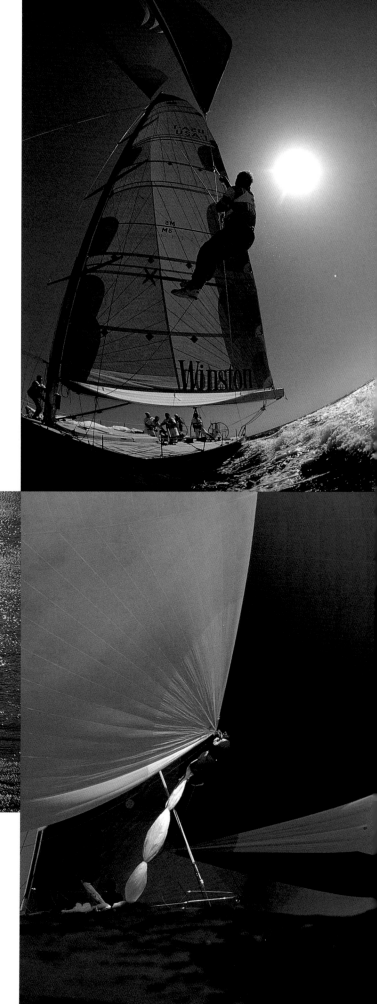

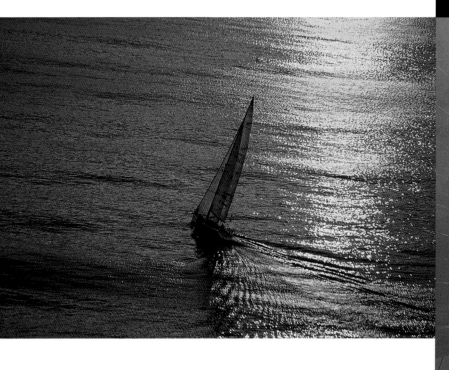

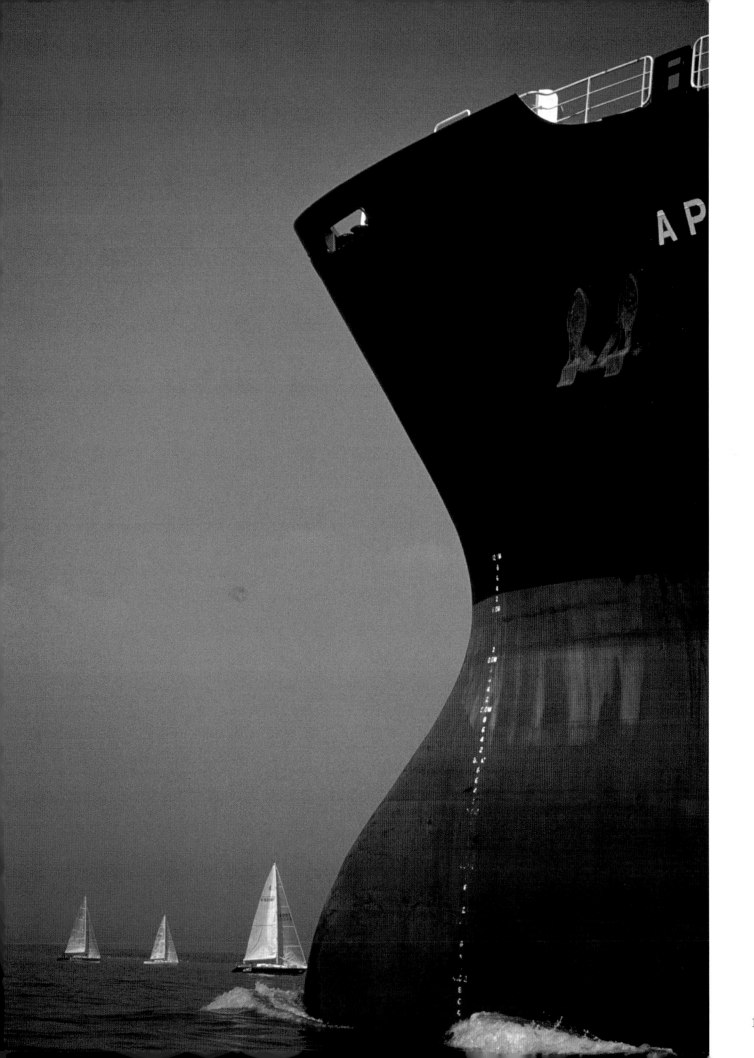

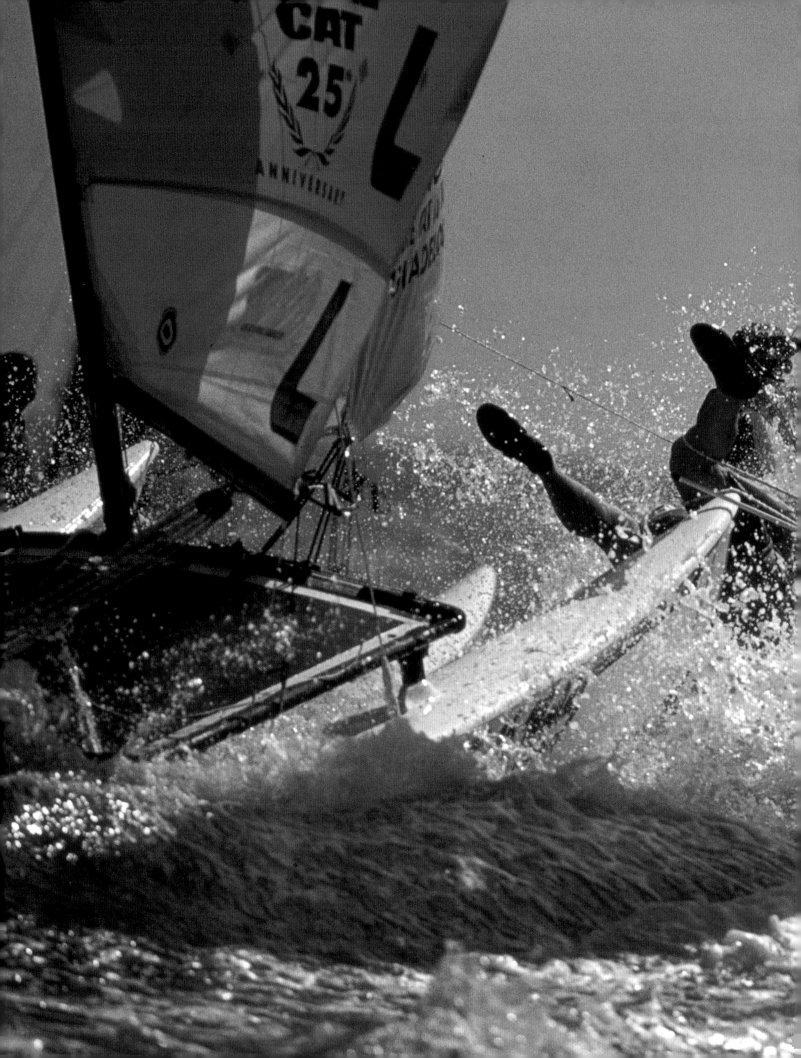

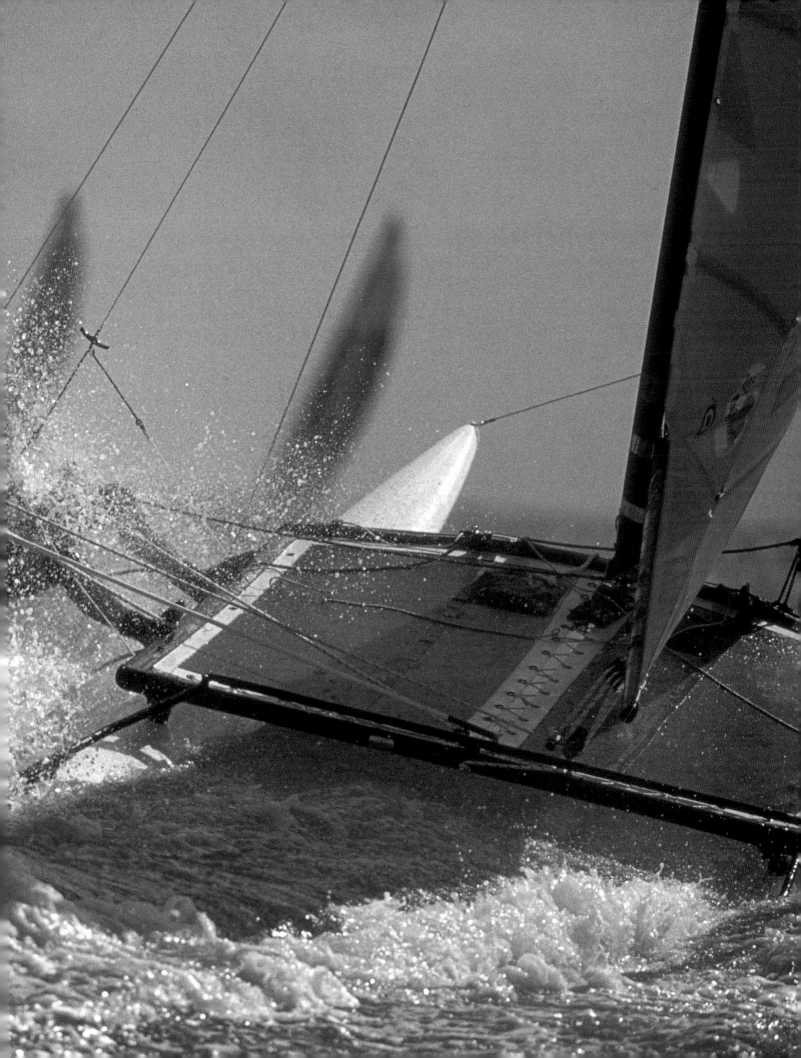

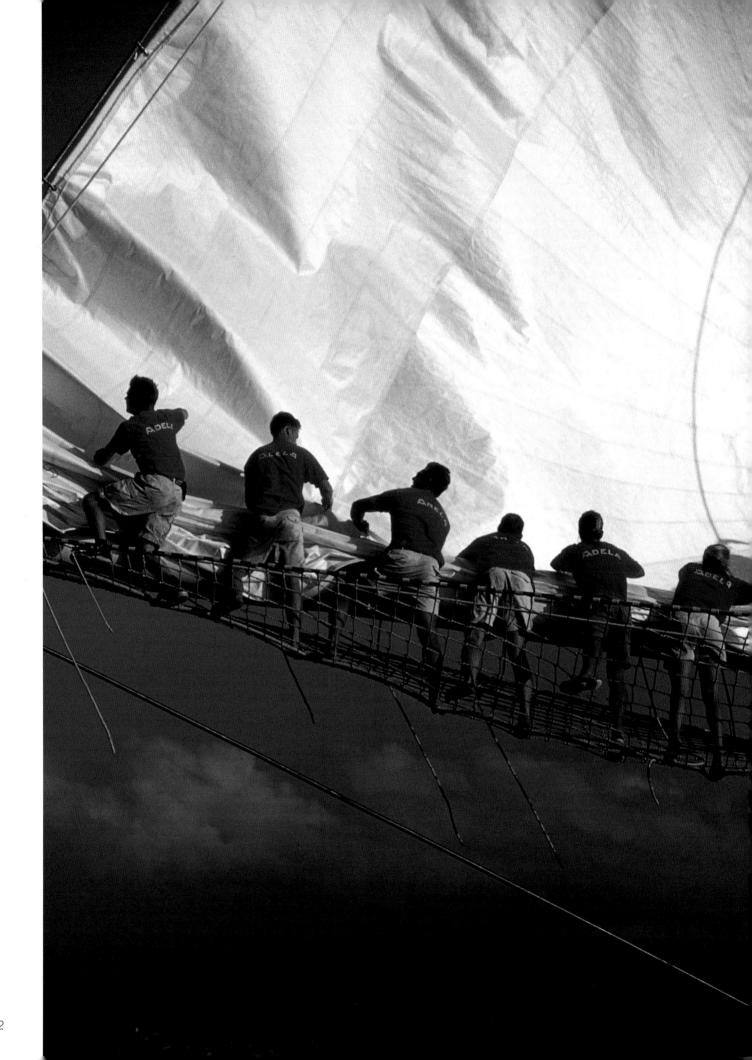

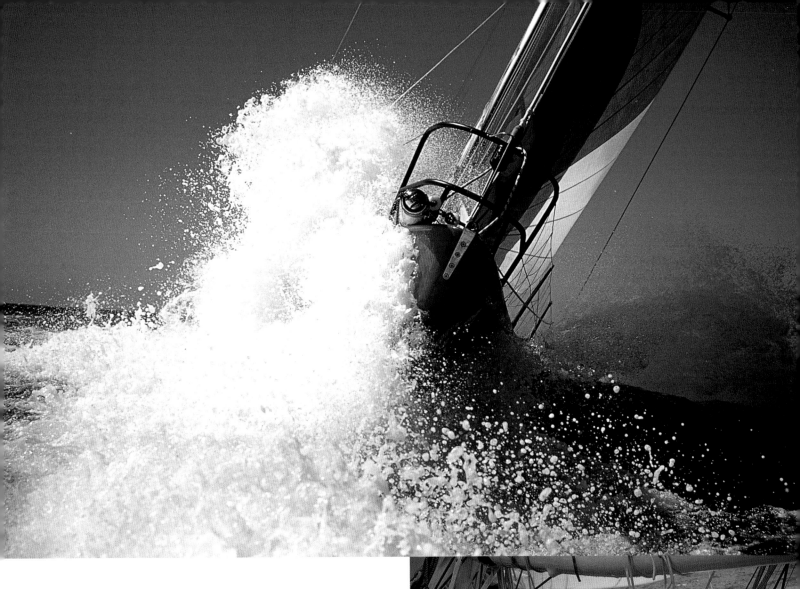

(Left) Some of the larger yachts take an incredible
number of crew to pull down or hoist sails.
Canon EOS 1V, 28-70mm lens, Fuji Provia 100

(Above) Winston Bow: I shot this image from the back
of my photo boat with the bow of the yacht just a few
inches away.
Canon EOS 1, 20-35mm lens, 1/500 sec. at f/5.6

(Right To shoot classic yachts, it is often better to have
muted colours giving an older feel to the image.On this day
it was blowing a force 7 in the Gulf of StTropez.
Canon EOS 1, 80-200mm, 1/500 sec. at f/5.6, Fuji 100

(Overleaf) Here I decided to use the texture of the water
as my main canvas, and then punctuate this with the yacht
and its shadow.
Canon EOS IV, Canon 70-200mm, 1/1000 sec. at f/8,
Fuji Provia 100

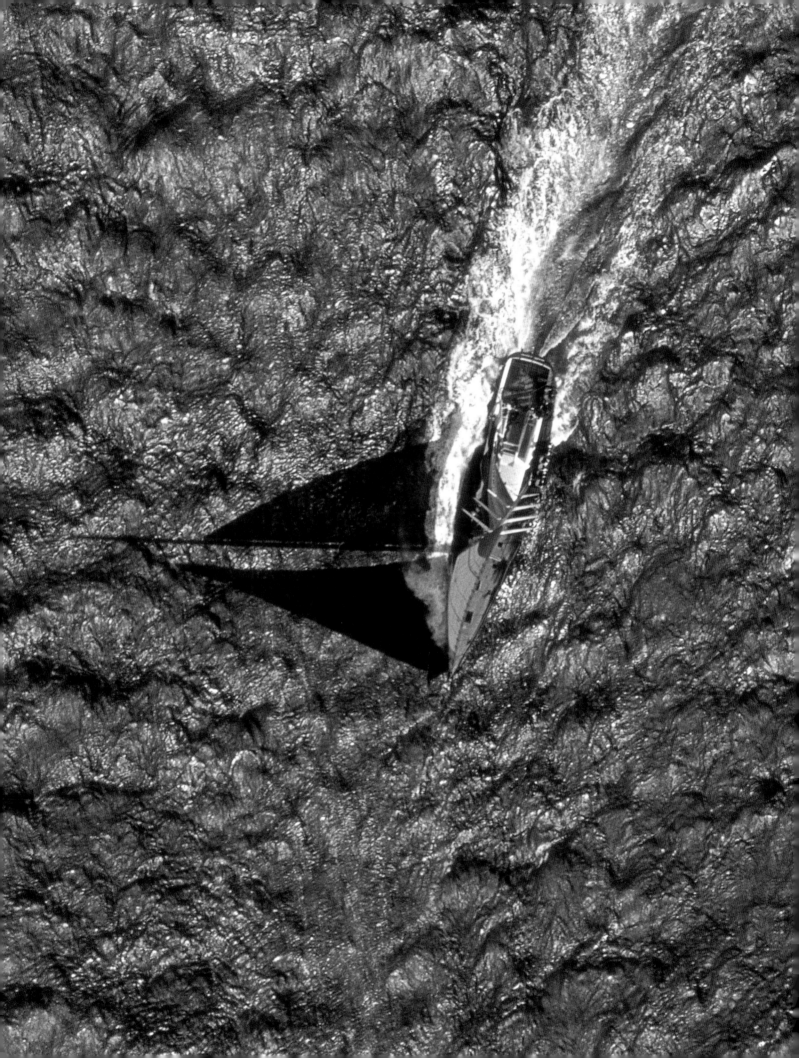

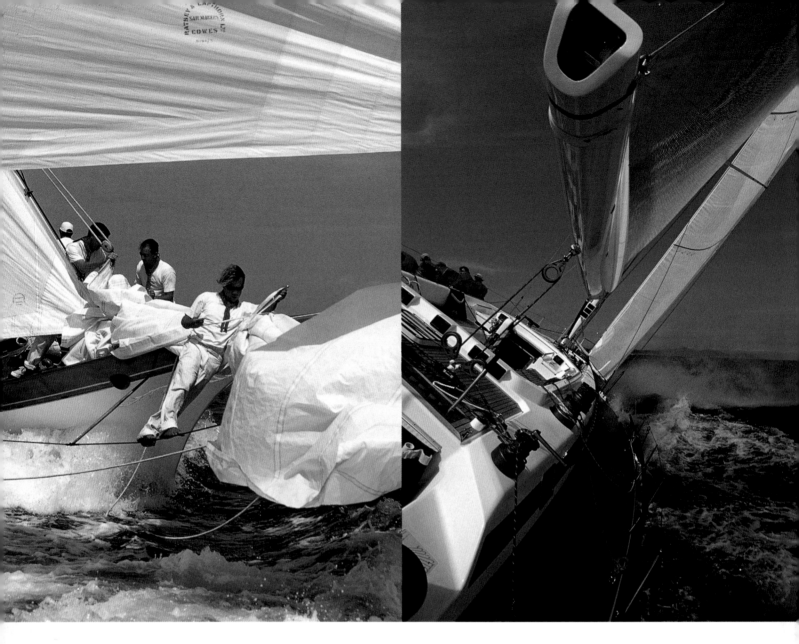

(Above left) I thought it was amazing that this crew member had no shoes while walking along the supporting bow stays of the boat.
Canon EOS 1V, Canon 28-70mm, 1/1000 sec. at f/8, Fuji Provia 100

(Above right) Here I was looking for an almost sculptural, futuristic effect.
Canon EOS IV, Canon 20-35mm, Fuji Provia 100

(Opposite page) Whilst being hoisted up an 80-foot (24-m) mast, I at first got trapped in the wires. I cropped this image to accentuate the focus on the tiny crewman at the end of the spinnaker pole struggling with the huge sails.
Olympus OM4, 50mm, Kodachrome 64

(Overleaf) I was hoisted up the 180-foot (55-m) mast during a race. The mast moves some 20–30 feet (6–9 metres) from side to side. After taking these images my legs were trembling when I got to the deck.
Canon EOS 1, 15mm fisheye, 1/1000 sec. at f/8, Fuji Provia

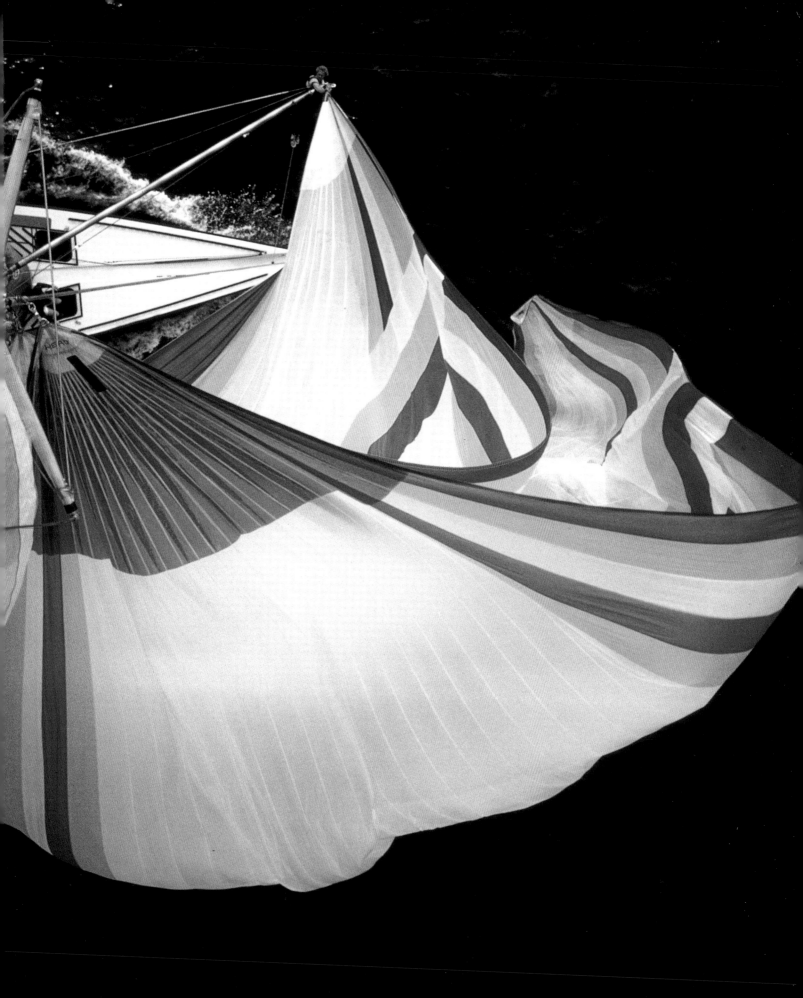

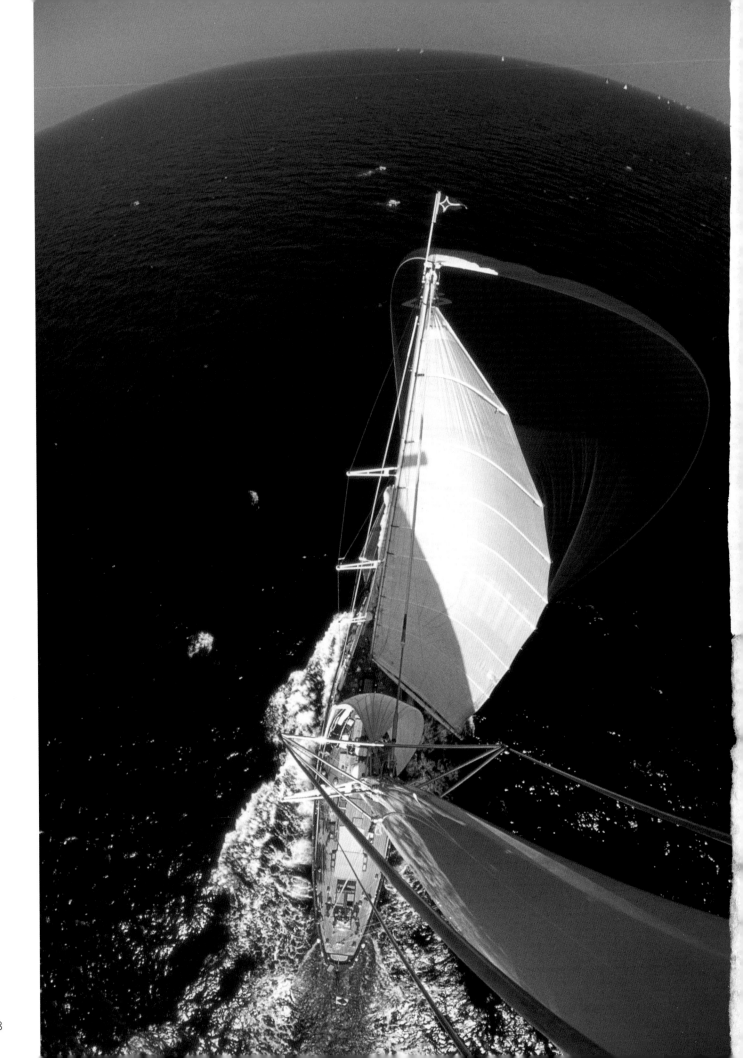